WEDDING PHOTOGRAPHY

Advanced Techniques *for* Digital Photographers

Bill Hurter

AMHERST MEDIA, INC. ■ BUFFALO, NY

ABOUT THE AUTHOR

Bill Hurter has been involved in the photographic industry for the past thirty years. He is the former editor of *Petersen's PhotoGraphic* magazine and currently the editor of both *AfterCapture* and *Rangefinder* magazines. He has authored over thirty books on photography and hundreds of articles on photography and photographic technique. He is a graduate of American University and Brooks Institute of Photography, from which he holds a BFA and Honorary Masters of Science and Masters of Fine Art degrees. He is currently a member of the Brooks Board of Governors. Early in his career, he covered Capital Hill during the Watergate Hearings and worked for three seasons as a stringer for the L.A. Dodgers. He is married and lives in West Covina, CA.

Check out Amherst Media's blogs at: http://portrait-photographer.blogspot.com/
http://weddingphotographer-amherstmedia.blogspot.com/

Copyright © 2010 by Bill Hurter.
All rights reserved.

Front cover photograph by Bruce Dorn.
Back cover photograph by Ben Chen.

Published by:
Amherst Media, Inc.
P.O. Box 586
Buffalo, N.Y. 14226
Fax: 716-874-4508
www.AmherstMedia.com

Publisher: Craig Alesse
Senior Editor/Production Manager: Michelle Perkins
Assistant Editor: Barbara A. Lynch-Johnt
Editorial Assistance from: Sally Jarzab, John S. Loder

ISBN-13: 978-1-58428-990-6
Library of Congress Control Number: 2009911196
Printed in Korea.
10 9 8 7 6 5 4 3 2 1

Table of Contents

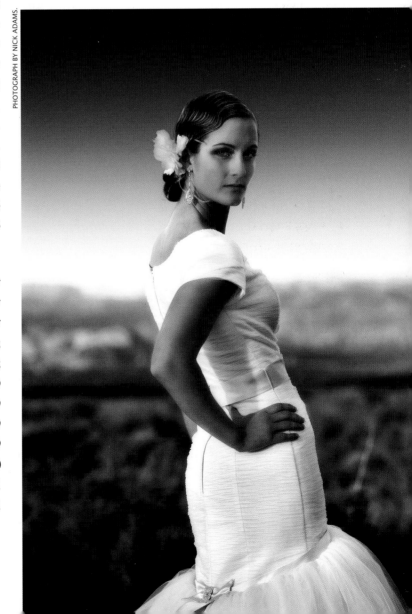

PHOTOGRAPH BY NICK ADAMS.

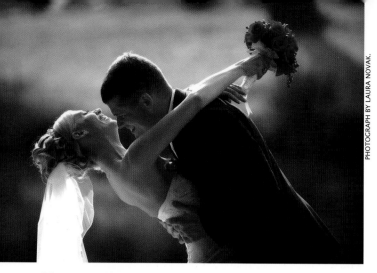

PHOTOGRAPH BY LAURA NOVAK.

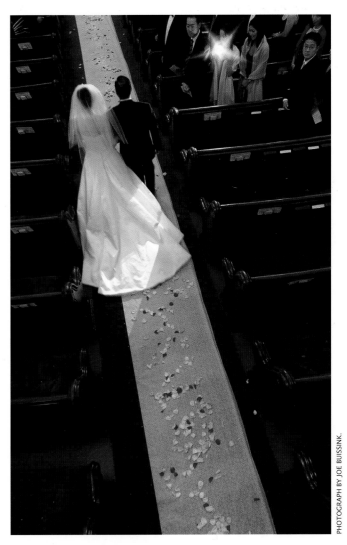

PHOTOGRAPH BY JOE BUISSINK.

PHOTOGRAPH BY ANNIKA METSLA.

What Makes a Wedding Photographer Great?

The rewards of being a successful wedding photographer can be great—not only financially, but also in terms of community status. The wedding photographer of the new millennium is not regarded merely as a craftsman, or as a "weekend warrior," but as an artist and an important member of the community.

In preparing the text for this book, I searched for the right words to define what makes "great" wedding photography and, consequently, "great" wedding photographers. Consistency is surely one ingredient of greatness. Those photographers who produce splendid albums each time out are well on their way to greatness. Great wedding photographers also seem to have highest-quality people skills. Through my association with WPPI and *Rangefinder* magazine, I talk to hundreds of wedding photographers each year. A common thread among the really good ones is affability and likability. They are fully at ease with other people and they have a sense of personal confidence that inspires trust.

WORKING WELL UNDER PRESSURE

Each couple, and their families, make months of detailed preparations—not to mention a considerable financial investment—in their once-in-a-lifetime event. It is the day of dreams and, as such, expectations are high. Couples don't just want a photographic "record" of the day's events, they want inspired, imaginative images and an unforgettable presentation. Additionally, there are no second chances if anything should go wrong photographically.

As a result, wedding photographers must master a wide variety of different types of photography and be able to perform under pressure in a very limited time frame. This pressure is why many gifted photographers do not pursue wedding photography as their main occupation.

CAPTURING STYLE AND ELEGANCE

Today's wedding coverage reflects an editorial style that is pulled directly from the pages of bridal magazines. Noted Australian wedding photographer Martin Schembri calls this form of wedding coverage a "magazine style" of wedding photography, "a clean, straight look." It's reminiscent of advertising/fashion photography—and, in fact, if you study the bridal magazines you'll notice that there is often very little difference between the advertising photographs and the editorial ones.

These magazines are what prospective brides look at constantly. It's how they want to be featured in their own wedding pictures. As a result, most successful wedding

photographers scour the bridal magazines, studying the various examples of editorial and advertising photography—just to ensure they are ready to deliver the latest looks.

BEING A SKILLED OBSERVER

Great wedding photographers are invariably great observers. They see—and capture—the innumerable fleeting moments that often go unnoticed. The experienced professional knows that the wedding day is overflowing with these special moments and that memorializing them is the essence of great wedding photography.

With experience comes an intuitive sense of the rhythm and flow of such events; through keen observation, the photographer begins to develop a knack for predicting what will happen next. Great wedding photographers are always watching and monitoring the events—and usually more than one event at a time.

GOOD TIMING

Being in the right place at the right time—and ready to capture that perfect image—is a function of good preparation, experienced observation, and quick reaction time.

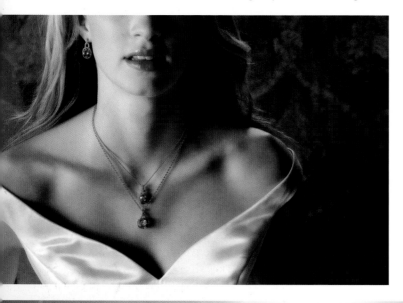

LEFT—Nick Adams created a bold cropping to isolate the beautiful features and necklaces of this bride. Nick used a single 4x3-foot softbox as a frontal main light and two monolights behind a 6x8-foot scrim behind the bride. The two backlights were used at 45-degree angles to the bride and were used to add crisp highlights to her hair and the line of her shoulders. Reflectors were used at either side of the model to help redirect stray light. The image was made with a Nikon D2X and 17–55mm f/2.8 lens at ISO 100. The exposure was $1/160$ second at f/8. BELOW—Even with great afternoon backlighting and a beautiful location, the single most defining element of this engagement portrait is timing. Knowing when the moment and interaction were at their peak made this photo a great one. Photograph by Roberto Valenzuela.

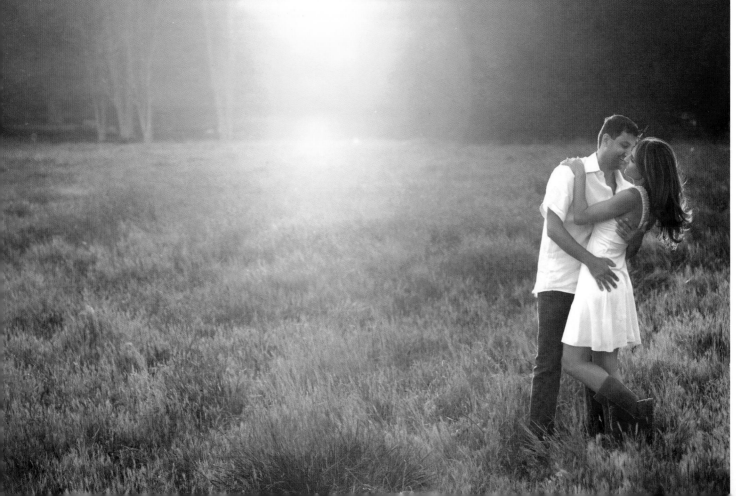

Preparation. Great wedding photographers do their homework. After all, the more you know about the scheduled events and their order, the better you can determine the best ways to document each one. Based on this information the photographer can better choreograph his movements to be in the optimum position for each phase of the wedding day. The confidence that this kind of preparation provides is immeasurable. (For more on the importance of preparation, see chapter 6.)

Reaction Time. The better you know an event, the better your reflexes will become. However, there is also an

Some wedding photographers take style to the next level. Michael Schuhmann, for example, says of his work, "It's different; it's fashion, it's style." This image is quite unlike the original, having been altered considerably in Photoshop.

GRAPHIC DESIGN SENSE

Charles Maring is as much a graphic designer as he is a top wedding photographer, with studios in Connecticut and New York City. He assimilates design elements from the landscape of the wedding—color, shape, line, architecture, light and shadow—and he also studies the dress, shoes, rings, accessories, the color of the bridesmaids' dresses, etc., and then works on creating an overall work of art (*i.e.*, the album) that reflects these design elements on every page.

Cliff Mautner blends fashion and photojournalistic coverage into all his wedding shots. Here, Cliff took advantage of existing light and fast optics and a high ISO to get this priceless shot. Notice the four couples in the background looking intently at the bride and groom. The shot was made with a Nikon D3 and 28mm f/1.4 lens at ISO 3200. The image was made in RAW mode and the color temperature warmed up to 2800K to give the image an old-time look.

intangible aspect to reaction time that all photographers must hone: instinct, the internal messaging system that triggers reaction. You must train yourself to translate input into reaction, analyzing what you see and determining the critical moment to hit the shutter release. Master wedding photojournalist Joe Buissink says, "Trust your intuition so that you can react. Do not think. Just react—or it will be too late."

Keep in mind that there is an ebb and flow to every action. Imagine a pole-vaulter; at one moment he is ascending and in the next moment he is falling—but in between those two moments, there is an instant of peak action. That is what the photographer should strive to isolate. With a refined sense of timing and good observation skills you will greatly increase your chances for successful exposures in wedding situations.

Like a good sports photographer, who may work quietly on the sideline for hours without speaking, wedding photographers must also concentrate to see multiple picture opportunities emerging simultaneously, a task that is rigorous and demanding. The camera is always at the ready—and usually in autofocus mode, so there is no guesswork or exposure settings to be made. Simply raise the camera, compose, and shoot.

THE ABILITY TO IDEALIZE

One trait that separates competent photographers from great ones is the ability to idealize. The exceptional photographer produces images in which the people look great. To do this, the photographer must be skilled at hiding pounds and recognizing a person's "best side." This recognition must be instantaneous and the photographer must have the skills needed to make any needed adjustments in the posing or lighting to achieve a flattering like-

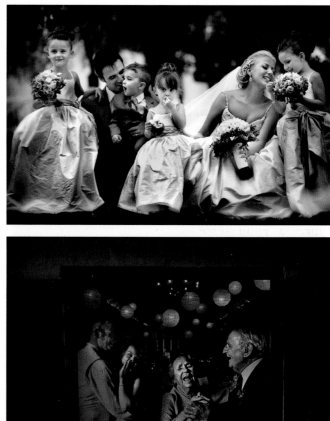

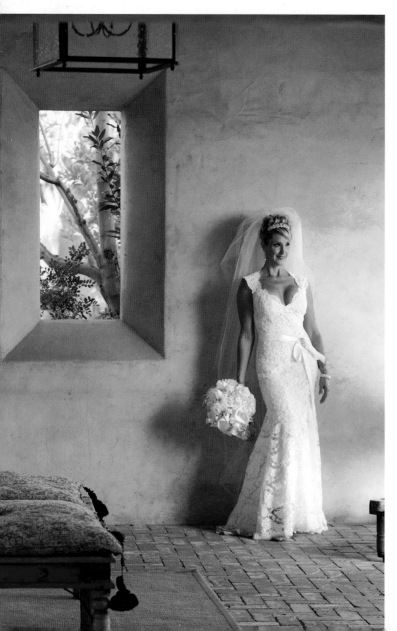

TOP—Timing is truly everything. Ryan Schembri, through expert reflexes, isolated these multiple stories occurring simultaneously in a single scene. **ABOVE**—Here is another Ryan Schembri image that incorporates great timing. Shooting through the open doors was a nice touch that helped reveal this special moment. Image made with Nikon D3, 30mm f/2/8 lens at ¹⁄₅₀ second at f/2.8 at ISO 3200.

ness. Through careful choice of camera angles, poses, and lighting, many "imperfections" can be made unnoticeable.

It is especially important that the bride be made to look as beautiful as possible. Most women spend more time and money on their appearance for their wedding day than for any other day in their lives. The photographs should chronicle just how beautiful the bride really looked.

The truly talented wedding photographer will also idealize the events of the day, looking for opportunities to in-

LEFT—Ken Sklute is a master at idealizing his brides. Here, the bride appears to be leaning against the adobe wall—but she is not; that pose would cause her to look larger to the camera. Ken used the beautiful portico lighting and a wonderful pose, looking away from the camera, to bring out the innate beauty of this lovely bride.

fuse emotion and love into the wedding pictures. In short, wedding photographers need to be magicians.

IMMERSION

In talking to a great many very successful wedding photographers, I've noticed that an experience they all talk about is total immersion. They become completely absorbed in the event. This sense of engagement requires a good sense of balance, though. You must be able to feel and relate to the emotions of the event, but you cannot be drawn into the events to the extent that you either become a participant or lose your sense of objectivity. As Greg Gibson says, "If I find myself constantly engaged in conversations with the bride and family members, then I withdraw a bit; I don't want to be talking and not taking photos."

Celebrated wedding photographer Joe Buissink has described this as staying "in the moment"—a Zen-like state that, at least for him, is physically and emotionally exhausting. Buissink stays in the moment from the time he begins shooting until the conclusion of the event six to eight hours later.

REACTIVE vs. PROACTIVE

Traditional wedding coverage featured dozens of posed pictures pulled from shot lists that were passed down by generations of other traditional wedding photographers. There may have been as many as seventy-five scripted shots—from cutting the cake, to tossing the garter, to the father of the bride walking his daughter down the aisle. In addition to the scripted moments, traditional pho-

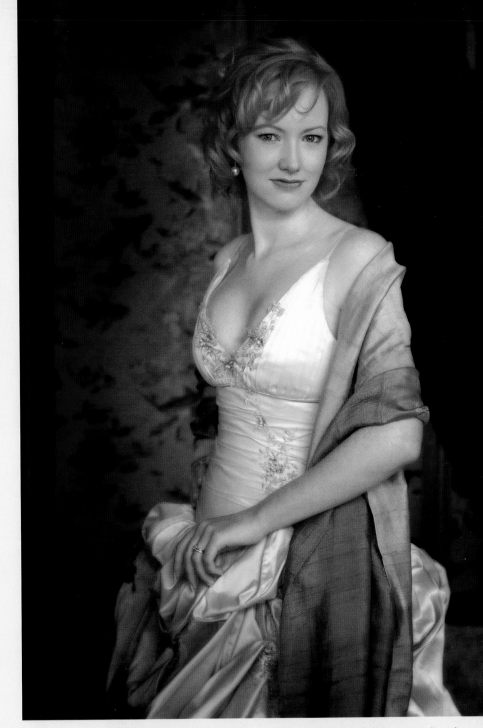

Studying the posing techniques of the master portraitists can help infuse your work with classical elements. This lovely bridal portrait by David Anthony Williams is made with daylight flooding in through double doors in his studio and several well-placed reflectors, including one directly in front of the bride on the floor. Note the elegant posing of the hand and wrist and the delicate separation between the fingers.

IT'S ABOUT SEEING

David Anthony Williams, an inspired Australian wedding and portrait photographer, believes that the key ingredient to great wedding photos is something he once read that was attributed to the great Magnum photographer Elliot Erwitt: "Good photography is not about zone printing or any other Ansel-Adams nonsense. It's about seeing. You either see or you don't see. The rest is academic. Photography is simply a function of noticing things. Nothing more." Williams adds, "Good wedding photography is not about complicated posing, painted backdrops, sumptuous backgrounds, or five lights used brilliantly. It is about expression, interaction, and life! The rest is important, but secondary."

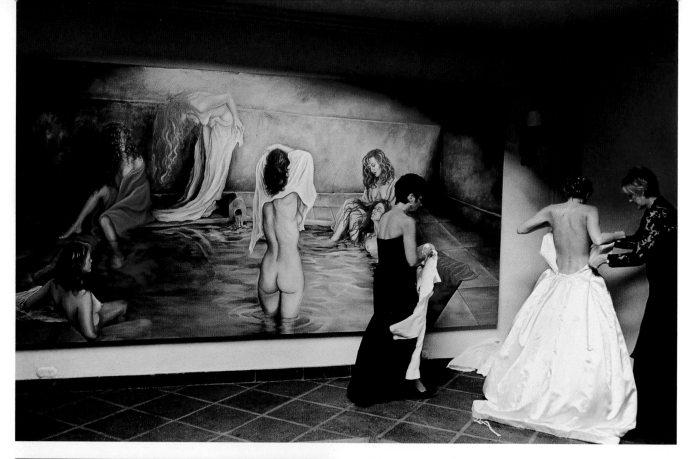

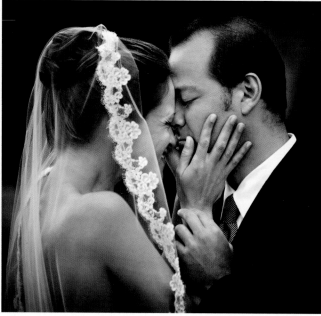

ABOVE—There is no shot-list entry for this image by Joe Buissink, who shoots most of his weddings on film. Joe is a keen observer and knows a great shot in the making when he sees one. **LEFT**— Two-time Pulitzer Prize winner Greg Gibson has great timing, as one might expect. This shot captures the intense, wide-ranging emotions that are a part of every wedding day. The image was made with a Canon EOS 5D and EF 70–200mm f/2.8L IS USM lens. The exposure was $1/800$ second at f/2.8 at ISO 320.

tographers filled in the album with "candids," many of which were staged (or at least made when the subjects were aware of the camera.)

The contemporary wedding photographer's approach can be quite different. To be sure, a certain number of posed images ("formals") are still included in most wedding coverage, so the modern wedding photographer must still know how to pose people and direct appealing

images (*i.e.*, proactive). For most of the event, however, today's wedding photographer tends to be quietly invisible (*i.e.*, reactive), largely fading into the background so that the subjects are not aware of his presence. When working in the style, usually described as photojournalistic, the photographer does not intrude on the scene. Instead, he documents it from a distance with the use of longer-than-normal lenses and, usually, without flash. When people are not aware they are being photographed they are more likely to act naturally and the scene is more likely to be documented genuinely. Moving quietly through the event, the photographer is alert and ready, but always listening and watching, sensitive to what is happening and always ready to react to the unexpected.

It should be noted, however, that the proactive *vs.* reactive approaches vary from photographer to photographer, from client to client, and from year to year. Tom

TOP—Tom Muñoz has learned that his clientele likes a more formal, posed type of image. Although Tom still aims for spontaneity in his images, he will set up the pose when needed. **BOTTOM**—Tom Muñoz is both a careful observer as well as a skilled people person. He can make everyone feel at ease—from youngsters to nervous brides. The photo was made with a Canon EOS 1Ds Mark II and EF 85mm f/1.2L II USM lens at ISO 640.

Muñoz is a master wedding photographer in his twenties who photographed his first full wedding alone at the age of twelve—even though he had to have the couple drive him everywhere as he had "no ride." As a fourth-generation photographer (there are six independently owned Muñoz studios in the South Florida area), Tom has been through the wedding photojournalistic phase and, while a practitioner, believes that clients also want the formality of yesterday in their images. "There's been a shift back toward the more traditional," he says.

GOOD PEOPLE SKILLS

To achieve greatness, a wedding photographer needs to be a "people person," capable of inspiring trust in the bride and groom. Although today's styles favor a more photojournalistic approach, the wedding photographer cannot be a fly on the wall for the entire day. Interaction with the participants at crucial, often stressful moments during the wedding day is inevitable and that is when the photographer with people skills really shines. Photographer David Anthony Williams says, "I just love it when people think I'm a friend of the couple—someone they just haven't met yet who happens to do photography."

Joe Buissink has been called a "salt of the earth" person who makes his clients instantly like and trust him. That trust leads to complete freedom to capture the event as he sees it. It also helps that Buissink sees the wedding ceremonies as significant and treats the day with great respect.

Buissink says of his people skills, "You must hone your communication skills to create a personal rapport with clients, so they will invite you to participate in their special moments." And he stresses the importance of being objective and unencumbered. "Leave your personal baggage at home," he says. "This will allow you to balance the three principle roles of observer, director, and psychologist."

Kevin Kubota, a successful wedding and portrait photographer from the Pacific Northwest, always encourages his couples to be themselves and to wear their emotions on

their sleeves, an instruction that frees the couple to be themselves throughout the entire day. He also tries to get to know them as much as possible before the wedding and also encourages his brides and grooms to share their ideas

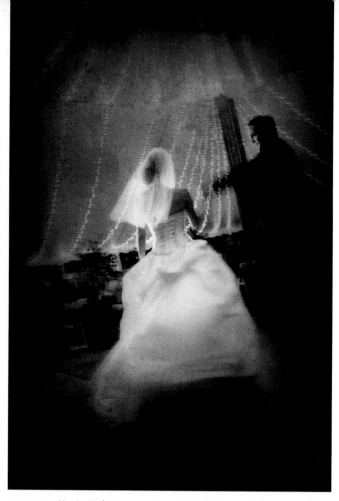

TOP LEFT—Kevin Kubota encourages his bride and groom to share their ideas for special images like this one. Spending time with the couple is the only way to get them to open up to you. **BOTTOM LEFT**—Marcus Bell has an uncanny ability to reveal the fleeting, unique moments of the day. This is the kind of image that brides like to see in their albums. **ABOVE**—Michael Schuhmann says, "I love to photograph people who are in love and are comfortable expressing it." Notice how the bride is centered in the composition, and yet it is an asymmetrically designed image.

as much as possible, opening up the dialogue of mutual trust between client and photographer.

Tom Muñoz also points out that a little flattery goes a long way. "Besides knowing how to pose a woman, one of the biggest things that changes her posture and expression is what you tell her. We're not dealing with models," Muñoz stresses. "As stupid as it sounds, telling a bride how beautiful she looks changes how she photographs and how she perceives being photographed. It becomes a positive experience rather than a time-consuming, annoying one," Tom states, adding, "The same thing goes for the groom. His chest pumps up, he arches his back—they fall right into it. It's very cute."

STORYTELLING SKILLS

Today's great photographers are also gifted storytellers. By linking the spontaneous events of the day, they create a complete narrative of the wedding day, which is what the modern bride wants to see in her wedding coverage. It is important to note that this story should not be a fictionalized fairy tale; it should reflect the real experiences and emotions of the day. Today's wedding coverage may even (sensitively) reveal "flaws"; the savvy wedding photographer knows that these are part of what makes every wedding a unique and personal event.

LOVING WHAT YOU DO

As in most professions, the people who excel are often the ones who truly love what they do. For many the thrill is in the ritual. For others, the thrill is in the celebration or the romance. Michael Schuhmann is one of those photographers who genuinely loves his work. He explains, "I love to photograph people who are in love and are comfortable

RIGHT—The bridesmaids are seated leaning forward, as if anticipating something. The point of sharp focus is the hands clutching the Kleenex, showing the emotion of the story. Photograph by Michael O'Neill. **BOTTOM LEFT**—Tom Muñoz says, "As stupid as it sounds, telling a bride how beautiful she looks changes how she photographs and how she perceives being photographed." **BOTTOM RIGHT**—Posed or natural? Who can be sure? Marcus Bell's groups have a sense of spontaneity that "posed" groups don't have. It's a characteristic that adds to the photojournalistic feel of his weddings.

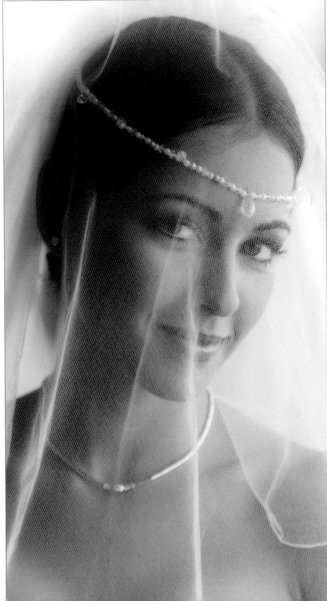

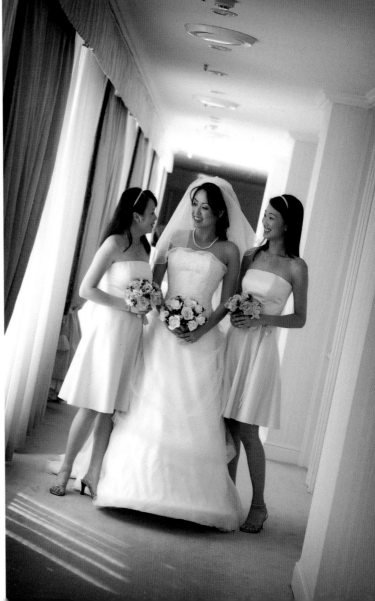

expressing it—or who are so in love that they can't contain it. Then it's real."

Some photographers relish the creative challenge of weddings. Greg Gibson, a Pulitzer Prize–winning photojournalist turned wedding photographer says, "All weddings are alike: there's a man and a woman in love, they're going to have this big party, there's the anticipation, the preparation, the ceremony, and the party. It's like the movie *Groundhog Day*. The challenge is to find the nuances." That is what keeps Gibson fresh—despite photographing fifty weddings a year. (Gibson also notes that wedding photography is more fun than his previous career. "When I go to a wedding people are always glad to see me—I'm welcomed in," he says. "As a journalist that isn't always the case. Monica [Lewinsky] wasn't happy to see me when I showed up at the Mayflower Hotel.")

SHOOT MORE, NOT LESS

According to wedding specialist Michael O'Neill, "When I first started photographing weddings (in the last millennium) the owner of the studio I worked for would have your head if you shot more than 120 exposures on even the most extravagant wedding. Today, I routinely shoot ten times that amount. Experiment. Go ahead. Don't be scared. You'll be amazed at what you can create by just trying different camera angles, different focal lengths, tighter compositions, rear-curtain flash-sync effects, etc.

"Shoot more 'stuff.' We can take a lesson from the good wedding photojournalists and videographers. Today's brides and grooms expect to see all of their wedding day. Shoot details. Shoot close-ups—flowers, rings, dress details, jewelry, shoes, architecture, landscapes, table settings, menus, champagne glasses, cake decorations, etc. These are almost as important to today's client as the portraits. Shoot candids all day long. Candids are not just reserved for the reception anymore. Take shots of the bridesmaids helping the bride get dressed and the flower girls' antics during the ceremony. Don't limit yourself to action shots; get reaction shots. When the couple exchanges vows, whirl around and capture the look on their parents' faces. Great storytelling includes both actions and reactions.

"I find myself thinking more and more like a graphic designer as well as a photographer these days, envisioning how a page layout may ultimately look and being sure to shoot the necessary background images."

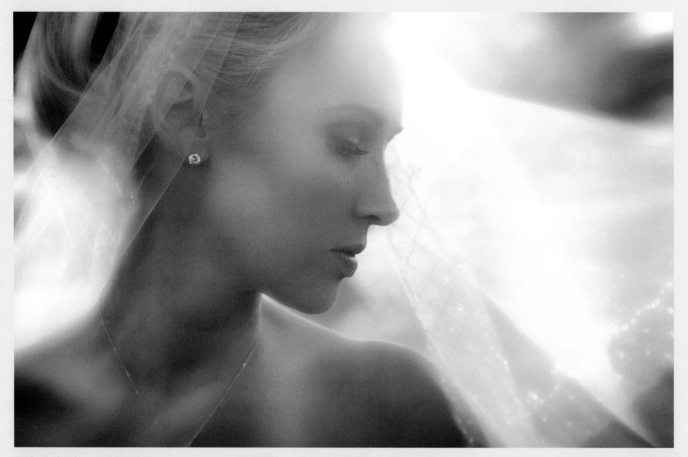

Today's brides and grooms expect to see all of their wedding day. Shoot all day long. That's the advice of wedding pro, Michael O'Neill. Here Michael used the setting sun as a backlight. The light's intensity helped create areas of overexposure mixed with areas of flare. Because of the wide lens aperture, the depth of field is shallow and the resulting image painterly. This is what O'Neill means by not being afraid to experiment.

Technical Considerations

Before the creative aspects of wedding photography can be considered, it is critical to ensure a mastery of the technical aspects of the craft. No matter how perfectly conceived an image may be, it will fall short of the mark if technical errors results in a poor exposure, poor focus, or other flaws.

EXPOSURE AND METERING

Exposure Latitude. Working with digital files is much different than working with film. For one thing, the exposure latitude, particularly in regard to overexposure, is virtually nonexistent (especially when shooting JPEGs; see page 34). Some photographers liken shooting digital to shooting transparency film: it is absolutely unforgiving in terms of exposure.

Proper exposure is essential because it determines the range of tones and the overall quality of the image. Underexposed digital files tend to have an excessive amount of noise; overexposed files lack image detail in the highlights. You must either be right on with your exposures or, if you

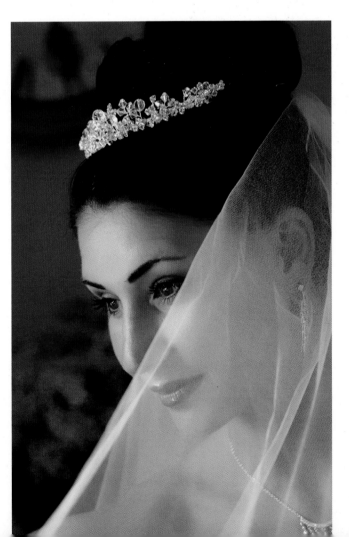

Michael O'Neill shot this available-light photograph of the bride before the ceremony. Natural window light was the main source, and a gold LiteDisc reflector was added for fill. Notice that there is highlight detail in her white veil and the gems in her hair, as well as good shadow detail in her dark hair. But the skin tones are perfectly exposed and white balanced. The need for careful exposure control over scenes with extremes in brightness is just one of the technical challenges wedding photographers face.

WHY DO YOU NEED A FLASHMETER?

According to Michael O'Neill, "My digital camera (a Nikon D3) is set in the manual-exposure mode about 90 percent of the time. It does not know that it is a digital camera with awesome 3D Color Matrix metering capabilities. It does, however, know how to record a properly lit and exposed scene the same way my film cameras did. My trusty Minolta flashmeter still occupies a readily accessible spot in my camera bag and gets pulled out for ambient-light or manual electronic-flash readings many times throughout the wedding day. I usually start my day metering the light falling through an appropriate window at the bride's home for intimate available-light portraits of the bride, her parents, and her bridesmaids."

make an error, let it be only slight underexposure, which is survivable. Overexposure of any kind is a deal breaker.

With digital capture, you must also guarantee that the dynamic range of the processed image fits that of the materials you will use to exhibit the image (*i.e.*, the printing paper and ink or photographic paper).

Weddings Present the Ultimate in Extremes. When it comes to exposure, the wedding day presents the ultimate in extremes: a black tuxedo and a white wedding dress. The photographer must hold the image detail in them, but neither is as important as proper exposure of the skin tones. Although this will be discussed the section on lighting (chapter 4), most pros opt for an average lighting ratio of about 3:1 so that there is detail in both the facial shadows and the highlights. Using flash or reflectors, they add fill light to attain that medium lighting ratio, which frees them to concentrate on exposures that are adequate for the skin tones.

The Nikon camera's 3D Color Matrix metering, according to Michael O'Neill, "was dead on for this difficult scene of a white car and bridal gown against a dark sky and background. Photoshop was used to enhance the saturation and contrast in the sky as well as to remove my own shadow from the foreground and the front of the car!"

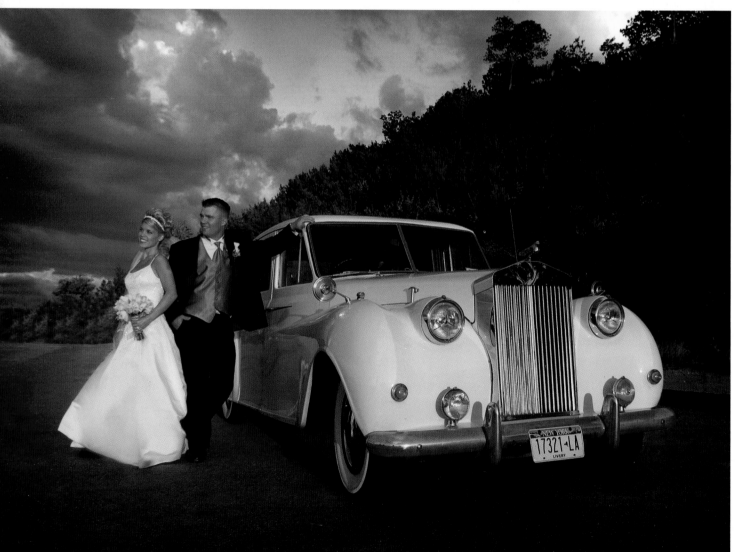

A Note About Shooting RAW. RAW files retain the most image data from the original capture. Unlike JPEGs, which are compressed, the RAW data stays with the original image and gives you much more latitude in adjusting exposure—in both highlights and shadows. As a result, images that might be unusable if shot in the JPEG format can often be salvaged if shot in the RAW format.

Incident Light Meters. The preferred type of meter for portrait subjects is the handheld incident-light meter. This does not measure the reflectance of the subjects but the amount of light falling on the scene. Simply stand where you want your subjects to be, point the hemisphere (dome) of the meter directly at the camera lens and take a reading. This type of meter yields extremely consistent results because it is less likely to be influenced by highly reflective or light-absorbing surfaces. (*Note:* When you are using an incident meter but can't physically get to your subject's position to take a reading, you can meter the light at your location if it is the same as the lighting at the subject position.)

It is advisable to run periodic checks on your meter—especially if you base the majority of your exposures on its data. You should do the same with any in-camera meters you use frequently. If your incident meter is also a flashmeter, you should check it against a second meter to verify its accuracy. Like all mechanical instruments, meters can get out of whack and need periodic adjustment.

Evaluating Exposure. There are two ways of evaluating the exposure of the captured image on the spot: by judging the histogram and by evaluating the image on the camera's LCD screen. The more reliable of the two is the histogram, but the LCD monitor provides a quick visual reference for making sure things are okay.

The histogram is a graph that indicates the number of pixels that exist for each brightness level. The range of the histogram represents 0–255 from left to right, with 0 indicating absolute black (black with no detail) and 255 indicating absolute white (white with no detail). Histograms are scene-dependent. In other words, the number of data points in the shadows and highlights will directly relate to the individual subject and how it is illuminated and captured.

In an image with a good range of tones, the histogram will fill the length of the graph (*i.e.*, it will have detailed shadows and highlights and everything in between). When

Claude Jodoin prefers to work in the widest possible color gamut, so he prefers Adobe 1998 RGB. He even does all his editing in that color space.

an exposure has detailed highlights, these will fall in the 235–245 range; when an image has detailed blacks, these will fall in the 15–30 range (RGB mode). The histogram may show detail throughout (from 0–255), but it will trail off on either end of the graph.

The histogram also gives an overall view of the tonal range of the image and the "key" of the image. A low-key image has its detail concentrated in the shadows (a high number of data points); a high-key image has detail concentrated in the highlights. An average-key image has detail concentrated in the midtones. An image with a full tonal range has a high number of pixels in all areas of the histogram.

COLOR SPACE

Many DSLRs allow you to shoot in the Adobe RGB 1998 or sRGB color space. There is considerable confusion over

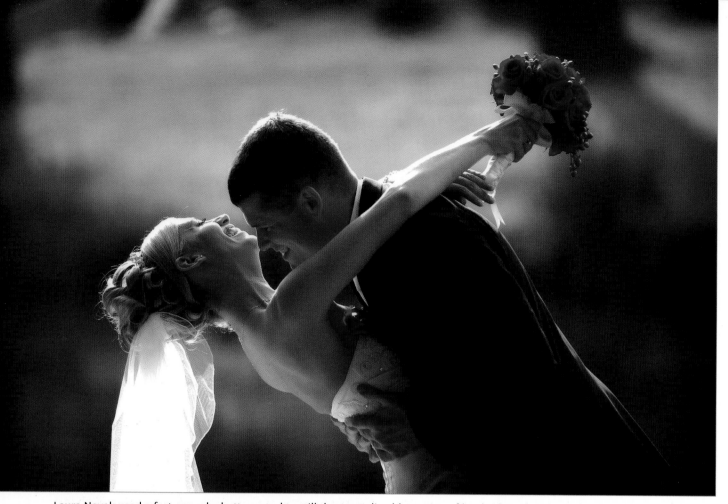

Laura Novak used a fast enough shutter speed to still the unpredictable motion of her bride and groom ($^1/_{250}$ second) and a wide-open lens aperture of f/2.8 to de-emphasize the background, accenting the couple.

which is the "right" choice. Because Adobe RGB 1998 is a wider gamut color space than sRGB, many photographers reason, "Why shouldn't I include the maximum range of color in the image at capture?" Others feel that sRGB is the color space of inexpensive point-and-shoot digital cameras and not suitable for professional applications. Professional digital-imaging labs, however, use this standardized color space—sRGB—for their digital printers. Therefore, even though the Adobe 1998 RGB color space offers a wider gamut, professional photographers working in Adobe 1998 RGB will be somewhat disheartened when their files are reconfigured and output in the narrower sRGB color space.

Many photographers who work in JPEG format use the Adobe 1998 RGB color space right up to the point that files are sent to a printer or out to the lab for printing. The reasoning is that, since the color gamut is wider with Adobe 1998 RGB, more control is afforded. Claude Jodoin is one such photographer, preferring to get the maximum amount of color information in the original file,

then editing the file using the same color space for maximum control of the image subtleties.

Is there ever a need for other color spaces? Yes. It depends on your particular workflow. For example, all the images you see in this book have been converted from their native sRGB or Adobe 1998 RGB color space to the CMYK color space for photomechanical printing. As a general preference, I prefer images from photographers be in the Adobe 1998 RGB color space as they seem to convert more naturally to CMYK.

METADATA
DSLRs give you the option of tagging your digital image files with data, which typically includes a date, time, caption, and the camera settings. Many photographers don't even know where to find this information, but it's simple: in Photoshop: go to File>File Info and you will see a range of data, including caption and identification information. If you then go to EXIF data in the pull-down menu, you will see all of the data that the camera automatically tags

with the file. Depending on the camera model, various other information can be written to the EXIF file, which can be useful for either the client or lab. You can also add your copyright symbol (©) and notice either from within Photoshop or from your camera's metadata setup files. Adobe Photoshop supports the information standard developed by the Newspaper Association of America (NAA) and the International Press Telecommunications Council (IPTC) to identify transmitted text and images. This standard includes entries for captions, keywords, categories, credits, and origins from Photoshop.

THE RIGHT SHUTTER SPEED

With Flash. If you are using electronic flash, you are locked into the flash-sync speed your camera calls for—unless you are "dragging" the shutter (working at a slower-than-flash-sync shutter speed to bring up the level of the ambient light, balancing the flash exposure with the ambient-light exposure). It should be noted that 35mm SLRs have a different shutter type than medium- and large-format cameras. 35mm SLRs use a focal-plane shutter, which produces a flash-sync speed of anywhere from $\frac{1}{60}$ to $\frac{1}{500}$ second (this is always marked in a different color on the shutter-speed dial). If you shoot at a shutter speed faster than the flash-sync speed using an SLR, the flash will only partially expose the film frame. Many medium-format cameras use lens-shutters, which allow you to synchronize with electronic flash at any shutter speed.

With Ambient Light. When shooting with continuous light sources, you must choose a shutter speed that stills both camera and subject movement. If using a tripod, a shutter speed of $\frac{1}{15}$ to $\frac{1}{60}$ second should be adequate to stop average subject movement. Outdoors, you should normally choose a shutter speed faster than $\frac{1}{60}$ second, because even a slight breeze will cause the subjects' hair to flutter, producing motion during the moment of exposure.

When handholding the camera, use a shutter speed that is the reciprocal of the focal length of the lens. For example, if using a 100mm lens, use $\frac{1}{100}$ second (or the next highest equivalent shutter speed, like $\frac{1}{125}$ second) under average conditions. If you are very close to the subjects, as you might be when making a portrait of a couple, you will need to use an even faster shutter speed because of the increased image magnification. When working farther away from the subject, you can revert to the shutter speed that is the reciprocal of your lens's focal length.

When shooting groups in motion, you should choose a faster shutter speed and a wider lens aperture. It's more

In creating this playful image, Michael O'Neill relied upon his Nikon's 3D matrix metering, coupled with the Nikon SB-800's high-speed flash-sync capabilities, to properly expose this scene while he concentrated on directing the high-flying, rowdy group.

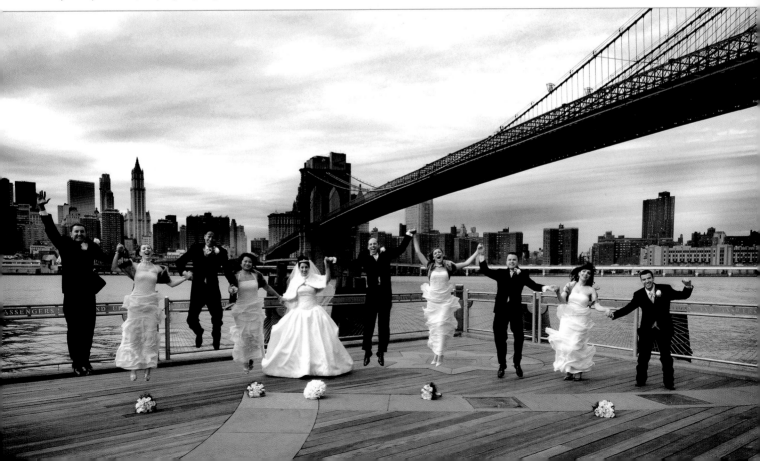

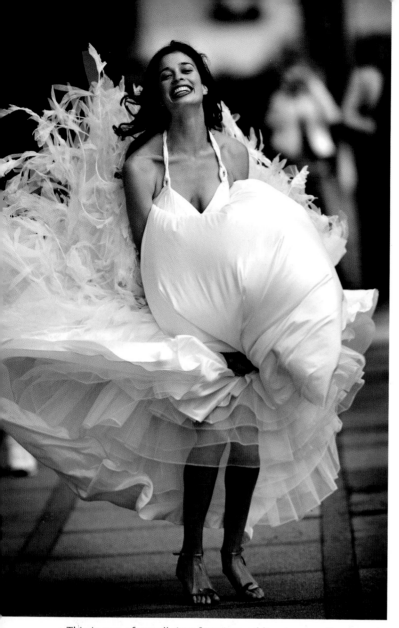

This is one of my all-time favorite wedding images. To create it, Mike Colón used an AF-S VR Nikkor 200mm f/2G IF-ED lens wide open. The lens is astronomically expensive—but, when it comes to lenses, you pay for speed. Quite naturally, Mike shoots wide open much of the time to exploit this lens's very shallow depth of field and impeccable sharpness. The lens's VR (vibration reduction) technology offers the equivalent of using a shutter speed three stops faster.

important to freeze subject movement than it is to have great depth of field for this kind of shot. If you have any question as to which speed to use, always use the next fastest speed to ensure sharpness.

Some photographers are able to handhold their cameras for impossibly long exposures, like ¼ or ½ second. They practice good breathing and shooting techniques to accomplish this. With the handheld camera laid flat in the palm of your hand and your elbows in against your body,

take a deep breath and hold it. Do not exhale until you've "squeezed off" the exposure. Use your spread feet like a tripod—and if you are near a doorway, lean against it for support. Wait until the action is at its peak (all subjects except still lifes are in some state of motion) to make your exposure. I have seen the work of photographers who shoot in extremely low-light conditions come back with available-light wonders by practicing these techniques.

Image Stabilization. A great technical improvement was the development of image stabilization (IS) lenses (also called vibration reduction [VR] lenses). These correct for camera movement, allowing you to shoot handheld with long lenses and slower shutter speeds. This means you can use the available light longer in the day and still shoot at low ISO settings for fine grain. It is important to note, however, that subject movement will not be quelled with these lenses, only camera movement. Canon and Nikon, two companies that currently offer this feature in some of their lenses, offer a wide variety of zooms and long focal length lenses with image stabilization.

WHITE BALANCE

White balance is the digital camera's ability to render colors accurately when shooting under a variety of different lighting conditions, including daylight, strobe, tungsten, and fluorescent lighting.

White balance is particularly important if you are shooting highest-quality JPEG files; it is less important when shooting in RAW file mode, since these files contain more data than the compressed JPEG files and are easily remedied later. While this would seem to argue for shooting exclusively RAW files, it's important to note that these files take up more room on media storage cards and they take longer to write to the cards. As a result, many wedding photographers find it more practical to shoot JPEGs and perfect the color balance when creating the exposure, much like shooting conventional transparency film with its unforgiving latitude.

A system that many pros follow is to take a custom white balance of a scene where they are unsure of the lighting mix. By selecting a white area in the scene and neutralizing it with a custom white-balance setting, you can be assured of an accurate color rendition. Others swear by a device called the ExpoDisc (www.expodisc.com), which attaches to the lens like a filter. You take a white-balance

reading with the disc in place and the lens pointed at your scene. It is highly accurate in most situations and can also be used for exposure readings.

A CLEAN IMAGE SENSOR

The image sensor in a digital camera must be kept clean of dust and other foreign matter in order for it to perform to its optimum level. Depending on the environment where you do most of your shooting, spots may appear on your images. Cleaning the sensor prior to every shoot will help you to minimize or eliminate such spots in your photos.

While each camera manufacturer has different recommendations for cleaning the sensor, Canon digital cameras

SYNC THEM UP

Wedding photographer Chris Becker offers this tip: When shooting with multiple camera bodies, be sure to sync the internal clocks of the cameras. This will make it much easier to sequentially organize your images after the event.

have a sensor-cleaning mode to which the camera can be set. With the camera's reflex mirror up (a function of the cleaning-mode setting), the company recommends light air from an air syringe to gently remove any foreign matter. Turning the camera off resets the mirror.

The newest DSLRs feature a sonic vibration sensor-cleaning mode that is fully automatic and does not involve

LEFT—In creating this beautiful bridal portrait, Ray Prevost had to be certain to correctly white balance the original exposure. It was critical to accurately capture the slightly darker than Caucasian skin tone, as well as the amazing colors of the bride's green eyes, flecked with rust. The lavender veil was a problem too in that it was kicking cool hues into the skin tones. The lighting was a large picture window to the right of the bride. **RIGHT**—Some photographers prefer using prime lenses all the time. One of Mike Colón's favorite lenses is the AF-S VR Nikkor 200mm f/2G IF-ED, which he uses for stealing moments all throughout the wedding day. This one was made in the church at $^{1}/_{250}$ second at f/2 at ISO 500.

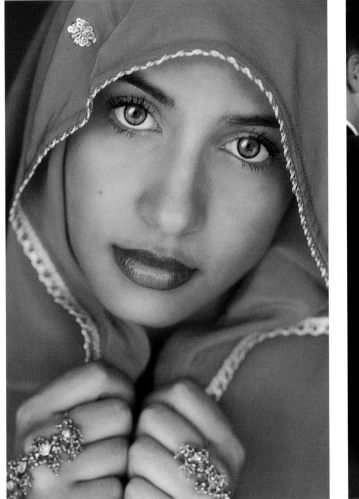

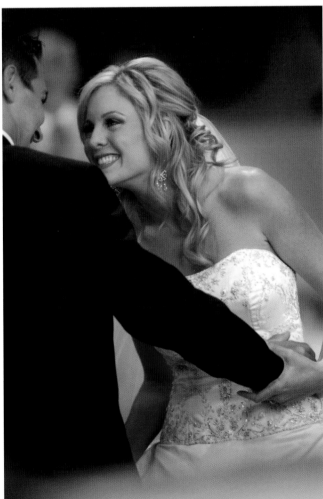

you having to touch the sensor with a cleaning device. One should realize the image sensor is an extremely delicate device. Do not use propelled air cans, which have airborne propellants that can coat the sensor in a fine mist, worsening the situation.

TOP LENS CHOICES

Fast Lenses. Fast lenses (f/2.8, f/2, f/1.8, f/1.4, f/1.2, etc.) will get lots of work on the wedding day, as they afford many more "available light" opportunities than slower speed lenses. Marcus Bell, an award-winning wedding photographer from Australia, calls his Canon 35mm f/1.4L USM lens his favorite. Shooting at dusk, with a high ISO setting, he can shoot wide open and mix lighting sources for unparalleled results.

Prime Lenses. Although modern zoom lenses, particularly those designed for digital SLRs, are extremely sharp, many photographers feel that a multipurpose lens cannot possibly be as sharp as a prime lens, which is optimized for use at a single focal length.

MARCUS BELL'S THREE CAMERA BAGS

Marcus Bell is experienced and prepared. "Luck favors the prepared" is his motto. At every wedding, he uses three small-sized bags of varying age, including what he calls a "bum bag," which he wears about his waist most of the day.

MAIN BAG
Spare batteries
Breath freshener ("A courtesy," he says.)
Air brush
Lens cleaning cloth
Two Canon EOS 5Ds
28–70mm f/2.8 lens
85mm f/1.2 lens
70–200mm f/2.8 lens (for ceremony)
Epson P4000 downloader (carried in pocket)
Point-and-shoot 8MP camera for backup
Digital flashmeter
Flashlight (for looking through the three bags)
Stain Stick and spare cloth (in case the bride sits or
 leans on something that causes a mark on the dress)

BUM BAG
Secondary lenses (35mm f/1.4, 17–35mm f/2.8)
Crochet hook (if needed to help fasten the bride's dress)
Arctic Butterfly (a battery-powered sensor-cleaning brush)
Small handheld video light (battery powered)
Extension tube for close-ups
More spare batteries
30GB worth of cards (4GB capacity each)

BACKUP BAG
EOS 1D Mark II
85mm f/1.8 lens
50mm f/1.4 lenses
Tele-extender (rarely used but always available)
More spare batteries
Charger for batteries
Timetable sheet for events
Instructions how to get there
Any additional notes on the event

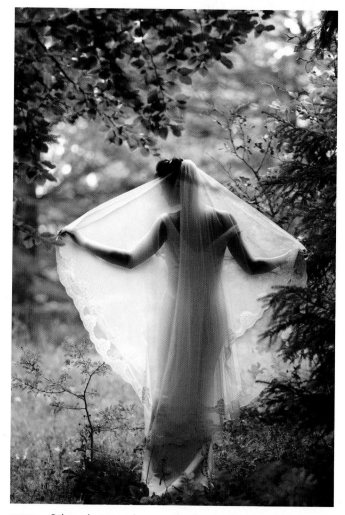

ABOVE—Other photographers prefer fast zooms for all their wedding work, preferring the flexibility and speed that zooms provide. David Beckstead is one such wedding photographer. This delicate bridal was made with a Canon EOS 1D Mark II and EF 70–200mm f/2.8L USM at 155mm. **FACING PAGE**—Because of his preparations, Marcus Bell is prepared for any contingency—from a dimly lit pub (where a wonderful portrait of the bride and groom emerges) to a softly lit kiss shot through the bride's veil, which was only a fleeting moment during the day. Preparation is one of the main keys to success as a top wedding photographer.

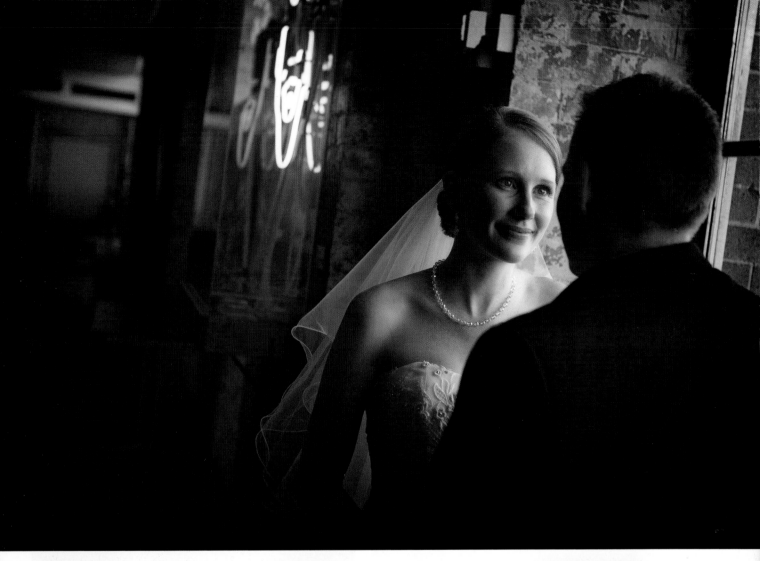
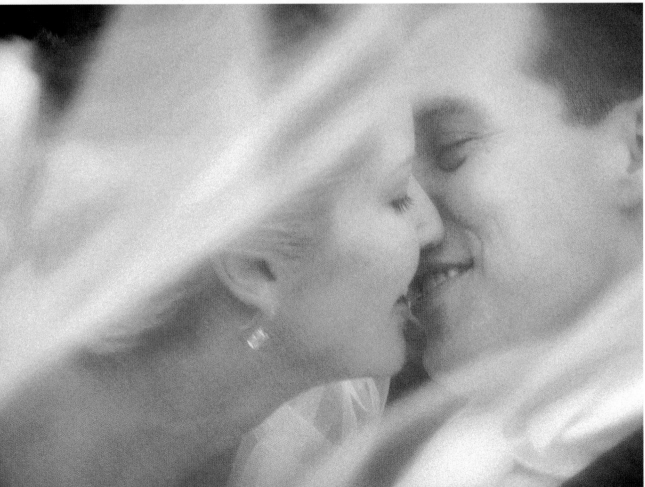

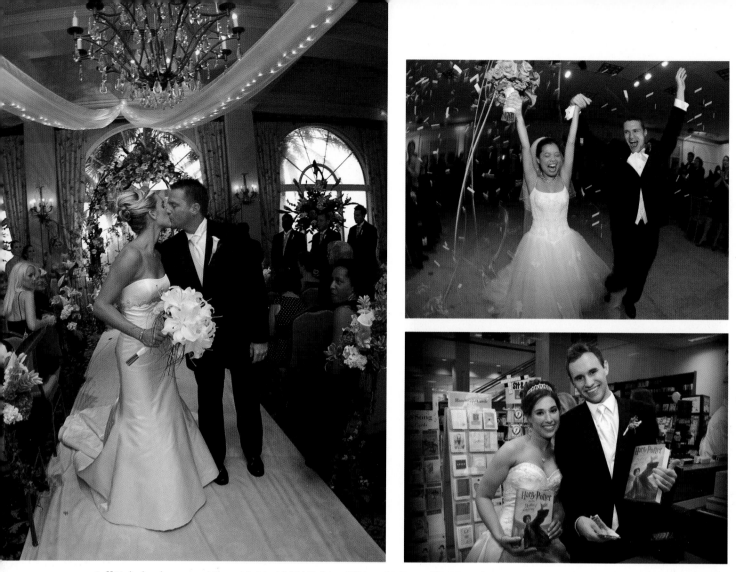

LEFT—Jeff Kolodny loves working with his AF DX Fisheye-Nikkor 10.5mm f/2.8G ED lens. He knows how to use it to instill distortion, if he wants it, or eliminate it, as in this image of the bride and groom just married. Rule of thumb with fisheyes and severe wide angles: Keep people centered and away from the corners and they will photograph pretty much distortion free! **TOP RIGHT**—No other lens immerses you in a scene more than a fisheye. Here Jeff Kolodny, using his 10.5mm fisheye lens, is very close to his subjects as they move across the dance floor. His wide-angle flash was set to overpower the room light slightly so that all the couple and the confetti would be frozen by the strobe. The exposure was 1/40 second at f/4.5. **BOTTOM RIGHT**—Wide-angle zooms are great for incorporating the background into the image. Here, the couple tied the knot on the same day a new Harry Potter book came out and Jeff Kolodny wanted to bring the bookstore into the story so he used an EOS EF 16–35mm f/2.8L II USM lens.

Mike Colón, a talented photographer from the San Diego area, uses prime lenses (not zooms) in his wedding coverage and shoots at wide-open apertures most of the time to minimize background distractions. He says, "The telephoto lens is my first choice, because it allows me to be far enough away to avoid drawing attention to myself but close enough to clearly capture the moment. Wide-angle lenses, however, are great for shooting from the hip. I can grab unexpected moments all around me without even looking through the lens."

Wide-Angle Lenses. Other popular lenses include the range of wide angles, both fixed focal length lenses and wide-angle zooms. Focal lengths from 17mm to 35mm are ideal for capturing the atmosphere as well as for photographing larger groups. These lenses are fast enough for use by available light with fast ISOs.

Zoom Lenses. For today's digital photographer, a popular lens for all types of photography is the 80–200mm f/2.8 from Nikon (or the Canon equivalent 70–200mm f/2.8). These are very fast, lightweight lenses that offer a wide variety of useful focal lengths for many applications. This makes them particularly popular among wedding photographers, who find them useful for all phases of the ceremony and reception. They are also internal focusing,

meaning that autofocus is lightning fast and the lens does not change its physical length as it is focused. At the shortest range, 80mm (or 70mm), these lenses are perfect for full- and three-quarter-length portraits. At the long end, the 200mm setting is ideal for tightly cropped candid coverage or head-and-shoulders portraits. These zoom lenses also feature fixed maximum apertures, which do not change as the lens is zoomed. This is a prerequisite for any lens to be used in fast-changing conditions. Lenses with variable maximum apertures provide a cost savings but are not as functional nor as bright as a faster, fixed-aperture lenses.

Telephoto Lenses. Another favorite lens type is the high-speed telephoto; Nikon's 400mm f/2.8 and 300mm

f/4.0 lenses, as well as Canon's 300mm and 400mm f/2.8L lenses, are in this category. These lenses are ideal for working unobserved and can isolate some wonderful moments, particularly of the ceremony. Even more than the 80–200mm lens, the 300mm or 400mm lenses throw backgrounds beautifully out of focus and, when used wide open, provide a sumptuously thin band of focus, which is ideal for isolating image details.

RIGHT—One of the reasons the 80-200mm and 70-200mm lenses are so popular is the wide range of framing and cropping possibilities available with such a lens. Here, Jeff Kolodny reaches out across the crowd to isolate the wedding ceremony itself. Jeff used a popular wedding lens, Canon's EF 70–200mm f/2.8L IS USM with a Canon EOS 5D. **BELOW**—One of Nick Adams' favorite lenses is the AF Nikkor 85mm f/1.4D IF because of its razor sharpness and thin band of focus, which blurs backgrounds into a blended canvas of tones. This image was made with a Nikon D2X and the 85mm f/1.4. The image was exposed for $1/160$ second at f/8. Nick used f/8 to create a wider band of depth of field that would hold the distance from the veil to the bride's hair.

Another popular choice is the 85mm (f/1.2 for Canon; f/1.4 or f/1.8 for Nikon), which is a short telephoto with exceptional sharpness. This lens gets used frequently at receptions because of its speed and ability to throw backgrounds out of focus, depending on the subject-to-camera distance.

Normal Lenses. One should not forget about the 50mm f/1.2 or f/1.4 "normal" lens for digital photography. With a 1.4x focal length factor, for example, that lens becomes a 70mm f/1.2 or f/1.4 lens that is ideal for portraits or groups, especially in low light. The close-focusing distance of this lens makes it an extremely versatile wedding lens.

TOP LEFT—Long telephotos and telephoto zooms let you cherry-pick the priceless shots that happen on wedding day without being observed—and, consequently, without spoiling the shot. Photograph by Dan Doke. **BOTTOM LEFT**—Because telephotos put you a good working distance from the subject, the perspective is ideal and never forced, particularly for close-up portraits. J.B. Sallee made this image with a Nikon D2X and AF DC-Nikkor 135mm f/2D at $\frac{1}{100}$ second at f/2.8. **BELOW**—Michael Costa used a 50mm f/1.4 lens with his Canon EOS 5D to create this nighttime shot. He metered for the couple and not the bonfire in the background. He shot the image at ISO 1600 at $\frac{1}{320}$ second at f/1.4. You can find f/1.4 or even f/1.2 50mm lenses on the used lens market for a pittance.

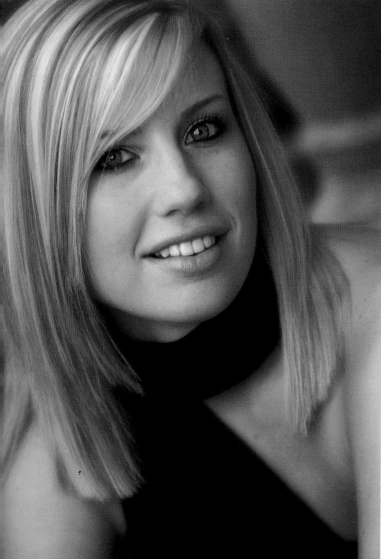

David Anthony Williams uses a 50mm f/1.2 lens and a small video light to photograph what he calls "detail minis." These are combined later in window-pane-type layouts for the couple's album. The minis are usually organized around a theme of some type.

FOCAL LENGTH AND PERSPECTIVE

Telephoto Lenses. Short- to medium-length telephotos provide normal perspective without subject distortion. If you used a normal focal-length lens (50mm in 35mm format, 75–90mm in the medium formats) (see pages 31–32 for more on this), you would need to move in too close to the subject to attain an adequate image size. Because it alters the perspective, close proximity to the subject exaggerates subject features—noses appear elongated, chins jut out and the backs of heads may appear smaller than normal. This phenomenon is known as foreshortening. The short telephoto provides a greater working distance between camera and subject, while increasing the image size to ensure normal perspective.

When photographing groups, some photographers prefer long lenses; for example, a 180mm lens on a 35mm camera. The longer lens keeps people in the back of the group the same relative size as those in the front of the group. When space doesn't permit the use of a longer lens, however, short lenses must be used—but you should be aware that the subjects in the front row of a large group will appear larger than those in the back of the group, es-

FOCAL LENGTH FACTORS

Since all but full-frame DSLRs have chip sizes smaller than 24x36mm (the size of a 35mm film frame), there is a magnification factor that changes the effective focal length of the lens. For instance, Nikon DSLRs have a 1.5X focal-length factor that makes a 50mm f/1.4 lens a 75mm f/1.4 lens—an ideal portrait lens.

Because digital lenses do not have to produce as wide a circle of coverage as lenses designed for full-frame (24x36mm) chips, lens manufacturers have been able to come up with some splendid long-range zooms that cover wide-angle to telephoto focal lengths. Lenses like Canon's EF 28–300mm f/3.5–5.6L IS USM and EF 28–200mm f/3.5–5.6 USM are fast, lightweight, and extremely versatile.

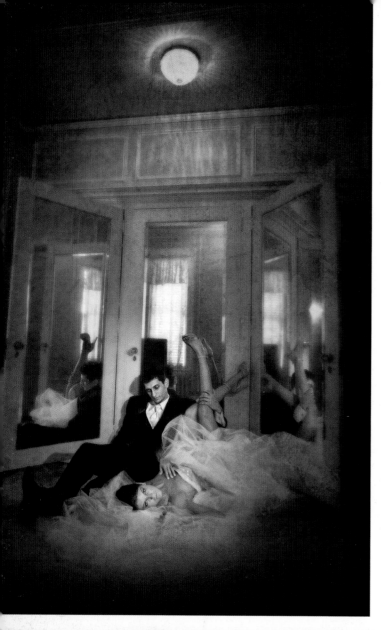
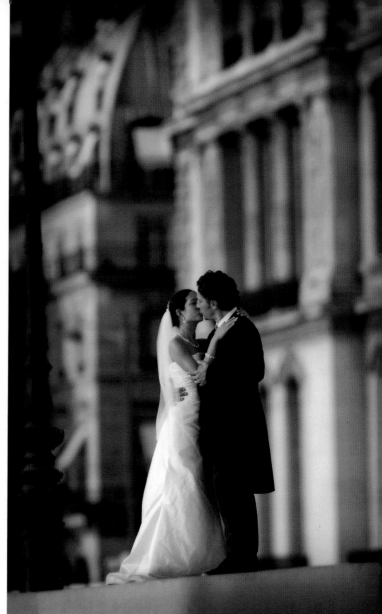

pecially if you get too close. Extreme wide-angle lenses will also distort the subjects' appearance, particularly those closest to the frame edges. Raising the camera height, thus placing all subjects at the same relative distance from the lens, can minimize some of this effect. Also, the closer to the center of the frame the people are, the less distorted they will appear.

Conversely, you can use a much longer lens if you have the working room. A 200mm lens, for instance, is a beautiful portrait lens for the 35mm format because it provides very shallow depth of field and throws the background completely out of focus (when used at the maximum aperture), providing a backdrop that won't distract viewers from the subjects. When used at wider apertures, this focal length provides a very shallow band of focus that can be used to accentuate just the eyes, for instance, or just the frontal planes of the faces in a close-up portrait.

Very long lenses (300mm and longer for 35mm) can sometimes distort perspective. With them, the subject's features appear compressed. Depending on the working distance, the nose may appear pasted onto the subject's face, and the ears may appear parallel to the eyes. While lenses this long normally prohibit communication in a posed portrait, they are ideal for working unobserved as a wedding photojournalist often does. You can make head-and-shoulders images from a long distance away.

Normal Lenses. When making three-quarter- or full-length group portraits, it is best to use the normal focal-

FACING PAGE, TOP LEFT—The opposite of the telephoto effect is the wide-angle effect, where background elements seem intimately close to the subjects. DeEtte Sallee made this image with a Canon EOS 5D and EF 16–35mm f/2.8L II USM at 23mm. Because she didn't want the background tack-sharp, she shot the scene wide open at f/2.8. FACING PAGE, TOP RIGHT—Mike Colon used his Nikon D2X and AF-S VR Nikkor 200mm f/2G IF-ED at an exposure of 1/4000 second at f/2.0 to blur the background of the Venice architecture. The telephoto lens compresses the background, stacking the architecture closer together than would it would normally appear. FACING PAGE, BOTTOM—Telephoto lenses "stack" perspective, compressing the apparent distance of background elements to the subject. Had this shot been made with a wide-angle lens at an appropriate camera-to-subject distance to create the same subject size, the background would be much more dominant—even if had been taken at a wide-open aperture. Photograph by Kevin Jairaj. BELOW—Joe Photo used a 17mm lens at f/5.6 to photograph this wedding party group gone temporarily insane. Joe wanted to incorporate the sylvan splendor of the background in the image, so he stopped down the wide-angle lens a little bit to f/5.6 for increased depth of field. His shutter speed of 1/180 second was fast enough to stop the action of the group members.

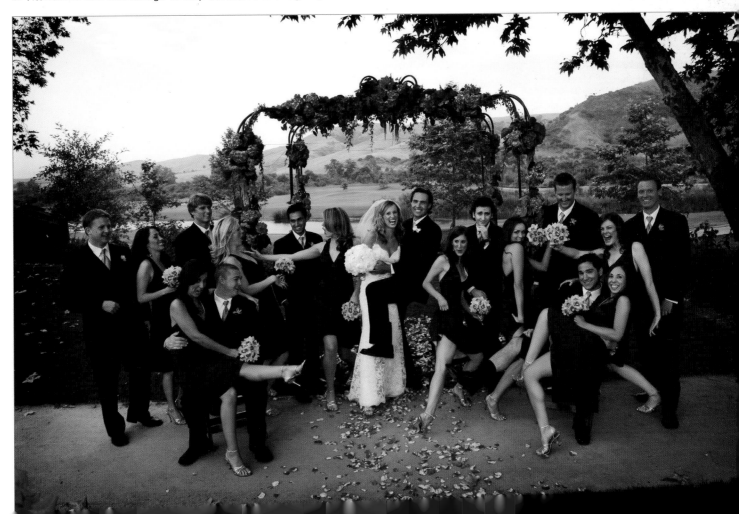

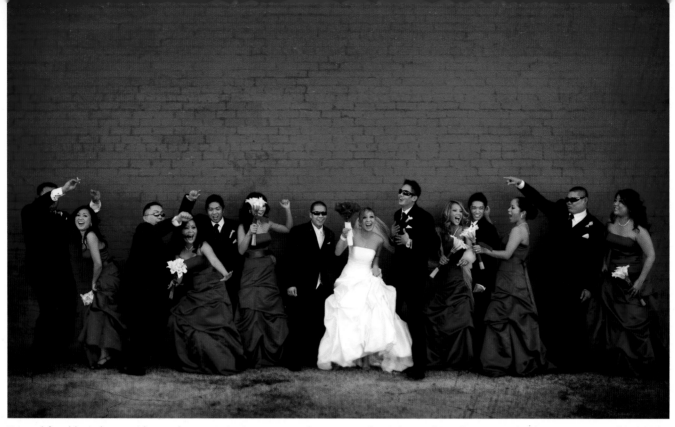

Normal focal lengths provide good perspective in groups as long as you have the working distance to back up. Here, JB Sallee used a 70mm focal length setting with his Canon EF 70–200mm f/2.8L IS USM and Canon EOS 5D.

length lens for your camera. Because you will be at a greater working distance from your subjects than you would be when making a close-up portrait, this lens will provide normal perspective. It can, however, be tricky to blur the background with a normal focal-length lens, since the background is in close proximity to the subjects. Fortunately, you can always blur the background elements later in Photoshop.

Wide-Angle Lenses. When making group portraits, you are often forced to use a wide-angle lens. In this case, the background problems noted above can be even more pronounced. Still, a wide angle is often the only way you can fit the group into the shot and maintain a decent working distance. For this reason, many group photographers carry a stepladder or scope out the location in advance to find a high vantage point, if called for.

FOCUS AND DEPTH OF FIELD

The closer you are to your subjects with any lens, the less depth of field you will have at any given aperture. When you are shooting a tight image of faces, be sure that you have enough depth of field at your working lens aperture to hold the focus on all the faces.

Photographer Michael O'Neill says, "All of my ceremony shots are done in the manual exposure mode—and most are done pre-focused with the camera's autofocus capabilities turned off. Ditto for the candid shots at the reception. Depth of field is a wonderful thing when you understand it. It's even better when [because of the focal-length factor] your digital camera gives you the depth of field of an 18mm lens when you're shooting at an effective focal length of 27mm."

Learn to use the magnification function on your LCD back to inspect the depth-of-field of your images. The viewfinder screen is often too dim when the lens is stopped

EVALUATING AN LCD IMAGE

With high-resolution LCDs, larger screens, and more functions in the playback mode of the camera, there's no reason you can't use the LCD most of the time for evaluating images. For example, most professional DSLRs let you zoom and scroll across an image at high magnification to evaluate details. This will tell you if the image is sharp or not. You can also set certain playback presets to automatically indicate problems, like clipped highlights. These are regions of the image in which no detail is present. I personally like this feature because the clipped highlights blink on the LCD preview, telling you what areas were not properly exposed and how to remedy the situation. On Nikon's playback menu, you can switch from histogram back to highlight-clipping mode in an instant. As you begin to use these features, they become second nature.

down with the depth-of-field preview to gauge overall image sharpness accurately. A good way to guarantee sharpness with a tiered group, such as group shot that is two or three rows deep, is to focus on the intermediate point between the nearest and farthest point you want sharp, and then stop down to an intermediate aperture like f/5.6 or f.8 to ensure you hold the two zones of focus. Double-check the focus on your LCD to see that you got the sharpness that you wanted.

When working up close at wide lens apertures, where the depth of field is reduced, you must focus carefully to hold the eyes, lips, and tip of the nose in focus. This is where a good working knowledge of your lenses is essential. Some lenses will have the majority (two thirds) of their depth of field behind the point of focus; others will have the majority (two thirds) of their depth of field in front of the point of focus. In most cases, depth of field is split 50–50, half in front of and half behind the point of focus. It is important that you know how your different lenses operate and that you check the depth of field with the lens stopped down to the taking aperture, using your camera's depth-of-field preview control or by previewing the sharpness with the camera's LCD.

With most lenses, if you focus one third of the way into the scene, you will ensure optimum depth of focus at all but the widest apertures. Assuming that your depth of field lies half in front and half behind the point of focus, it is best to focus on the eyes. The eyes are the region of greatest contrast in the face, and thus make focusing easier. This is particularly true for autofocus cameras that often seek areas of highest contrast on which to focus.

Focusing a three-quarter- or full-length portrait is a little easier because you are farther from your subjects, where depth of field is greater. With small groups, it is essential that the faces fall in the same focusing plane. This is accomplished with posing and carefully maneuvering your subjects or camera position.

ISO SETTINGS AND NOISE

Noise occurs when stray electronic information affects the image sensor. It is made worse by heat and long exposures. Noise shows up more in dark areas, making evening and night photography problematic with digital capture. It is worth noting because it is one of the areas where digital capture is quite different from film capture. (*Note:* This is,

fortunately, becoming less of an issue. New software on the latest DSLRs automatically reduces noise in long-exposure situations. This is quite effective, regardless of the ISO setting.)

Whether it's film or a digital-camera setting, the ISO affects the image quality in much the same way; the higher

What is equally important to the bride's expression and the exceptional composition is the focus on the bride's gown. The beadwork and beautiful fabrics used in the making of the dress are displayed flawlessly. Photograph by Michael O'Neill.

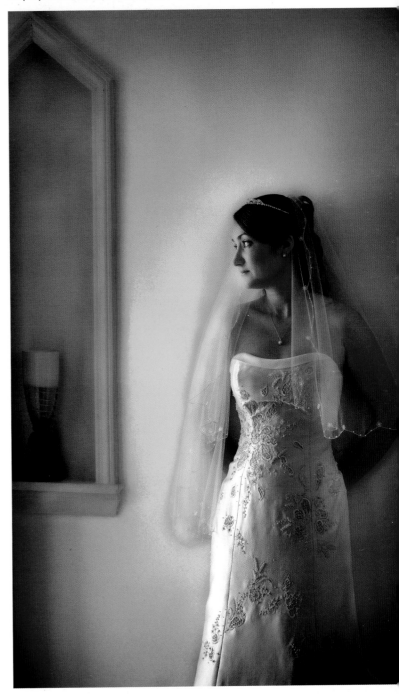

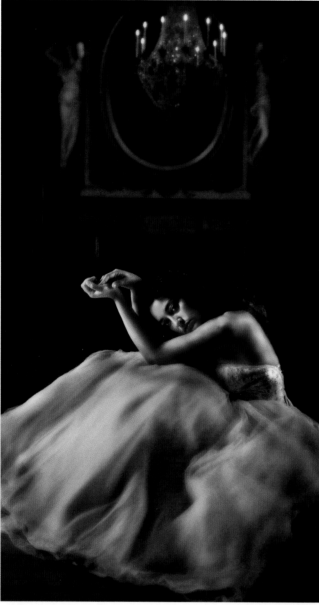

There is only one region of sharpness in this delicate bridal portrait by Scott Robert Lim: the bride's face and hair. The exposure of $^{1}/_{400}$ second at f/4 provided a nice slice of sharp focus—only about six to eight inches in depth—with the EF 24–105mm f/4L IS USM lens in use with the photographer's Canon EOS 5D. The painting and chandelier in the background are soft, as is the foreground area of the dress.

the ISO, the more noise (with digital) or grain (with film) will be recorded. The lower the ISO, the finer the image quality will be.

Most digital camera systems, at this writing, feature a sensitivity range from 100 to 1600 ISO (or, in some cases, 3200 ISO). The latest pro DSLRs from Nikon (D3S) and Canon (EOS 1D Mark IV) feature remarkably high ISOs—and low noise even at higher settings. Nikon's D3S

offers an ISO setting up to 102,400. At this setting, the results are a little noisy—about the equivalent of Kodak Tri-X film.

There are also a number of noise-reducing software applications available that are quite effective. Adobe Camera RAW features two types of noise reduction (one for color noise [chrominance] and another for black & white noise [luminance]) that can be applied in RAW-file processing. Another product, Nik Software's dFine 2.0, is a very sophisticated noise-reducing software that lets you selectively reduce noise in various parts of the image, which can be determined by color range or manually set control points. Of course, you can also reduce noise globally. DFine 2.0 works with both chrominance and luminance noise simultaneously.

FILE FORMATS

Graphic file formats differ in the way they represent image data (*i.e.,* as either pixels or as vectors), compression technique (how much data is compressed), and which Photoshop features they support. With the exception of the Large Document Format (PSB), Photoshop RAW, and TIFF, all file formats can only support documents with a file size of 2GB or less.

JPEG Format. The JPEG (Joint Photographic Experts Group) format is commonly used to display photographs and other continuous-tone images in hypertext markup language (HTML) documents over the Internet and other online services. The JPEG format supports the CMYK, RGB, and Grayscale color modes, but does not support alpha channels. JPEG images retain all the color information in an RGB file but compress the file size by selectively discarding data. A JPEG image is automatically decompressed when opened. A higher level of compression results in lower image quality, and a lower level of compression results in better image quality (see page 38 for more on compression).

Since most wedding photographers require the speed and flexibility offered by smaller file sizes (contrast this with the RAW file format discussed on the next page), most shoot in the JPEG Fine mode. If you decide to shoot in this format, keep in mind that your exposure and white balance must be flawless; smaller file sizes mean that less data is recorded, and this will reveal any weakness in your technique.

When it comes time for postproduction processing, most photographers who shoot in the JPEG mode either save the file as a JPEG copy each time they work on it, or save it to the TIFF format, which is "lossless," meaning it can be saved again and again without degradation.

JPEG 2000 Format. The JPEG 2000 format provides more options and greater flexibility than the standard JPEG format. Using JPEG 2000, you can produce images with better compression and quality for both Internet and print publishing.

Unlike traditional JPEG files, which are lossy, the JPEG 2000 format supports optional lossless compression. The JPEG 2000 format also supports 16-bit color or grayscale files, 8-bit transparency, and it can retain alpha channels and spot channels. Grayscale, RGB, CMYK, and Lab are the only modes supported by the JPEG 2000 format.

A very interesting feature of the JPEG 2000 format is that it supports using a Region of Interest (ROI) to minimize file size and preserve quality in critical areas of an image. By using an alpha channel, you can specify the region (ROI) where the most detail should be preserved, allowing greater compression and less detail in other regions.

RAW Format. RAW files offer the benefit of retaining the highest amount of image data from the original capture. While not as forgiving as color negative film, RAW files can be "fixed" in postproduction to a much greater degree than JPEGs. As a result, images that might be unusable if shot in the JPEG format can be adjusted to perfection if shot in the RAW format. (*Note*: This is done using RAW file-processing software, such as Adobe Camera Raw, to translate the file information and convert it to a useable format.)

Aside from a little extra processing time, the only serious drawback to RAW files is that they are larger than JPEG files. If you are like most wedding photographers and need fast burst rates, RAW files can slow you down. They will also fill up your memory cards much more quickly than JPEG files. Still, because camera buffers have increased in size and processing speeds have increased in performance, greater numbers of today's pro wedding photographers are shooting RAW files. If you know a situation is coming where you will need fast burst rates, you can temporarily switch to JPEG Fine and then jump back to shooting RAW files when the moment passes.

If you shoot in RAW mode, be sure to back up your images as RAW files; these are the original images and contain the most data.

Adobe DNG Format. RAW file formats are proprietary to the camera manufacturer (meaning RAW files from a Canon camera are actually a different format than RAW files from a Nikon camera). To resolve this disparity, Adobe Systems introduced an open RAW file format, appropriately named the Digital Negative (DNG) format. Adobe is pushing digital camera manufacturers and imaging-software developers to adopt DNG RAW format. Unlike the numerous proprietary RAW formats out there, the DNG format was designed with enough built-in flexibility

Here, the downward tilt of the lens and camera match the sloping plane of focus of the scene. The photographer only needed an exposure of $1/400$ second at f/4 to keep everything in focus—from the bricks in the foreground to the houses in the background. Scott Robert Lim used an EF 24-105mm f/4L IS USM lens to create this image.

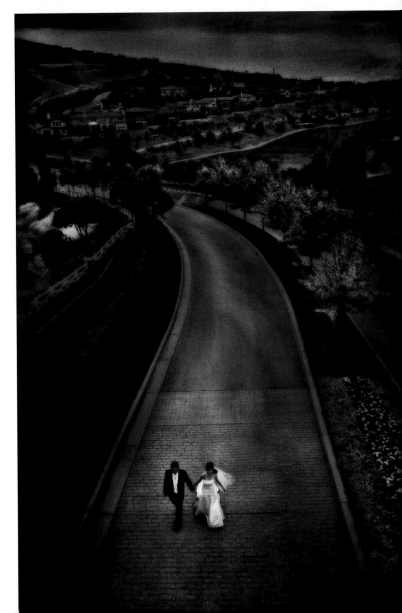

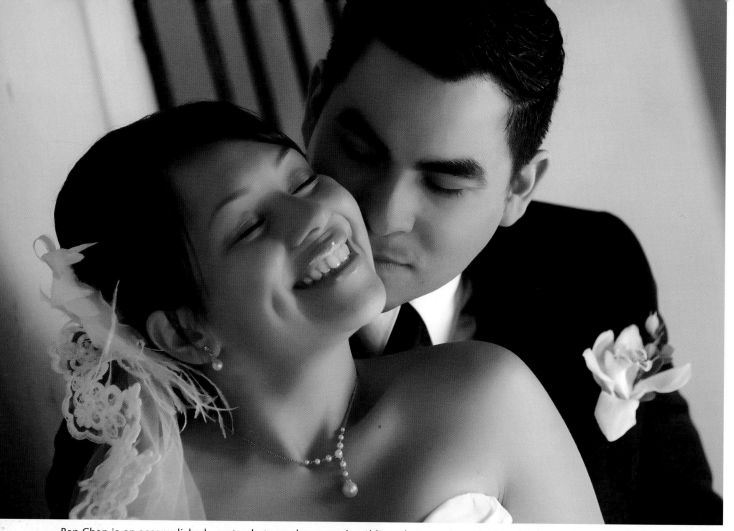

Ben Chen is an accomplished sports photographer turned wedding photographer. He shot this image in RAW and adjusted the color temperature, tint, shadows, brightness, contrast, sharpness, color noise reduction, and used a medium contrast tone curve.

to incorporate all the image data and metadata that a digital camera might generate. Proprietary RAW images that are pulled into Photoshop CS2 and above can be saved to the DNG file format with all the RAW file format characteristics being retained. DNG save options include the ability to embed the original RAW file in the DNG file, to convert the image data to an interpolated format, and to vary the compression ratio of the accompanying JPEG preview image.

GIF Format. Graphics Interchange Format (GIF) is a file format commonly used to display indexed-color graphics and images in hypertext markup language (HTML) documents over the Internet. GIF is an LZW-compressed format (see page 38) designed to minimize file size and electronic transfer time. The GIF format preserves transparency in indexed-color images; however, it does not support alpha channels.

TIFF Format. TIFF (Tagged Image File Format) files are the most widely used file format in digital photography.

TIFF supports the following image modes: RGB, CMYK, Grayscale, Lab, and Indexed color. TIFF files are lossless, meaning that they do not degrade in image quality when repeatedly opened and closed. TIFF files may be compressed when saved in Photoshop by using three different compression schemes: LZW, JPEG, or ZIP (see page 38).

TIFF files are commonly used to exchange files between applications and computer platforms. TIFF is a flexible bitmap image format supported by virtually all painting, image-editing, and page-layout applications. Also, virtually all desktop scanners can produce TIFF files. TIFF documents can have a maximum file size of 4GB. Photoshop CS and later support large documents saved in the TIFF format; most other applications (and older versions of Photoshop) do not support documents with file sizes greater than 2GB.

Photoshop can save layers in a TIFF file; however, if you open the file in another application, only the flattened image is visible. Photoshop can also save annotations,

transparency, and multi-resolution pyramid data in TIFF format.

Photoshop EPS Format. EPS (Encapsulated Post-Script) files can contain vector and bitmap graphics and are supported by almost all graphics, illustration, and page-layout programs. EPS files are used to transfer PostScript-language artwork between applications. When you open an EPS file containing vector graphics, Photoshop raster-izes the image, converting the vector graphics to pixels.

The EPS format supports Lab, CMYK, RGB, Indexed Color, Duotone, Grayscale, and Bitmap color modes, but does not support alpha channels. EPS does, however, support clipping paths. To print EPS files, you must use a PostScript printer.

DCS Format. The DCS (Desktop Color Separations) format, a version of the standard EPS format, lets you save color separations of CMYK images. You can use the DCS 2.0 format to export images containing spot channels.

PSD Format. PSD (Photoshop Document) is the de-fault file format and the only format that supports most Photoshop features (other than the Large Document Format [PSB]). Due to the tight integration between Adobe products, other Adobe applications can directly import PSD files and preserve many Photoshop features.

When saving a PSD file for use in a previous version of Photoshop, you can set a preference to maximize file com-patibility. Normally, you should choose Always from the Maximize PSD File Compatibility menu. This saves a com-

The JPEG format allows the photographer to work quickly and conserve storage space. This file, when closed, is 1.47MB as a JPEG. Once opened, it is a 20.60MB file, meaning that it was saved at less-than-highest quality as a JPEG. Once transported or sent to another party, files like these should be saved as lossless TIFF files to preserve the image data. This beautiful bridal formal was made by Kevin Jairaj.

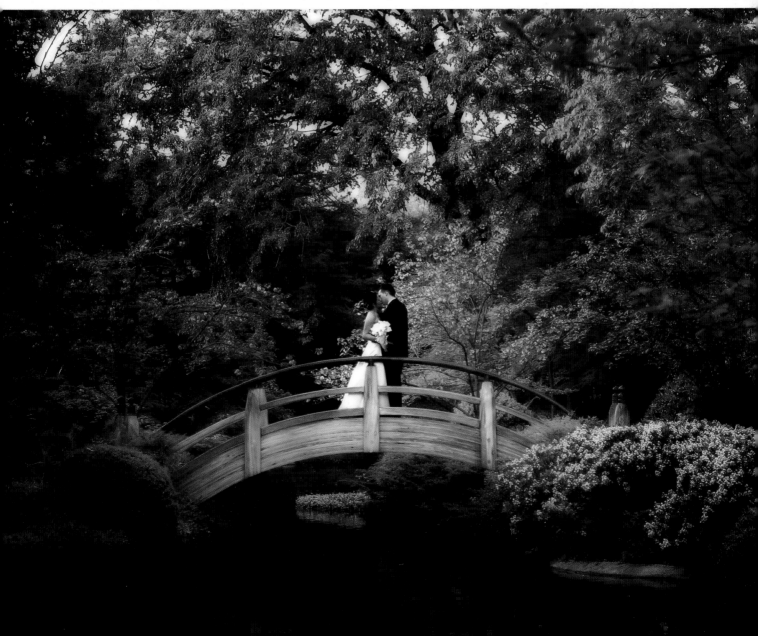

posite (flattened) image along with the layers of the document. If file size is an issue or if you're only opening your files in Photoshop, turning off Maximize PSD File Compatibility will reduce the file sizes significantly.

PSD files are worthwhile if complicated manipulations were performed in Photoshop. In the File Info section of a PSD file, all of the procedures will be documented in chronological order.

FILE COMPRESSION

Many file formats use compression to reduce the file size of bitmap images. Lossless formats compress the file without removing image detail or color information. Lossy formats remove detail. The following are some commonly used compression schemes:

CAPTURE SHARPENING *vs.* OUTPUT SHARPENING

In your camera's RAW file presets (or in your RAW file processing software) there will be a setting for image sharpening. You should choose the default setting, which is 25 percent. This is the setting recommended by most of the software manufacturers.

The latest version of Adobe Camera Raw (4.1) features drastically improved sharpening features and allows you to further control capture sharpening with four new controls: amount, radius, detail and masking. The thinking is that many photographers' workflow is based on speed and many images shot in RAW never even make it to Photoshop. The enhanced sharpening features of Adobe Camera Raw 4.1 give those photographers greater control over clarity, detail and sharpness of their images.

The sharpening function in your RAW file processor is capture sharpening (a global function) and should not be confused with the output sharpening for specific devices that is performed in Photoshop (selective sharpening). Output sharpening in Photoshop is usually the final step in the image-saving process. Some photographers use Unsharp Mask filter, others use Smart Sharpen. Whatever tool you prefer, avoid oversharpening an image in Photoshop, which will product artifacts. It's a good practice to use the "view pixels" setting in Photoshop when performing any sharpening function.

Another good tool for sharpening is the Nik Sharpener Pro 2.0 Selective Tool, which allows one to apply any of the program's numerous sharpening filters selectively to your images. Using the mouse or a pen tool, you can paint sharpness onto the image, quickly and easily controlling the amount and location of the sharpening effect.

LZW—Lossless compression; supported by TIFF, PDF, GIF, and PostScript language file formats.

JPEG—Lossy compression; supported by JPEG, TIFF, PDF, and PostScript language file formats. Recommended for continuous-tone images, such as photographs. When saving an image in Photoshop, you can specify the image quality by choose an option from the Quality menu (in the JPEG Options dialog box), entering a value between 0 and 12. For the best results, always choose the highest quality (10 to 12). JPEG files can be printed only on Level 2 (or later) PostScript printers and may not separate into individual plates for photomechanical reproduction.

ZIP—Lossless compression; supported by PDF and TIFF file formats. Like LZW, the ZIP compression strategy provides the greatest reduction in file size when used for images that contain large areas of a single color.

WORKFLOW ISSUES

Protecting Your Source Files. It is extremely important to back up your original (source) files before you reuse your memory cards. A good friend of mine, who shall remain nameless, asked his assistant to download and reformat the cards at the wedding only to find out later that the cards had been reformatted but the image files had not been saved. There were no wedding pictures except for the cards still in the cameras.

A good rule of thumb is to backup the files to CDs or DVDs as soon as possible. Avoid reformatting the memory cards until that has been done and verified. After you backup your source files, it's a good idea to erase all of the images from your memory cards and then reformat them. It simply isn't enough to delete the images, because extraneous data may remain on the card causing data interference. After reformatting, you're ready to use the memory card again.

Some photographers shoot an entire job on a series of cards and take them back to the studio prior to performing any backup. Others download, back up, and reformat cards directly during a shoot. Marcus Bell formats his cards before each wedding so that he never has to format a card at a wedding—for fear of accidentally wiping out the con-

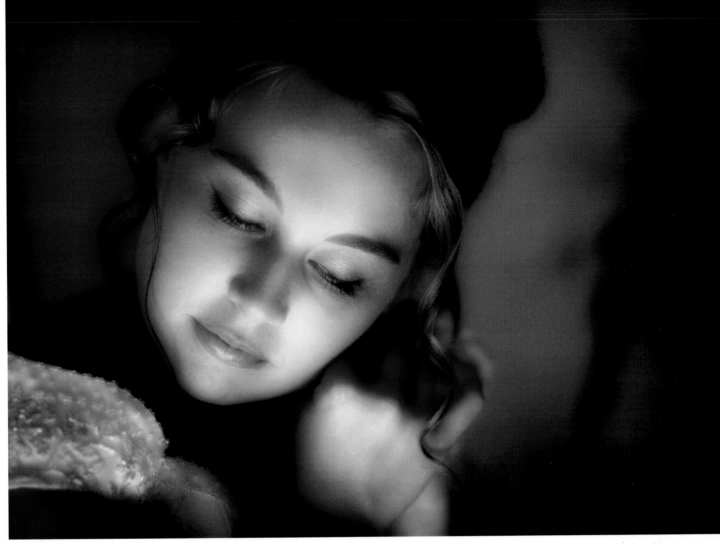

Dan Doke made this beautiful and quiet portrait of the bride with his EF 85mm f/1.2L II USM lens and Canon EOS 1D Mark II at ¹⁄₅₀₀ second at f/1.2. Because Dan uses an assistant for all of his weddings, he had someone to position the reflector precisely to light the frontal planes of the bride's face. Careful shading and vignetting in Photoshop completed the image.

tents of a card full of new images. During the day he makes an additional backup by downloading the cards to the Epson P4000 media storage drive and viewer. He then keeps the day's exposed cards in his right pants' pocket, ensuring they do not accidentally get mixed in with the blank cards.

This is a question of preference and security. Photographers who shoot with a team often train their assistants to perform these operations to guarantee the images are safe and in hand before anyone leaves the wedding.

Dan Doke's Wedding Workflow. Dan Doke is an award-winning wedding photographer who shoots quite a few high-end weddings each year. On an average wedding-day shoot, Dan will work roughly eight hours with one assistant. (*Note:* Their gear bags include a selection of Canon lenses: 24–70mm f/2.8; 70–200mm f/2.8; 16–35mm f/2.8; 85mm f/1.2; 300mm f/4; 135mm f/2; and 35mm

f/1.4. He also packs a Tamron 90mm Macro lens, a Sigma 8mm fisheye lens, plus Canon 580 Speedlites and a Quantum D-2 flash with battery packs.) Dan shoots the important shots, while his assistant helps with everything else—holding additional lighting, taking candid photographs, and doing whatever is necessary. Dan works quickly and unobtrusively, only stepping in when necessary to make sure that everyone is in place.

Dan joins his team in the studio the day after the wedding and downloads the cards. He says, "I have a 1.5-terabyte computer with five drives, and I make copies onto two of them. I then drag files onto my server for backup and then onto DVDs. This gives me files in four areas." Within a week, his studio staff goes through all the images and picks the best shots. Some edits are done in Photoshop and then uploaded to Flip Album (www.flipalbum .com) so the bride can make selections.

Here you see Mike Colón's elaborate WiFi setup. The assistant with the laptop is near the center of the photograph and the seated guests can't take their eyes off the projected images. Photograph by Mike Colón.

Dan supervises all the work himself. He uses Natural Color Lab (Stoughton, MA) for prints and Lab Prints' Image Composite Studio for his album designs. He consistently strives to produce the highest quality albums and uses PictoBooks exclusively, a system he regards as "the best I've ever seen."

Mike Colón's WiFi Workflow. Today's wedding clients expect immediacy. They aren't content with seeing proofs four weeks after the honeymoon. As a result, Newport Beach wedding photographer Mike Colón has revised his wedding workflow so that he can deliver wedding photos at the wedding reception—even photos taken during the reception.

Mike has each of his Nikon DSLRs fitted with a Nikon WT-1A wireless transmitter. As he shoots, the WT-1A automatically sends each file to an Apple laptop, which comes with a built-in WiFi transceiver. It takes about two seconds for each image to transfer. At the same time, the images are still being written to the memory card in the camera as backup.

During the ceremony, Mike's assistant—with the PowerBook—stays within transmitting range (typically about 100 feet, although the optional Nikon WA-E1 extended antenna can transmit up to 450 feet from the camera) and checks the images as they are being shot in real time. Once he has a good number of images, Colón's assistant begins to create a slideshow. At the reception, Mike uses a digital projector to display a show for the guests. Images captured right up to the start of the slide show can be incorporated into the presentation. Mike says the surprise of seeing the images immediately really delights both the guests and the bride and groom. Not surprisingly, he finds the spontaneity often makes guests more likely to order prints. If it's not possible to project the slide show, he will show the images directly on the PowerBook.

While all this is going on, Colón also selects key images that he outputs as 4x6-inch prints on a Mitsubishi dye-sub printer. At the end of the wedding, he places these in a mini album that the bride and groom can take with them on their honeymoon.

BACKUP AND EMERGENCY EQUIPMENT

Wedding photographers live by the expression, "If it can go wrong, it will go wrong." That is why most seasoned pros carry backups—extra camera bodies, flash heads, transmitters, batteries, cords, twice the required amount of film or storage cards, etc. For AC-powered flash, extra extension cords, several rolls of duct tape (for taping cords

to the floor), power strips, flash tubes, and modeling lights also need to be on hand. Other items of note include the obligatory stepladder for making groups shots, flashlights, a mini tool kit (for mini emergencies), and quick-release plates for your tripods (these always seem to get left behind on a table or left attached to a camera).

REMOTE TRIGGERING DEVICES

If using multiple flash units (to light the dance floor, for instance), some type of remote triggering device will be needed to sync all the flashes at the instant of exposure. There are a variety of these devices available.

Light-Actuated. Light-actuated slaves are sensitive to the light of a flash unit being fired and trigger flash to which they are attached at the same instant. Unfortunately, this can be your flash or someone else's flash—a real drawback to this type of remote flash trigger.

Infrared. Infrared remote flash triggers are more reliable. Since many monolight-type flash units come equipped with an infrared sensor built in, it is a simple matter of syncing the flashes with the appropriate transmitter.

Radio (Digital or Analog). A third type, the radio remote triggering device, uses a radio signal that is transmitted when you press the shutter release and then picked up by individual receivers mounted to each flash. These are reliable, but not foolproof—a cordless microphone may trigger them accidentally.

Radio remotes transmit signals in either digital or analog form. Digital systems, like the Pocket Wizard, are much more reliable and are not affected by local radio signals. Some photographers will use, as part of their standard equipment, a separate transmitter each camera being used (for instance, their assistant's camera), as well as a separate transmitter for the handheld flashmeter, allowing the photographer to take remote flash readings from anywhere in the room.

SPARE BATTERIES

One of the major improvements in DSLR design is the improved life and usefulness of batteries. Camera batteries are much better than they were and should last all day without replacement. However, it's always a good idea to bring extra batteries and a charger or two. Spare packs should be fully charged and ready to go and you should have enough to handle your cameras, your assistant's cameras, and the backup gear. If downloading images to a laptop, do not forget to pack spare laptop batteries and/or the computer's AC adapter.

INTERNATIONAL TRAVEL WITH GENE HIGA

Gene Higa does destination weddings and travels about three weeks out of every month. He travels with multiple Tamrac and Lowepro roller/backpack bags, which are certified to fit in the overhead compartment of any aircraft. Because Gene may have to go from a roller to a backpack in seconds, his bags need to be versatile. His equipment consists of two Canon EOS 5D bodies, two Canon EOS-1D Mark II bodies and a Canon EOS 20D for backup. His lenses include a 15mm f/2.8 fisheye, 14mm f/2.8, 24–70mm f/2.8, 24–105mm IS f/4.0, 50mm f/1.0, two 70–200mm IS f/2.8 lenses, and two 16–35mm f/2.8 lenses. Gene also packs two 580EX flashes, 30GB in Lexar and SanDisk Extreme CompactFlash cards, two Quantum battery packs, rechargeable AA batteries, Canon battery packs, and power adapters.

After the wedding, Gene uses ROES (remote order entry system), which is his direct link to Bay Photo Lab. As long as he has an Internet connection, he can upload images to his lab. The prints are then delivered to his studio within a week of returning home. Gene posts the images on his web site so that by the time the guests and couple return home, the images are ready to be viewed. This approach has great sales impact because the wedding and the vacation are still fresh in their minds.

He edits with iView Media Pro, and he creates galleries using Troy Winder's Pickpic (www.pickpic.com), which gives guests the option to purchase prints online. Gene works with Bay Photo Lab because of the fast turnaround time and the fact that they use Kodak Endura paper, which gives him the rich tonality he prefers.

Part of the job of an international wedding photographer like Gene Higa is to incorporate exotic locales into the wedding pictures—but without the images looking like postcards or ads.

Posing Principles

There are some formals that must be made at each wedding. These are posed portraits in which the subjects are aware of the camera, and the principles of good posing and composition are employed to make the subjects look their best. Even in photojournalistic wedding coverage, there is an absolute necessity for posed images. For those times—and

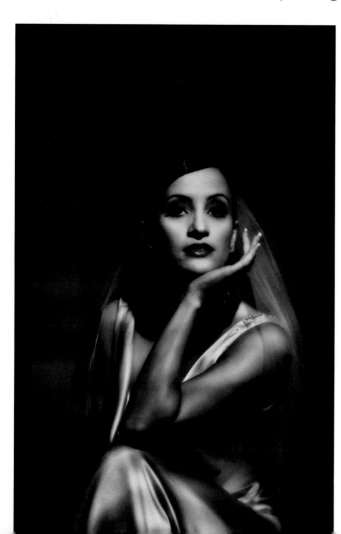

because any good wedding photographer who is not aware of the traditional rules of posing and composition is deficient in his or her education—the basics are included here.

The rules of posing are not formulas, but like all good rules, they must be understood before they can be effectively broken. The more you know about the rules of posing, and particularly the subtleties, the better your wedding images will be. And the more you practice these principles, the more they will become second nature and a part of your overall technique.

GIVING DIRECTIONS

There are a number of ways to give posing instructions. You can tell your subjects what you want them to do, you

Australian wedding photographer Jerry Ghionis likes to incorporate many of the traditional styles of posing into his modern bridal portraits. Apart from the strong butterfly lighting, a remnant of Hollywood-style portraiture, note the bride's hand. The fingers are separated and apart from her face in a very stylistic pose. This image looks more like it was made in the 1920s than today.

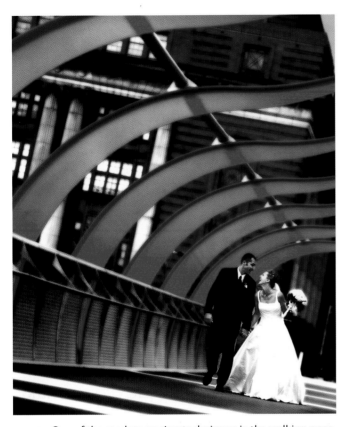

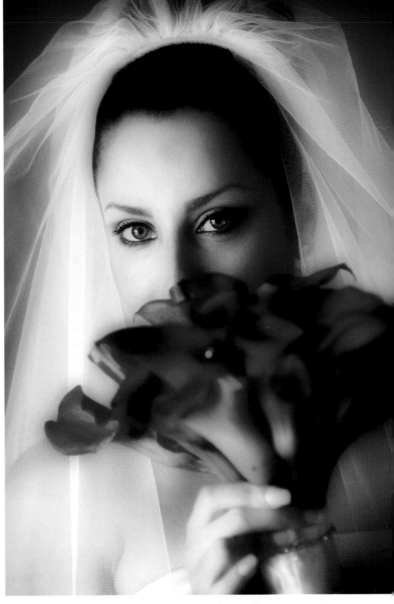

ABOVE—One of the modern posing techniques is the walking pose. Aside from making the couple look good, the photographer tries to blend the pose into the architectural elements in the scene. In this award-winning image, Jerry Ghionis captured the couple leaning in to each other and laughing, thereby "borrowing" one of the diagonals in the scene for the pose. RIGHT—Good posing skills are acquired over time and with diligence. In this charming bridal portrait by Dan Doke, notice how the eyes are at a slight angle, the head is tipped toward the near shoulder, and the fingers are slightly separated—all hallmarks of good posing technique.

can gently move them into position, or you can demonstrate the pose. The latter is perhaps the most effective, as it breaks down barriers of self-consciousness on both sides of the camera.

SUBJECT COMFORT

Your subjects should be made to feel comfortable. A subject who feels uncomfortable will most likely look uncomfortable in the photos. After all, these are normal people, not models who make their living posing. Use a pose that feels good to the subject. If the person is to look natural and relaxed, then the pose must be not only natural to them, but also typical—something they do all the time. Refinements are your job—the turn of a wrist, weight on the back foot, the angling of the body away from the

camera—but the pose itself must be representative of the person who is be photographed.

FACIAL POSITIONS

There are three basic face positions (relative to the camera) found in portraiture. Being aware of these positions will help you provide variety in your images—and you can incorporate the different head positions within group portraits. You may, at times, end up using all three head positions in a single group pose. The more people in the group, the more likely that becomes.

The Seven-Eighths View. If you consider the full face as a head-on "mug shot," then the seven-eighths view occurs when the subject's face is turned just slightly away from the camera. In other words, you will see a little more of one side of the subject's face. You will still see the subject's far ear in a seven-eighths view.

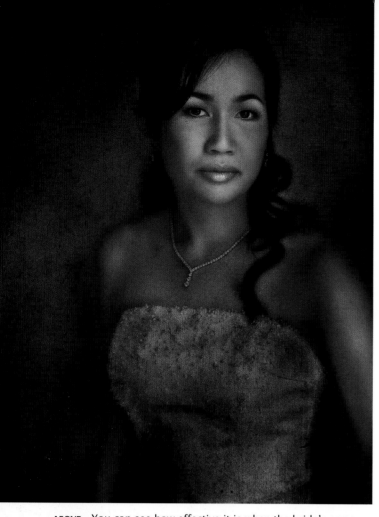

ABOVE—You can see how effective it is when the bride's arms are separated from her torso. A simple request such as "Bring your hands up closer to your waist," will do it. Her arms look slim and athletic and her waist looks tiny. This is a highly stylized image by Scott Robert Lim in which various texture screens and softening techniques were used to treat most of the photo, with very little done to the face. RIGHT—A great smile resonates throughout the wedding album. Here, British photographer Steve Tarling captured a priceless smile (along with a pink Cadillac). The spontaneity and joy in the image is contagious.

The Three-Quarters View. This is when the far ear is hidden from camera and significantly more of one side of the face than the other is visible. With this pose, the far eye will appear smaller because it is farther away from the camera than the near eye. Because of this, when posing subjects in a three-quarters view it is important to position them so that the subject's smaller eye (people usually have one eye that is slightly smaller than the other) is closest to the camera. This way, the perspective makes both eyes appear to be the same size in the photograph. This may not be something you have time to do when posing groups of people at a wedding, but when photographing the bride and groom, care should be taken to notice these subtleties.

The Profile. In the profile, the head is turned almost 90 degrees to the camera. Only one eye is visible. When posing your subjects in profile, have them turn their heads gradually away from the camera position until the far eye and eyelashes just disappear.

THE EYES

The best way to keep your subject's eyes active and alive is to engage the person in conversation. Try to find a common frame of interest. Inquire about the other person—almost everyone loves to talk about themselves! If the person does not look at you when you are talking, he or she is either uncomfortable or shy. In either case, you have to work to relax them. Try a variety of conversational topics until you find one they warm to and then pursue it. As you gain their interest, you will take the subject's mind off of the photograph.

Using a cable release with the camera tripod-mounted forces you to become the host and allows you to physically

hold the subject's gaze. One of the best ways to enliven your subject's eyes is to tell an amusing story. If they enjoy it, their eyes will smile—one of the most endearing expressions a human being can make.

One of the best photographers I've ever seen at "enlivening" total strangers is Ken Sklute. I've looked at literally hundreds of his wedding images and in almost every photograph, the people seem happy, relaxed, and natural. Nothing ever looks posed in his photography—it's almost as if he happened by this beautiful picture and snapped the shutter. One of the ways he gets people under his spell is his enthusiasm for excitement of the day. His joy is contagious and his affability translates into attentive subjects.

While it helps any wedding photographer to be able to relate well to people, those with special gifts—good story-tellers or people with a good sense of humor—should use those skills to get the most from their clients.

THE SMILE

Pay close attention to your subject's mouth, making sure there is no tension in the muscles around it; this will give the portrait an unappealing look. An air of relaxation best relieves tension, so talk to the person to take his or her mind off the photo.

An important aspect of good posing, even with thin brides is the instruction to separate the elbows from the waist—or to move the arms away from the body. The reason is that when the biceps is laying flat against the torso, it almost doubles in size. This problem is averted with brides by having her hold her bouquet at waist level, which forces the elbows away from the body. Photograph by Jeff Hawkins.

THE KISS

Whether you set it up, which you may have to do, or wait for it to occur naturally, be sure to get the bride and groom kissing at least once. These are favorite shots and you will find many uses for them in the album. For the best results, get a good vantage point and make sure you adjust your camera angle so neither person obscures the other.

Your coverage should include as many shots of the bride and groom embracing and kissing as you can get. You'd be surprised at how often this integral scene gets neglected or omitted. Photography by Johannes Van Kan of Flax Studio in Christchurch, New Zealand.

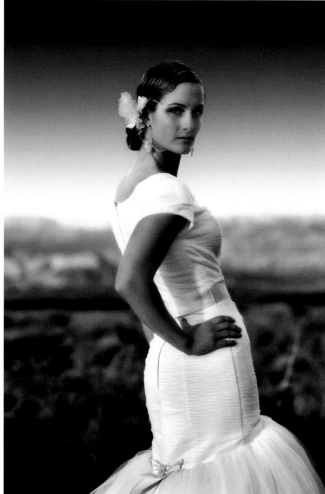

LEFT—Kevin Jairaj made this formal portrait of bride and groom kissing. Believe it or not, the bride and groom rarely get to kiss on their wedding day because they are so busy with other things. Kevin had the groom clutch the bride's waist and had the bride drop her bouquet, as if she were overwhelmed by the kiss. He used a 17mm lens and fired a flash from camera position. In Photoshop, he gave the church exterior a blue–black treatment. **RIGHT**—Good head and neck axis placement is crucial in good posing. In this lovely pose, the bride's body forms a highly pleasing S-curve while she looks back toward the camera with her head parallel to the near shoulder. Photograph by Nick Adams.

One of the easiest ways to produce a natural smile is to praise your subject. Tell her how good she looks and how much you like a certain feature of hers—her eyes, her hair style, etc. Simply saying "Smile!" will produce a lifeless expression. By sincere confidence-building and flattery, you will get the person to smile naturally and sincerely—and their eyes will be engaged by what you are saying.

Remind the subject to moisten her lips periodically. This makes the lips sparkle in the finished portrait, as the moisture produces tiny specular highlights on the lips.

THE SHOULDERS

One of the basics of flattering portraiture is that the subject's shoulders should be turned at an angle to the cam-

era. When the shoulders face the camera (straight on to the lens), the person will look wider than they really are. Additionally, the shoulders should be turned in a different direction than the face. This provides an opposing or complementary line within the photograph that, when seen together with the line of the body, creates a sense of tension and balance. With men, the shoulders are often turned the same general direction as the face (but not at exactly the same angle); with women, the shoulders are usually at an angle that opposes the angle of the face.

THE ARMS

Subjects' arms should not be allowed to fall to their sides, but should generally project outward to provide gently

sloping lines and a "base" for the composition. This is achieved in a number of ways. For men, ask them to put their hands in their pockets; for women, ask them to bring their hands to their waist (whether they are seated or standing). Remind them that there should be a slight space between their upper arms and their torsos. This triangular base in the composition visually attracts the viewer's eye upward, toward the face. It also protects subjects from appearing to have flat, flabby arms—and slims the midsection by preventing the arms and torso from appearing to be one solid mass.

THE HANDS

Posing hands properly can be very difficult because, in most portraits, they are closer to the camera than the subject's head and thus appear larger. One thing that will give

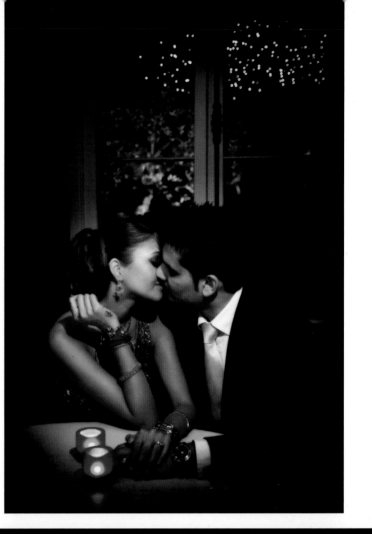

RIGHT—Here is another image where the hands are treated exceptionally well. Note the slight separation between the fingers. Photograph by Stuart Bebb. **BELOW**—Hands and arms should look natural and undistorted. Those are the only important rules for posing these sometimes troublesome parts of the body. In this Nick Adams image, the pose and the event seem natural and unposed, and the arms and hands look believable.

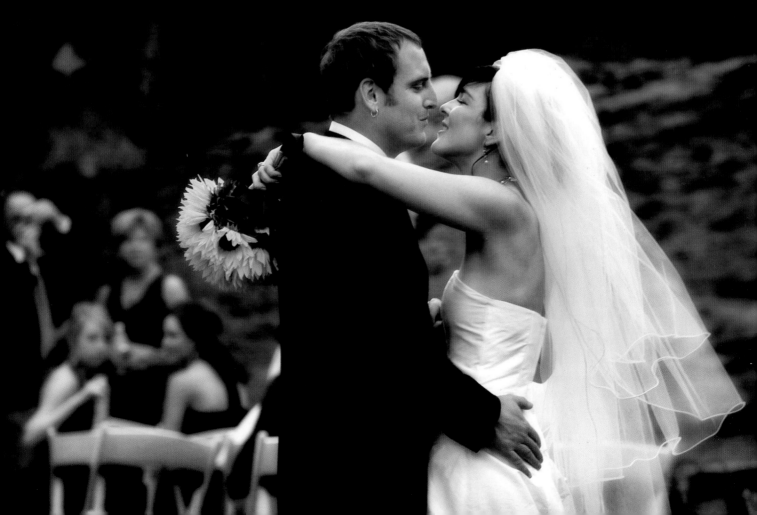

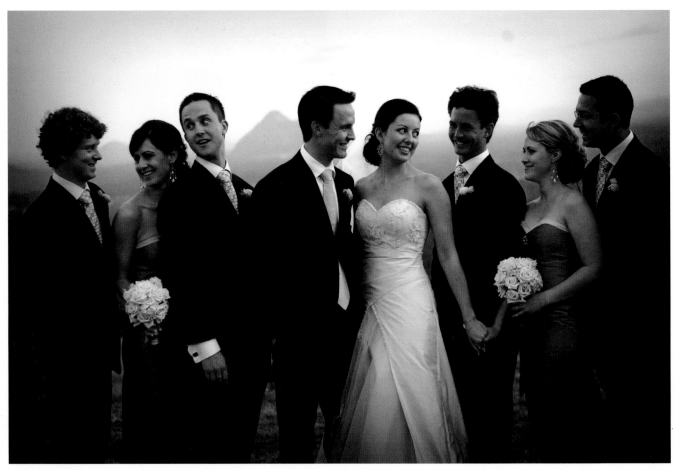

Marcus Bell has a "Use 'em or lose 'em" attitude towards hands in group photos. Here he chose to "lose 'em" for the most part. He hides hands in pockets, behind others in the group, behind bouquets so that there are only a few hands showing in this group of eight people. The fewer hands that are visible, the fewer hands the photographer must pose.

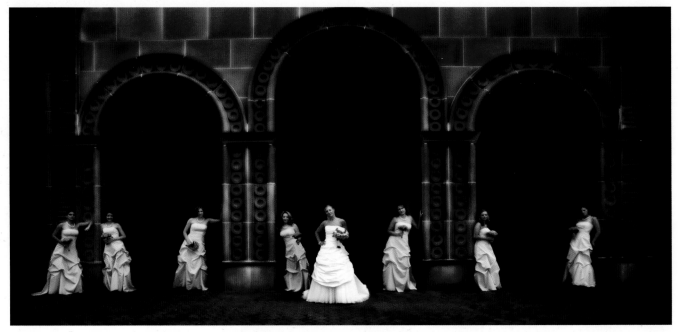

Kevin Jairaj made this distinctive group portrait of the bride and her bridesmaids. The posing adheres to all the fundamentals: weight on the back foot, elbows away from the body, show the edge of the hands, etc. Still, there is an attitude in each of the poses that contrasts with the formal church arches. It's a good example of a quirky but fun formal portrait.

hands a more natural perspective is to use a longer-than-normal lens. Although holding the focus on both the hands and face is more difficult with a longer lens, the size relationship between them will appear more natural. If the hands are slightly out of focus, this is not as crucial as when the eyes or face are soft.

One basic rule is never to photograph a subject's hands pointing straight into the camera lens. This distorts the size and shape of the hands, so you should always have the hands at an angle to the lens. Additionally, you should photograph the outer edge of the hand whenever possible. This gives a natural, flowing line to the hand and wrist and eliminates the distortion that occurs when the hand is photographed from the top or head-on. Try to raise the wrist slightly so there is a gently curving line where the wrist and hand join. Additionally, you should always try to photograph the fingers with a slight separation in between them. This gives the fingers form and definition. When the fingers are closed, there is no definition.

As generalizations go, it is desirable that the hands of a woman have grace and that the hands of a man have strength.

Hands in Groups. Hands can be a problem in group portraits. Despite their small size, they attract attention—especially against dark clothes. They can be particularly troublesome in seated groups, where (at first glance) you might think there are more hands than there should be for the number of people pictured.

A general rule of thumb is to either show all of the hand or show none of it. Don't allow a thumb or half a hand or only a few fingers to show. Hide as many hands as you can behind flowers, hats, or other people. Be aware of these potentially distracting elements and look for them as part of your visual inspection of the frame before you make the exposure.

Hands with Standing Subjects. When some of your subjects are standing, hands are an important issue. If you are photographing a man, folding his arms across his chest produces a good, strong pose. Remember, however, to have the man turn his hands slightly, so the edge of the hand is more prominent than the top of the hand. In such a pose, have him lightly grasp his biceps, but not too hard or it will look like he's cold. Also, remember to instruct the man to bring his folded arms out from his body a little bit. This slims down the arms, which would otherwise be

POSING PORTRAITS OF SEATED MEN

Whenever a man is seated it's a good idea to check his clothes. He should have his jacket unbuttoned to prevent it from looking tight. If wearing a tux with tails, he should also avoid sitting on them, as this will also alter the shape of the coat. If he has shirt cuffs, they should be pulled down to be visible. And if sitting cross-legged, make sure his socks are pulled up high enough so that you don't see any bare leg.

flattened against his body, making them (and him) appear larger. Separate the fingers slightly.

With a standing woman, one hand on a hip and the other at her side is a good standard pose. Don't let the free hand dangle, but rather have her twist the hand so that

This glamorous pose, created by Ken Sklute, shows all of the essential posing requirements. While it is formal and structured, it still looks relaxed—and it shows off this elegant bride at her finest.

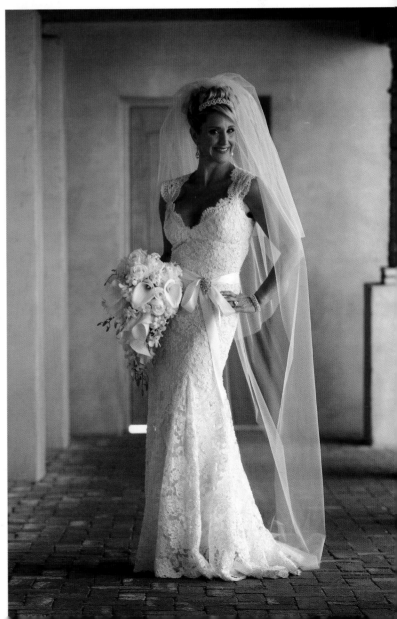

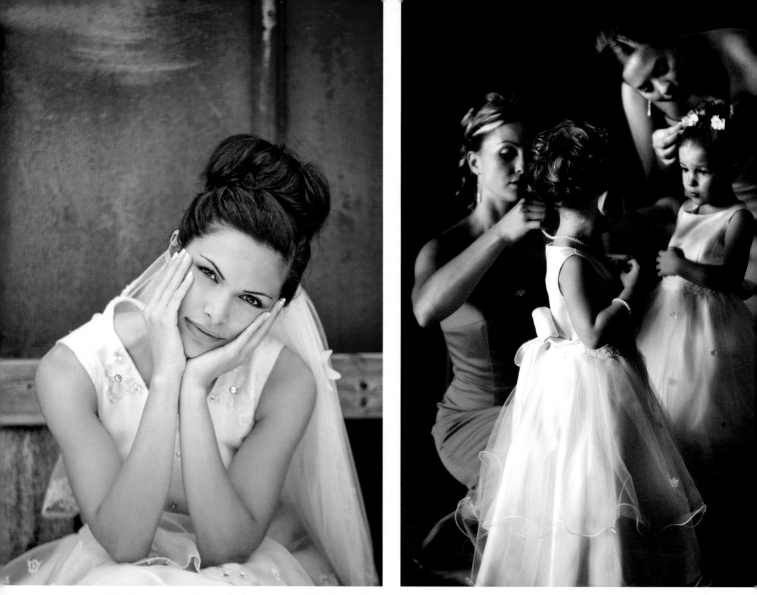

LEFT—This is a pose involving a little trickery. While the bride appears to be resting her head in her hands, actually, her hands are barely touching her face. The light touch creates an undistorted pose. Photograph by Marc Weisberg. (Canon EOS-1D Mark II and an EF 70-200mm f/2.8L IS USM lens at the 170mm setting.) RIGHT—One of the elements of good posing technique is that the photo not "look posed." Kevin Jairaj made this very serious portrait of two bridesmaids and two flower girls hard at work on final preparations. With minor direction and good point of view and lighting, he created a priceless image that looks natural and spontaneous.

the outer edge shows to the camera. Always create a break in the wrist for a more dynamic line.

WEIGHT ON THE BACK FOOT

No one should be standing at attention with both feet together. Instead, the shoulders should be at a slight angle to the camera, as previously described, and the front foot should be brought forward slightly. The subject's weight should always be on the foot farther from the camera. This has the effect of creating a bend in the front knee and dropping the rear shoulder to a position lower than the forward one. When used in full-length bridal portraits, a bent forward knee will lend an elegant shape to the dress.

With one statement, "Weight on your back foot, please," you can introduce a series of dynamic lines into an otherwise average composition.

PORTRAIT LENGTHS

Head-and-Shoulders Portraits. With close-up portraits of one or more people, it is important to tilt the head. As noted previously, the shoulders should also be at an angle to the camera lens (and the person's head should be at a slightly different angle). Often, head-and-shoulders portraits are of the face alone—as in a beauty shot. In such an image, it is important to have a dynamic element, such as a diagonal line, that will create visual interest. This can be

the line of the eyes or the tilt of the head or the line of the shoulders.

In a head-and-shoulders portrait, all of your camera technique will be evident, so focus is critical (start with the eyes) and the lighting must be flawless. Use changes in camera height to correct any irregularities (see pages 52–53). Don't be afraid to fill the frame with the bride or bride and groom's faces. Most people will never again look as good as they do on their wedding day!

Three-Quarter- and Full-Length Portraits. When you employ a three-quarter-length pose or a full-length pose, you have more of the body to contend with.

As noted above, it is important to angle the person to the lens. Don't photograph the person head-on, as this adds mass to the body. Also, your subject's weight should be on the back foot rather than distributed evenly on both feet—or worse yet, on the front foot. There should be a slight bend in the front knee if the person is standing. This helps break up the static line of a straight leg. The feet should also be at an angle to the camera; feet look stumpy when shot straight on.

When the subject is sitting, a cross-legged pose is effective. Position the top leg at an angle to the camera, not directly into the lens. When posing a woman who is seated, have her tuck the calf of the leg closest to the camera in behind the leg farther from the camera. This reduces the size of the calves, since the leg that is farther from the camera becomes more prominent. Whenever possible, have a

LEFT—Here is classically elegant head-and-shoulders portrait by Michael Schuhmann. At first glance, the portrait looks very symmetrical, but on closer inspection you'll see that there are numerous diagonal and curved lines, plus the pleasant line of the hands cupping her face. Notice too that the bride's hands are not pressing against her cheeks, which would distort her face; they are barely touching the skin. **RIGHT**—Annika Metsla, an award-winning wedding photographer from Estonia, created this charming head-and-shoulders portrait of the bride and groom. The portrait is really of the bride; the groom only serves to lead the eye toward the bride. With a 70–200mm lens used at f/2.8, she was only interested in holding focus on the bride's face.

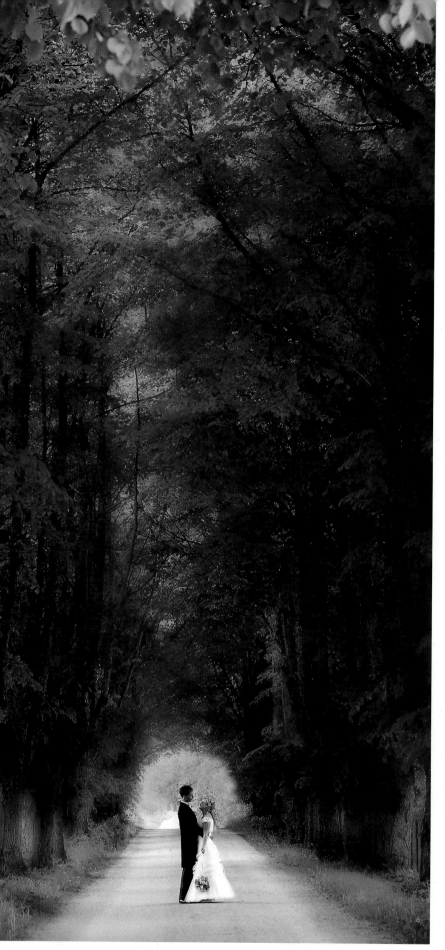

This full-length portrait by Annika Metsla reveals the beautiful canopy of trees overhead. Directly behind the couple is an arch of light that frames the couple. This type of image would never have been attempted in the days of traditional wedding photography.

slight space between the subject's leg and the chair, as this will slim down thighs and calves.

Never frame the portrait so that a joint—an elbow, knee, or ankle, for example—is cut off at the edge of the frame. This sometimes happens when a portrait is cropped. Instead, crop between joints—at mid-thigh or mid-calf, for example. When you break the composition at a joint, it produces a disquieting feeling.

CAMERA HEIGHT

When photographing people with average features, there are a few general rules that govern camera height in relation to the subject. These rules will produce normal (not exaggerated) perspective.

For head-and-shoulders portraits, the rule of thumb is that camera height should be the same height as the tip of the subject's nose. For three-quarter-length portraits, the camera should be at a height midway between the subject's waist and neck. In full-length portraits, the camera should be at the same height as the subject's waist. In each case, the camera is at a height that divides the subject into two equal halves in the viewfinder. This is so that the features above and below the lens–subject axis will be the same distance from the lens, and thus recede equally for "normal" perspective.

When the camera is raised or lowered, the perspective (the size relationship between parts of the photo) changes. This is particularly exaggerated with wide-angle lenses. By controlling perspective, you can alter the subject's physical traits.

By raising the camera height in a three-quarter- or full-length portrait, you enlarge the head-and-shoulders region of the subject, but slim the hips and legs. Conversely, if you lower the cam-

era, you reduce the size of the head, but enlarge the size of the legs and thighs. Tilting the camera down when raising the camera (and up when lowering it) increases these effects. The closer the camera is to the subject, the more pronounced the changes are. If you find that, after you adjust camera height for a desired effect, there is no change, move the camera in closer to the subject and observe the effect again.

When you raise or lower the camera in a head-and-shoulders portrait, the effects are even more dramatic. Raising or lowering the camera above or below nose height is a prime means of correcting facial irregularities. Raising the camera height lengthens the nose, narrows the chin and jaw line and broadens the forehead. Lowering camera height shortens the nose, de-emphasizes the forehead and widens the jaw line, while accentuating the chin.

While there is little time for many such corrections on the wedding day, knowing these rules and introducing them into the way you photograph people will help make many of these techniques second nature.

GROUP PORTRAITS

Designing group portraits successfully depends on the photographer's ability to manage the lines and shapes within a composition.

Lines are used to create visual motion within the image. They may be implied by the arrangement of the group, or inferred by grouping various elements within the scene. They might also be literal, like a fallen tree used as a posing bench that runs diagonally through the composition. Shapes are groupings of elements that create geometric forms—diamonds, circles, pyramids, etc. Shapes are used

LEFT—To create this image, Marc Weisberg raised the camera angle so that he could show the bridesmaids in the background. The camera height needed to be raised or the roof of the car would have obscured too much of them. The trick with camera height and perspective is to not raise or lower the angle so much that it affects perspective in a negative way. **RIGHT**—Here, Marc Weisberg lowered the camera height in this head and shoulders portrait to below the bride's chin to make her appear higher than the camera. It's a subtle adjustment that enhances the young bride's elegant neck.

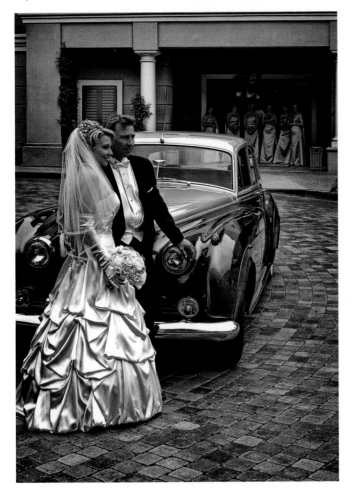
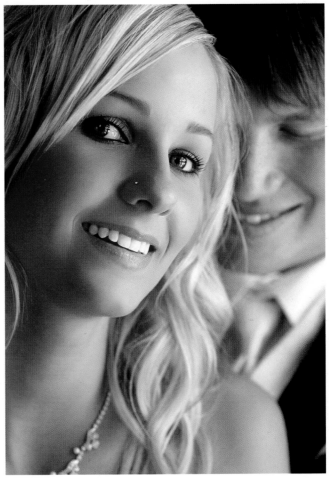

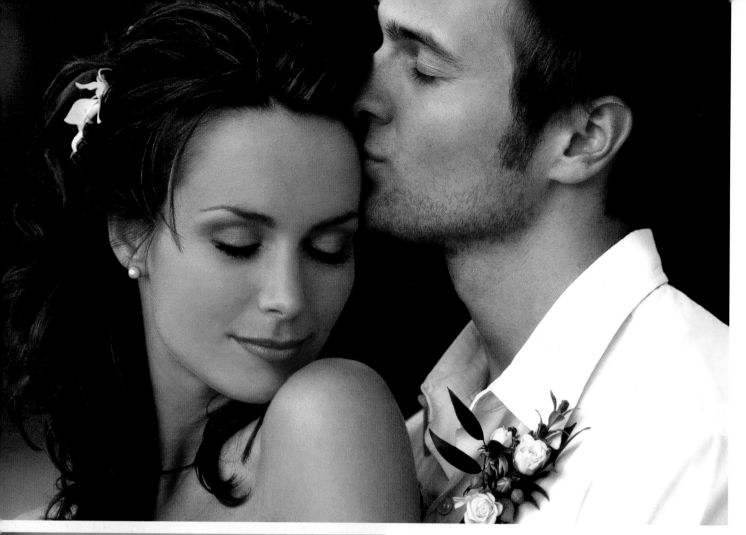

ABOVE—Gordon Nash created this lovely portrait of a bride and groom. He shot the image with a Nikon D2H and 135mm f/2.0 lens wide open at ISO 640. The pose is elegant: the bride turns back toward the groom, head tipped toward the near shoulder in the classic feminine pose. The sheer bliss of the emotion captured is amazing. **LEFT**—This wide-angle portrait, made with a 24–70mm lens, captures the romance of this couple's day. The photographer, Annika Metsla, had the couple lean across the bed and photographed them as they were about to kiss.

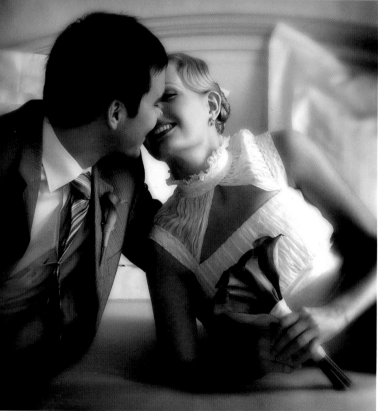

to guide the eye through the composition. The more you learn to recognize these elements, the more they will become an integral part of your compositions.

These are the keys to making a dynamic group portrait. The goal is to move the viewer's eye playfully and rhythmically through the photograph. The opposite of a dynamic image is a static one, where no motion or direction is found and the viewer simply "recognizes" (rather than enjoys) all of the elements in the photograph.

Couples. The simplest of groups is two people. Whether it's a bride and groom, mom and dad, or the best man and maid of honor, the basic building blocks call for

one person slightly higher than the other. Begin with the mouth of the lower person even with the forehead of the higher person. Many photographers recommend this "mouth-to-eyes" strategy as the ideal starting point.

Although they can be posed in parallel position, a more interesting dynamic with two people can be achieved by having them pose at 45-degree angles to each other, so their shoulders face in toward one another. With this pose you can create a number of variations by moving them closer or farther apart. (*Note:* When you have a choice—and the photographer always has a choice—position the bride closer to the camera than the groom. This keeps the [typically] smaller bride in proper perspective and allows her dress to be better seen.)

Another intimate pose for two is to have two profiles facing each other. One face should still be higher than the other, as this allows you to create an implied diagonal between their eyes, giving the portrait a sense of direction.

Since this type of image is usually made from fairly close up, make sure that the frontal planes of the subjects' faces are roughly parallel and equidistant from the camera so that you can hold focus on them both.

Adding a Third Person. A group portrait of three is still small and intimate. It lends itself well to a pyramid- or diamond-shaped composition, or an inverted triangle, all of which are pleasing to the eye. Don't simply adjust the height of the faces so that each is at a different level, turn the shoulders of those at either end of the group in toward the central person to loop the group together.

Adding a third person, you will begin to notice the interplay of lines and shapes inherent in good group design. As an exercise, plot the implied line that goes through the shoulders or faces of the three people in the group. If the line is sharp or jagged, try adjusting the composition so that the line is more flowing, with gentler edges.

Try different configurations. For example, create a diagonal line with the faces at different heights and all the people in the group touching. It's a simple yet pleasing

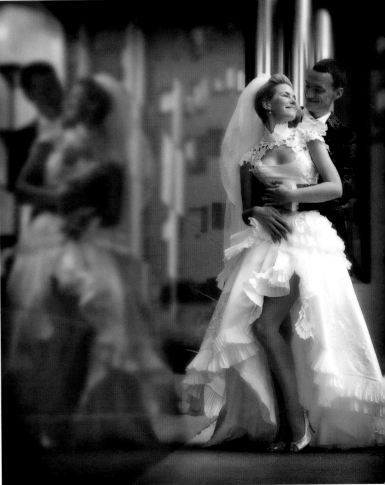

TOP—Once a prime location like this is found, it can be used for all of the formal pictures. The lighting was room light and a single Canon 580EX bounced into the ceiling. Photograph by Ben Chen. **BOTTOM**—Annika Metsla used the reflective marble to produce a secondary image of the couple. Note the bride's weight is on her back foot and her front leg is bent, creating a pleasing S-curve. The hands are intermingled so that they appear to be as one.

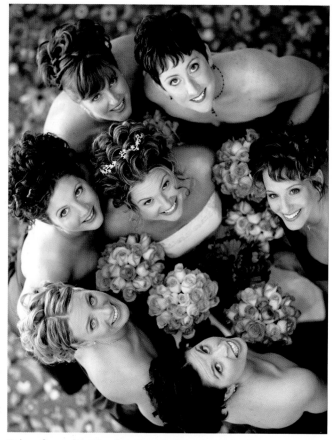

Taken from directly above, and capitalizing on the symmetry of the bouquet-like composition, Dan Doke created a beautiful portrait of the bride and her bridesmaids. Using an 85mm lens, the perspective is good and normal. With a wide-angle lens, faces this close to the frame edges would have been distorted.

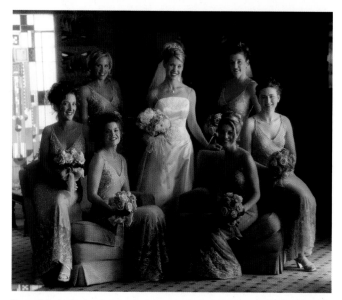

Ken Sklute is a master at posing groups. Here, the bride and bridesmaids were lit by available light from the patio doors. Two armchairs attractively seat four women, while three stand behind in a symmetrical composition. Note how the ladies seated in the armchairs are forward on the edge of the seat cushion.

design. The graphic power of a well-defined diagonal line in a composition will compel the viewer to keep looking at the image. Adjust the group by having those at the ends of the diagonal tilt their heads slightly in toward the center of the composition.

Try a bird's-eye view. Cluster the group together, grab a stepladder or other high vantage point, and you've got a lovely variation on the three-person group. It's what photographer Norman Phillips calls "a bouquet." For a simple variation, have the people turn their backs to each other, so they are all facing out of the triangle.

Adding a Fourth and Fifth Person. This is when things really get interesting. As you photograph more group portraits, you will find that even numbers of people are harder to pose than odd. Three, five, seven, or nine people seem much easier to photograph than similarly sized groups of an even number. The reason is that the eye and brain tend to accept the disorder of odd-numbered objects more readily than even-numbered objects. (*Note:* As you add more people to a group, remember to do everything you can to keep the film plane parallel to the plane of the group's faces in order to ensure that everyone in the photograph is sharply focused.)

THE ARMCHAIR AS A POSING TOOL

An armchair is the perfect posing device for photographing from three to eight people. The chair is best positioned at about 30 to 45 degrees to the camera. Regardless of who will occupy the seat, they should be seated laterally across the seat cushion on the edge of the chair—so that all of their weight does not rest on the chair back. This promotes good posture and narrows the lines of the waist and hips for both men and women.

Using an armchair allows you to seat one person, usually the man, and position the other person close to (or on) the arm of the chair, leaning on the far armrest. This puts their faces in close proximity but at different heights. A variation of this is to have the woman seated and the man standing. If their heads are far apart, you should pull back and make the portrait full-length.

With four people, you can simply add a person to the existing poses of three described above—with the following advice in mind. First, be sure to keep the eye height of the fourth person different from any of the others in the group. Second, be aware that you are now forming shapes within your composition. Think in terms of pyramids, extended triangles, diamonds, and curved lines. Finally, be aware of lines, shapes, and direction as you build your groups.

An excellent pose for four people is the sweeping curve of three people with the fourth person added below and between the first and second person in the group. Keep in mind that, while a triangle shape normally calls for three people to comprise its form, you can add a fourth and still keep the shape intact.

The fourth person can also be positioned slightly outside the group for accent, without necessarily disrupting the harmony of the rest of the group.

Six People (and Up). As your portrait groupings exceeds six people, you should start to base your overall composition on linked shapes—like linked circles or triangles. What makes combined shapes work well is to turn them toward the center. Such subtleties unify a composition and make combining visually appealing design shapes more orderly.

When adding a sixth or an eighth person to the group, the group should still retain an asymmetrical look for best effect. This is best accomplished by creating elongated, sweeping lines and using the increased space to slot in extra people.

Formals of Bigger Groups. Compositions will always look better if the base is wider than the top, so the final person in a large group should elongate the bottom of the group.

Each implied line and shape in the photograph should be designed by you and should be intentional. If the arrangement isn't logical (*i.e.*, the line or shape doesn't make sense visually), then move people around and start again.

Try to coax S shapes and Z shapes out of your compositions. They form the most pleasing shapes to the eye and will hold a viewer's gaze within the borders of the print. Remember that the diagonal line also has a great deal of visual power in an image and is one of the most potent design tools at your disposal.

IS IT POSING OR DIRECTING?

Marcus Bell first observes the bride naturally, making mental notes of what he'd like to see in his images of her. Then, if he can't replicate the nuance, he'll ask the bride to do what he saw. For instance, he might observe the bride walking with her head down, then glancing up with a smile. To get the same look, Marcus might suggest she walk, looking down. If she doesn't happen to look up, he'll simply ask her to glance up at him while she is walking—all without making her self-conscious. He will keep the flow going, but is constantly observing the nuances that occur naturally. These are the opportunities that make great pictures.

Greg Gibson, in the first half of his career, was an award-winning photojournalist. Now, he's an award-winning wedding photographer. He respects the role of the wedding photojournalist, but is not trapped by the definition. He says, "My clients are professional people; they want to enjoy their day and not be encumbered by posing for pictures. They want to record the day—of the real feelings they share with their friends and family members. My experience gives my work instant credibility. I try to take advantage of the resources at a wedding. If a bride is getting dressed in an area with bad light, I may say, 'Can we come over here and do this?' But I don't try to create moments or impose something on their day by saying, 'Let me get you and your mother hugging.' I try to let those things happen spontaneously and use my background and experience to put myself in the right position to anticipate those moments."

When asked about what kind of wedding photojournalist he is, Gibson responded, "I'm not a true fly on the wall. I interact with the client. There are two camps of photojournalists: ones who want to be totally invisible; they don't talk or interact. I'm definitely in the other camp. I laugh and joke with the client, get them to relax with my presence. We're going to spend a lot of time together and I don't want them to feel like there's a stranger in the room."

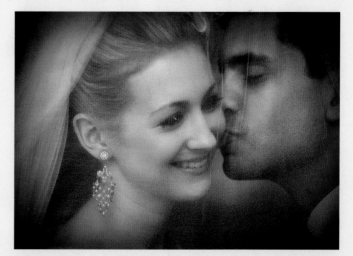

As if invisible, Greg Gibson captured this splendid moment on a wedding day. A slightly longer-than-normal lens removed him physically from the scene. The rest was just timing and intuition.

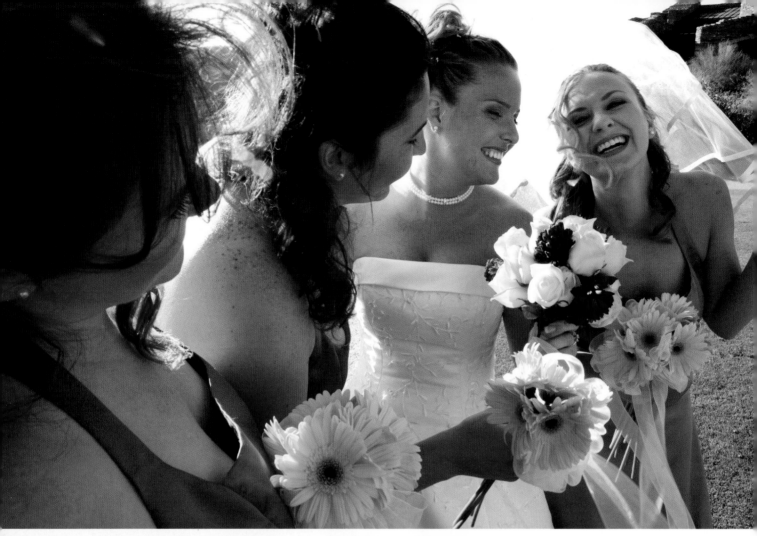

ABOVE—This is a fun group shot of a bride and her three bridesmaids done with a 17mm f/2.8 lens. The photographer, David Beckstead, likes the way wide-angles put you inside a group, especially when working close to the people. It's invariable that some distortion will occur working this close, but it's a small price to pay for the intimacy. **LEFT**—The best group photographs are often those made when the people in the group are unaware of the photographer's presence. Here the group is totally absorbed and enjoying what they are seeing. Marc Weisberg tried to alter his vantage point slightly to get the majority of faces visible. The image was shot in the RAW mode and the contrast of the image was boosted significantly in RAW processing. (Canon EOS 1D Mark III; EF 70–210mm f/2.8 lens at 95mm; $1/160$ second at f/5.6; ISO 800)

The use of different levels creates a sense of visual interest in large groups and lets the viewer's eye bounce from one face to another (as long as there is a logical and pleasing flow to the arrangement). The placement of faces, not bodies, dictates how pleasing and effective a composition will be.

Getting Everyone in the Picture. If you decide to do a huge group portrait of everyone at the wedding, make it sound fun—which it should be. The best man and ushers, as well as your assistant, can usually be enlisted to do the organizing. Have the guests put their drinks down before they enter the staging area. Try to coordinate the group so that everyone's face can be seen and the bride and groom are the center of interest. Tell the group that they need to be able to see you with both eyes to be seen in the photo.

Look for a high vantage point, such as a balcony or second-story window, from which you can make the portrait. Or you can use the trusty stepladder—but be sure someone holds it steady (particularly if you're at the very top). Use a wide-angle lens and focus about a third of the way into the group, using a moderate taking aperture to keep everyone sharply focused.

KEEPING THE CAMERA BACK PARALLEL TO THE SUBJECTS
As your groups get bigger, it is important to keep your depth of field under control. One easy solution is to raise the camera height, angling the camera downward so that the film/image-sensor plane is more parallel to the plane of the group. This does not change the depth of field that exists at that distance and lens aperture, but it optimizes the plane of focus to accommodate the depth of the group. By raising the camera height, you are effectively shrinking the depth of the group, making it possible to get the front and back rows in focus at the same time. (*Note:* A stepladder is an invaluable tool for this.) Another trick is to have the last row in a group lean in while having the first row lean back, thus creating a shallower subject plane, making it easier to hold the focus across the entire group.

An additional consideration is that lenses characteristically focus objects in a more or less straight line—but not completely straight. If you arrange your subjects in a straight line and back up so that you are far away from the group, all of the subjects will be rendered sharply at almost any aperture. At a distance, however, the subjects are small in the frame. For a better image, you must move closer to the group, making those at the ends of the group proportionately farther away from the lens than those in the middle of the lineup. Those farthest from the lens will be difficult to keep in focus. The solution is to bend the group, making the middle of the group step back and the ends of the group step forward so that all of the people in the group are the same relative distance from the camera. To the camera, the group looks like a straight line, but you have actually distorted the plane of sharpness to accommodate the group.

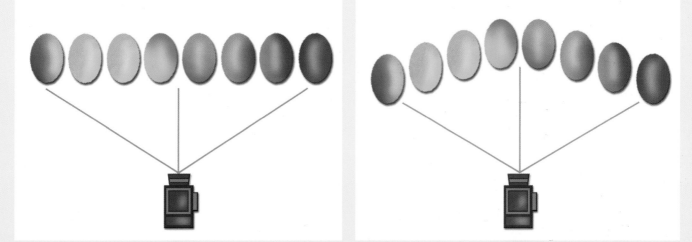

When you photograph a group in a straight line, those closest to the center of the line are closest to the lens. Those on the ends of the line are farther away from the lens. When you "bend" the group, you can make each person the same distance from the lens, thus requiring the same amount of depth of field to render them sharply. Diagram concept by Norman Phillips; diagram by Shell Dominica Nigro.

Lighting Principles

Contemporary wedding photography encompasses many different disciplines, and it is essential to be well versed in all of them. However, no pictures are more important to the bride and groom than their engagement photos and formal portraits. These significant images demand an understanding of studio portraiture, which is quite different

but related to the techniques normally employed on the wedding day.

Because of the hurried nature of the wedding day, it is sometimes impossible to give the lighting the same degree of complexity you would for a studio shoot. Fortunately, basic portrait lighting can be done with as few as two lights—and many wedding-day formal portraits are made with little more than existing light and sometimes a reflector. With the help of an assistant (and a little bit of time) you can pull off some surprisingly elegant formal portraits the day of the wedding.

BASIC PORTRAIT LIGHTING

There are five basic lights used in portrait lighting: the main and fill lights (the most important lights), the hair

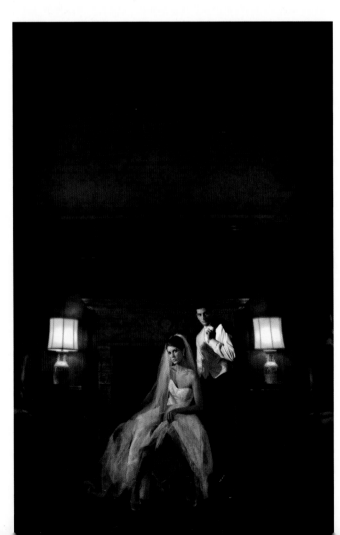

The lighting for this subtle portrait started with the two lights on either side of the couple. This gave an overall lighting value to the room. For frontal lighting the photographer used a single hot light to the couple's right. This was positioned so that it would light one side of their faces dramatically, leaving the other side in shadow. No fill light was used. Photograph by JB Sallee.

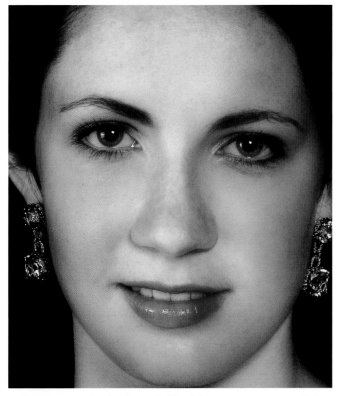

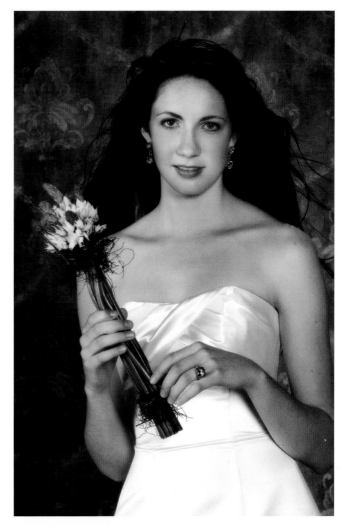

Nick Adams made this beautiful bridal portrait using a 4x3-foot softbox as a main light and two monolights behind a 6x8-foot scrim. Because this is a beauty type of lighting, where there is very little difference between the intensity of the key and fill lights, the main and fill lights were at about equal intensities on either side of the camera. Reflectors were used at either side of the bride to help redirect stray light. A monolight with beauty dish was placed about nine feet high and angled down to create an elegant hair light. In the close-up image, you can see that the light above the camera created a very subtle shadow under her nose. You can also see the positions of the lights by analyzing the catchlights (white, specular highlights) in the bride's eyes.

and background lights (optional in many cases), and a side light or kicker (often used to bring out texture or add drama to the lighting).

Most photographers opt for studio strobes—either self-contained monolight-type strobes, or those systems using a single power pack into which all lights are plugged. Some use a combination of the two types. A full system of reflectors and diffusers is required with any studio lighting system, however one should opt for portability when doing location work, such as wedding-day and reception photography.

Main Light and Fill Light. The main and fill lights should be high-intensity lights. These may be used in parabolic reflectors that are silver-coated on the inside to reflect the maximum amount of light. However, most

photographers don't use parabolic reflectors anymore. Instead, they opt to use diffused main- and fill-light sources. If using diffusion, either umbrellas or softboxes, each light assembly should be supported on its own sturdy light stand.

The fill light should be weaker than the main light—it may be a reflector or a small, diffused strobe. If using a diffused light source, such as an umbrella or softbox for a fill light, be sure that you do not create a secondary set of facial shadows. This could happen if the lights are of the same intensity. All lights, whether in reflectors of diffusers, should be "feathered" by aiming the core of light slightly away from the subject, employing the edge of the beam of light.

Hair Light. The hair light is a small light—usually a scaled-down reflector with barndoors for control. (*Note:* Barndoors are black, metallic, adjustable flaps that can be opened or closed to control the width of the beam of the light, ensuring that you light only the parts of the portrait

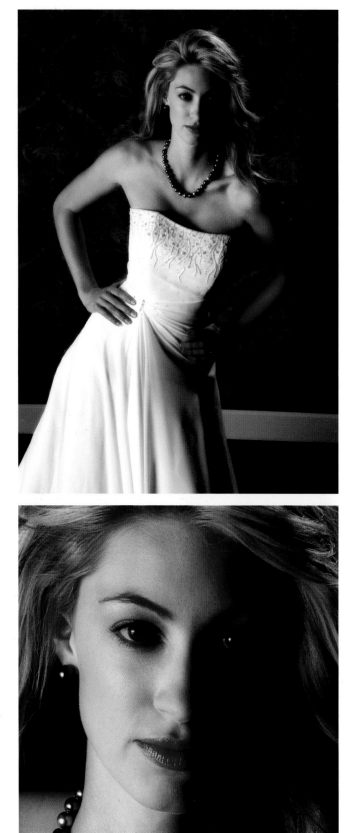

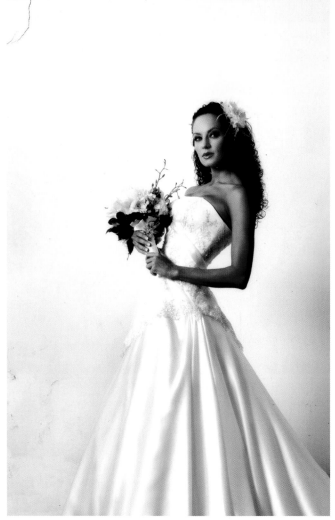

Here is a good example of short lighting, where the main light is illuminating the side of the face turned away from the camera, so that the shadow side of the face is revealed to the lens. To create this image, Nick Adams used a single softbox. The white dress and wall provided ample fill.

For this formal, Nick Adams used a softbox at head height and to the left of the camera at almost 90 degrees. He used no fill light but did use a dramatic hair light to accent the bride's lovely hair. You can see the position of the main light in the close-up image.

you want lit. They also keep stray light off the camera lens, which can cause lens flare.) Hair lights are normally used undiffused and adjusted to a reduced power setting. However, strip lights (small, narrow softboxes) are sometimes used as hair lights because of their easy mobility and the broad, diffused highlights they create.

Background Light. The background light is also a low-output light. It is used to illuminate the background so that the subject will separate from it tonally. The background light is usually used on a small stand placed directly behind the subject, out of view of the camera lens. It can also be placed on a higher stand or boom and directed onto the background from either side of the set.

Kicker Light. Kickers are optional lights that are used in much the same way as hair lights. These add highlights to the sides of the face or body to increase the feeling of depth and richness in a portrait. Because they are used behind the subject, they produce highlights with great brilliance, as the light just glances off the skin or clothing. Since kickers are set behind the subject, barn doors should be used on them to control the light.

LIGHTING TIPS FROM MAURICIO DONELLI

According to Mauricio Donelli, "To have the most spectacular and beautiful image of a bride, the most important tip is to be very, very fast—owning the situation and giving the bride the confidence to be beautiful in front of your lens. If you lose control and spend too much time, you will freeze everything and will lose the perfect image, the perfect moment.

"I use the D2X and the Leaf back 28 for the Mamiya—and I don't work with too much artificial light. Also, if most of the situations are being taken at night, the fact is that I work a lot with very slow shutter speeds. This gives a good mix between the flash and the ambient light present. Also, you can work with the single lights that you find in ceilings and walls, placing them behind the subject to give the effect of warmth and depth.

"Sometimes we don't need to use a lot of light. It is most important to have a good and light tripod with you, and also to have one or two flashes but out of view from the camera. Also, it is good to have one or two assistants working around the subject with flashes. Of course, you will need to trigger them from the camera with radio-controlled devices. They work effectively and are very handy to use with a flash on a monopod. Also, it is important to have a decent-size reflectors (LiteDiscs) to reflect light back onto your subject's shadow areas.

"I never use generators. Most weddings always take place in hotels or homes—but even when they do the wedding in an open area and put up tents, they need to have light. I always ask to the wedding coordinators to have two or three plugs for my monolights inside the tent. I never use more than one, but I travel with two, so if one goes bad I have the second one.

"Much of the time, the pictures are taken with natural light and filled with mobile flash from the camera. I prefer the Metz 60-CT4 series. They are the best I've used for this type of fill."

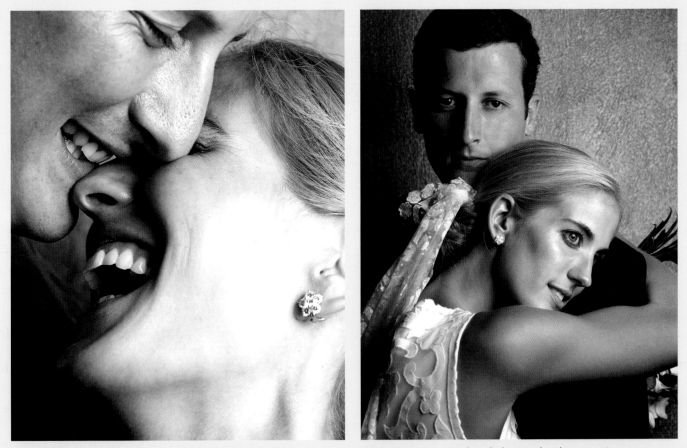

With a single monobloc strobe in a round softbox positioned close to the bride and groom by a light stand or by an assistant, you can create diverse, wonderful images in a very quick time, per the recommendations of photographer Mauricio Donelli, who brings a small complement of strobes and light modifiers to his weddings. He also brings assistants to set the lights and move them from location to location.

Loop lighting is an intermediate pattern between butterfly and Rembrandt lighting. The main light is high and to one side of the model's face, but not as high as in the butterfly pattern, nor as low as in the Rembrandt pattern. Here no fill light was used in order to keep the light dramatic. Photograph by JB Sallee.

BROAD AND SHORT LIGHTING

There are two basic types of portrait lighting: broad lighting and short lighting.

Broad lighting means that the main light is illuminating the side of the face that is turned toward the camera. Broad lighting is used less frequently than short lighting because it flattens and de-emphasizes facial contours. It is often used to widen a thin or long face.

Short lighting means that the main light is illuminating the side of the face turned away from the camera. Short lighting emphasizes facial contours and can be used to narrow a round or wide face. When used with a weak fill light,

short lighting produces a dramatic effect with bold highlights and deep shadows.

BASIC PORTRAIT LIGHTING SETUPS

While it may prove difficult or even impossible to replicate any one of the five basic portrait lighting setups on the day of the wedding, it is still a good idea to know what they are and how to achieve them. Each of the lighting patterns takes its personality from the placement of the main light. The concept of single-source lighting is important. The sun is the primary light source in all of nature; all other light sources are subordinate to it. This is the rule of the main light in the studio; like the sun, it is the single light to which any other lights are subordinate.

Paramount Lighting. Paramount lighting, sometimes called butterfly lighting or glamour lighting, is a lighting pattern that produces a symmetrical, butterfly-shaped shadow directly beneath the subject's nose. It emphasizes cheekbones and good skin. It is generally not used on men because it tends to hollow out cheeks and eye sockets too much.

For this style, the main light is placed high and directly in front of the subject's face, parallel to the vertical line of the subject's nose. Since the light must be high and close to the subject to produce the wanted butterfly shadow, it should not be used on women with deep eye sockets, or very little light will illuminate the eyes. The fill light is placed at the subject's head height directly under the main light. Since both the main and fill lights are on the same side of the camera, a reflector must be used opposite these lights and in close to the subject to fill in the deep shadows on the neck and shaded cheek.

The hair light, which is always used opposite the main light, should light the hair only and not skim onto the face of the subject. The background light, used low and behind the subject, should form a semi-circle of illumination on the seamless background (if using one) so that the tone of the background grows gradually darker toward the edges of the frame.

Loop Lighting. Loop lighting is a minor variation of Paramount lighting. The main light is lowered and moved more to the side of the subject so that the shadow under the nose becomes a small loop on the shadow side of the face. This is one of the more commonly used lighting setups and is ideal for people with average, oval-shaped faces.

The fill light is moved to the opposite side of the camera from the main light in loop lighting. It is used close to the camera lens. In order to maintain the one-light character of the portrait, it is important that the fill light not cast a shadow of its own. To determine if the fill light is doing its job, you need to evaluate it from the camera position. Check to see if the fill light is casting a shadow of its own by looking through the viewfinder.

In loop lighting, the hair light and background lights are used the same way they are in Paramount lighting.

Rembrandt Lighting. Rembrandt or 45-degree lighting is characterized by a small, triangular highlight on the shadowed cheek of the subject. It takes its name from the

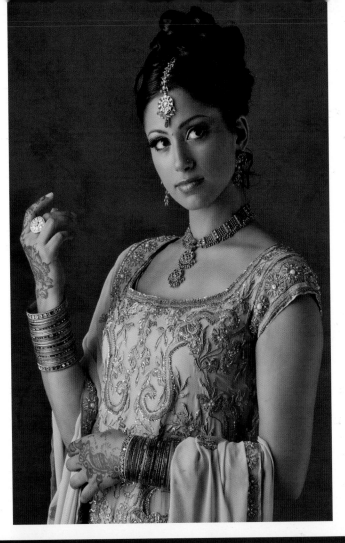

RIGHT—This is a beautiful image made with a single softbox and no fill. The lighting is true Rembrandt-style with a perfect triangular highlight on the shadow side of her face. Note, too, the elegant posing of the hands. Photograph by Cherie Steinberg Coté.
BELOW—This stunning night portrait by Nick Adams illustrates both Rembrandt lighting (note the diamond-shaped highlight on the shadow side of the face) and broad lighting, in which the side of the face turned toward the camera is illuminated. Adams used a softbox for the main light and a hair light to illuminate the bride's hair and veil. Notice the difference in intensity between the main light and the hair light. In order to record background detail at night, Nick slowed the shutter speed to $3/10$ second. The taking aperture was f/7.1.

TOP—Cherie Steinberg Coté photographed this unusual bridal veil, and hat. Because of the size of the hat, the rounded softbox was lowered to a little above face height, producing a hybrid split lighting. The close proximity and softness of the light caused the light to wrap around the contours of the bride's face with no shadow edges. BOTTOM—The position of the main light and the turn of the head dictates the type of lighting pattern that will be produced. In this exceptional image by Dan Doke, the bride was lit with a modified profile-lighting pattern. The head was not fully turned in the traditional profile pose and, as a result, the main light is not a true backlight, although it is behind the bride.

famous Dutch painter who used window light to illuminate his subjects. This lighting is dramatic and more often used with masculine subjects. Rembrandt lighting is often used with a weak fill light to accentuate the shadow-side highlight.

For Rembrandt lighting, the main light is moved lower and farther to the side than in loop and Paramount lighting. In fact, the main light comes almost from the subject's side, depending on how far his or her head is turned away from the camera.

The fill light is used in the same manner as it is for loop lighting. The hair light, however, is often used a little closer to the subject for more brilliant highlights in the hair. The background light is in the standard position.

With Rembrandt lighting, kickers are often used to delineate the sides of the face. As with all front-facing lights, avoid shining them directly into the lens. The best way to check for this is to place your hand between the subject and the camera on the axis of the kicker. If your hand casts a shadow on the lens, then the kicker is shining directly into the lens and should be adjusted.

Split Lighting. Split lighting occurs when the main light illuminates only half the face. It is an ideal slimming light. It can also be used with a weak fill to hide facial irregularities. Split lighting can also be used with no fill light for dramatic effect.

In split lighting, the main light is moved farther to the side of the subject and lower. In some cases, the main light may be slightly behind the subject, depending on how far the subject is turned from the camera. The fill light, hair light, and background light are used normally for split lighting.

Profile or Rim Lighting. Profile or rim lighting is used when the subject's head is turned 90 degrees away from the camera lens. It is a dramatic style of lighting used

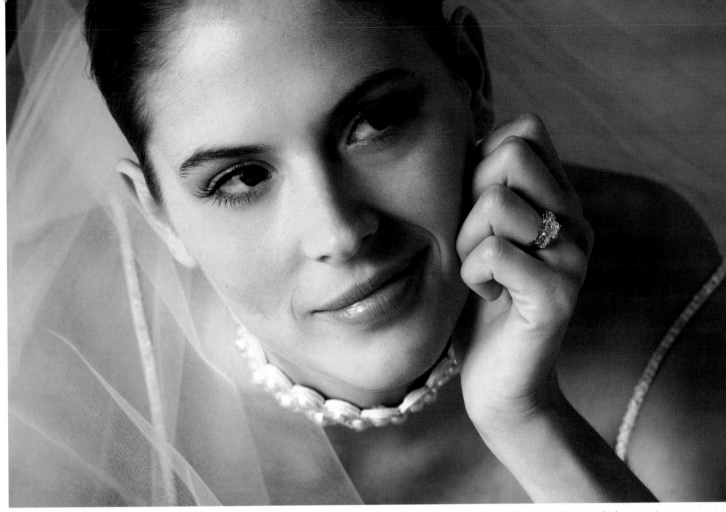

Feathering the light can produce dynamic highlights. Here, a softbox was used close to the bride as a directional beauty light, creating a soft effect. Feathering the light away from the bride allowed the photographer to use the more dynamic edge of the light. Note the beautiful highlight brilliance (specular highlights within a large highlight area). Photograph by Cherie Steinberg Coté.

to accent elegant features. It is used less frequently now than in the past, but it is still a stylish look.

In rim lighting, the main light is placed behind the subject so that it illuminates the profile of the subject and leaves a polished highlight along the edge of the face. The main light will also highlight the hair and neck of the subject. Care should be taken so that the accent of the light is centered on the face and not so much on the hair or neck.

The fill light is moved to the same side of the camera as the main light and a reflector is used to fill in the shadows. An optional hair light can be used on the opposite side of the main light for better tonal separation of the hair from the background. The background light is used normally.

ADAPTING THE FORMAL LIGHTING PATTERNS TO SUIT THE SITUATION

While the basic lighting patterns do not have to be used with absolute precision, it is essential to know what they

are and how to achieve them. If, for instance, you are photographing your bride and groom outdoors, you can position a single main light to produce the desired lighting pattern and ratio, then use the ambient light (shade or backlighting) as the fill light. No other lights are needed to produce every one of the five basic portrait lighting setups. The use of reflectors, instead of an independent fill light or kickers, may accomplish much the same results in terms of controlling light.

You can also create an elegant profile of the bride with a single flash used as a backlight, outlining the edges of her face, neck, and the wedding veil. With the daylight as fill, only one light is required to produce an elegant, classically lit portrait.

DOUBLE SHADOWS AND CATCHLIGHTS

The fill light can pose its own set of problems. If it is too close to the subject, the fill light will produce its own set of specular highlights that show up in the shadow area of

A SPECIAL GROUP PORTRAIT

Marc Weisberg shot this image late in the day as the sun was slipping away. The shadows that appear are actually from his Quantum flash, which was mounted with a Bogen quick-release plate on a Bogen tripod to camera left. "Instead of using a light meter, which I use now for my large-group portraits to nail the exposure, I used my more expensive light meter: my Canon 1-D," says Mark. He set the camera to manual, then dialed in the exposure while looking (at the meter scale) through the viewfinder. He then shot a test image to make

sure that he was not clipping the shadows or highlights. "Then I set my Quantum flash one stop under, a trick I learned this from Monte Zucker, and metered the flash output with my Sekonic L508 light meter," continues Mark. "Pocket Wizards (I love these things) were used to trigger my Quantum flash at about f/4.0. I now use a Sekonic L358 with the built-in Pocket Wizard chip to fire my flashes and read ambient and flash output."

In postproduction, the saturation was selectively enhanced in Photoshop and the LucisArt filter was used with a mask.

"Since this filter wreaks havoc on the skin, a mask was created so that I could selectively apply the effects to the dress, bringing out the delicate folds, and to the shoes and tuxedos, to bring out the highlights better. I also used the LucisArt filter with a mask to bring out texture details in the walls, terra cotta tiles, and plants," says Mark. (Canon 1-D; 17–35mm f/2.8 L lens; 1/60 second at f/5.7)

the face, making the skin appear excessively oily. To solve the problem, move the camera and light back slightly or move the fill light laterally away from the camera slightly. You might also feather the light into the camera a bit. This method of limiting the fill light is preferable to closing down the barn doors to lower the intensity of the fill light.

The fill light often creates second set of catchlights (small specular highlights) in the subject's eyes. This gives the subject a directionless gaze, so it is usually removed later in retouching. When using a large diffused fill light, there is usually not a problem with dual catchlights. Instead, the fill produces a large, milky highlight that is much less objectionable.

LIGHTING RATIOS

The term "lighting ratio" is used to describe the difference in intensity between the shadow and highlight sides of the face. It is expressed numerically as a ratio: 2:1, 3:1, etc. In the studio, one can control the lighting ratio precisely; in

the field, however, your goal should not be to create a specific ratio like 3:1, it should be more general. Ask yourself, "Is there detail in both important highlight and shadow areas?" or "Are the shadow areas too dark and lifeless?" These make lighting ratios a practical consideration.

One of the tools a professional should have at every wedding is an incident flashmeter, which also measures ambient light. From the subject position, you can measure the highlight side of the face separately from the shadow side of the face, thus determining the difference between the two and the effective lighting ratio. With digital, you can also inspect the lighting by firing a few test frames. This is particularly valuable if using strobe, where you cannot see the result with the naked eye.

It doesn't matter if your main light is strobe and your fill light is ambient room light; when determining ratios, it is all about light intensity. In a 2:1 lighting ratio, the main and fill light sources are the same intensity. A 3:1 lighting ratio is produced when the main light is one stop

greater in intensity than the fill light. In a 4:1 ratio, the main light is 1½ stops greater in intensity than the fill light. In a 5:1 ratio, the main light is two stops greater than the fill light.

OVERLIGHTING

When setting the lights, it is important that you position the lights gradually, studying their effect as you use more and more light on the subject. If you merely point the light directly at the subject, you will probably overlight the person, producing pasty highlights with no detail. The highlights, when properly brilliant, will have minute specular (pure white) highlights within the main highlight. This further enhances the illusion of depth in a portrait.

Adjust the lights carefully, and observe the effects from the camera position. Instead of aiming the light so that the core of light strikes the subject, feather the light so that you employ the edge of the light on the subject. Sometimes feathering alone won't make the skin "pop" (show highlight brilliance) and you'll have to make a lateral adjustment to the light or move it back from its current position. A good starting position for your main light is eight to twelve feet from the subject.

STUDIO LIGHTING ON LOCATION

One of the great advantages of working in a studio, as opposed to working on location, is that you can adjust the ambient light level of the studio to a low level, thus making the studio lighting dominant. On location, you must deal with the location lighting, which occurs at much higher levels than you would prescribe for the studio.

For example, imagine a courtyard where the main light is diffused daylight coming in through an archway or doorway. Your ambient fill level would be very low, as there may be no auxiliary light sources nearby. Unless your goal was to produce high-contrast lighting (not great for brides), you would need to raise the level of the ambient or fill light. This might be accomplished locally (*i.e.*, on the subject via a silver reflector), or it might be accomplished more universally by raising the overall interior light level by using ceiling-bounce strobes. This solution would allow you to shoot in a number of areas within the location, not just the one closest to the archway. The point of

the illustration is that you must be able to react to the lighting situation with the tools at your disposal.

The challenges of working with outdoor and mixed lighting will be the subject of our next chapter.

A strong backlight rims the bride and the gentlemen hoisting her chair in the air. Bruce Dorn used the light to best advantage and increased his exposure level to capture the shadow side of the event. The net effect blew out the highlights, but this shot is still a huge success because of its spontaneity. It's a good example of reacting quickly to what light you have to work with. Dorn also softened the background in Photoshop, making it look almost misty.

Outdoor and Mixed Lighting

Weddings are photographed in almost every kind of light you can imagine—open shade, bright sun, dusk, dim room light, and every combination in between. Savvy wedding photographers must feel at home in all these different situations and know how to get great pictures in them. Their ability to work with outdoor lighting is really what separates the good wedding photographers from the great ones. Learning to control, predict, and alter these various types of light will allow the photographer to create great wedding pictures all day and all night long.

LOCATION LIGHTING EQUIPMENT

Reflectors. It is a good idea to take a selection of portable light reflectors to every wedding. Reflectors should be fairly large for maximum versatility. Light discs, which are reflectors made of fabric mounted on flexible and collapsible circular frames, come in a variety of diameters and are a very effective means of providing fill-in illumination. They are available from a number of manufacturers and come in silver (for maximum fill output), white, gold foil (for a warming fill light), and black (for blocking light from hitting a portion of the subject). In most instances, an assistant is required to position and hold the reflector for maximum effect.

When the shadows produced by the main light are harsh and deep, you can use a large reflector (or several reflectors)

The Spanish-style portico is like window lighting on steroids. You get the benefits of intensity, directionality and softness, without the need for long shutter speeds. Here, Bruce Dorn took advantage of light quality and intensity to create an action portrait that is truly priceless. He further worked the image in Painter and Photoshop to create a genuine work of art.

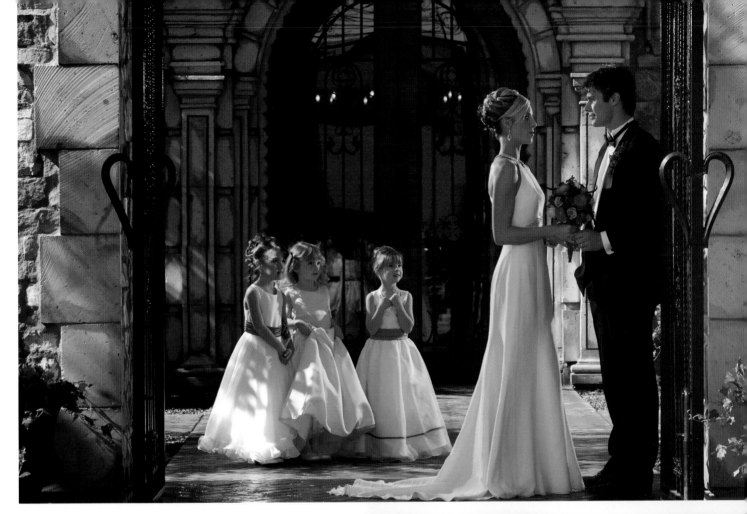

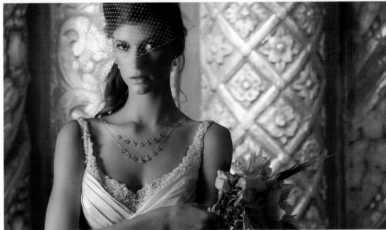

ABOVE—Bruce Dorn is a master at mixing light sources on location. Here he began by leveling the camera on a tripod so that the image would be architecturally pure. The main light is the low-angled sunlight from camera left. Some fill comes from sunlight bounced from the warm-toned stone; more fill comes from reflectors. Additional backlight (from camera right) is used to rim light the bride and little girls. It is the superb mix of light that makes this image work. **RIGHT**—This image, taken at The Orpheum Theatre in Phoenix, AZ, features one of Bruce Dorn's favorite continuous light sources: the Frezzi Mini-Fill. Dorn notes the light is compact but robust and uses full-spectrum, color-correct bulbs identical to those used to illuminate art in gallery presentations. Here, the Frezzi was equipped with a 100-watt, 3200-degree Kelvin (tungsten) semi-spot PAR-style lamp. An optional flip-down dichroic filter can be added to convert the tungsten-balanced lamp to daylight, but photographers on a budget can substitute a 50-watt 4700-degree Kelvin lamp at considerably less expense. This image was created using two Frezzis—one above and to the left, to create a Rembrandt lighting pattern on the bride, and another on the background, to add dimensionality and separation.

to provide fill. With foil-type reflectors used close to the subject, you can sometimes even overpower sunlight from behind the subject, creating a flattering main light.

Be careful about bouncing light in from beneath your subjects. Lighting coming from under the eye/nose axis is generally unflattering. Try to "focus" your reflectors (this really does require an assistant), so that you are putting light only where you want it.

Electronic Flash. On-camera flash is often used outdoors—especially with TTL-balanced flash-exposure systems. With such systems, you can adjust the flash output for various fill-in ratios, thus producing consistent exposures. In these situations, the on-camera flash is most frequently used to fill in the shadows caused by the daylight, or to match the ambient light output in order to provide

direction to the light (see pages 83–84 for more on this subject).

Beyond these specific situations, on-camera flash is used sparingly because of the flat, harsh light it produces. As an alternative, many photographers use flash brackets, which position the flash over and away from the lens, thus minimizing flash red-eye and dropping the harsh shadows

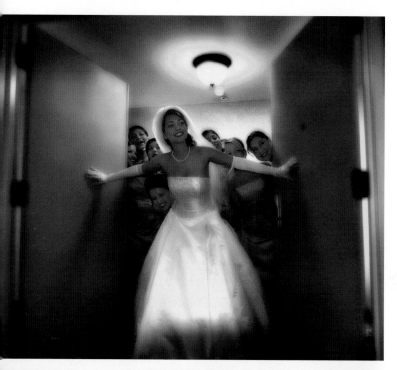

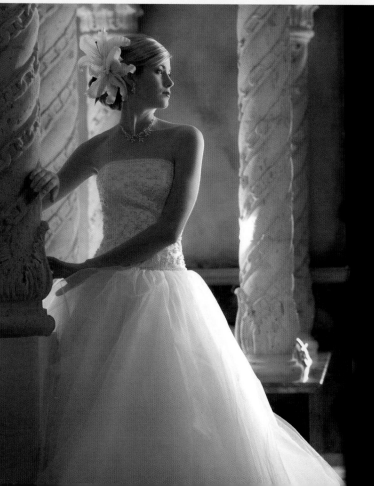

behind the subjects—a slightly more flattering light. Others prefer to bounce the flash, a technique that will be looked at in greater detail on pages 84–85.

The latest development in electronic flash is a device Nikon calls the SU-800 Wireless Speedlight Commander. This enables you to wirelessly coordinate the independent operation of two groups of Nikon Speedlights in close-up mode, or three groups (A, B, C) of compatible Speedlights in commander mode. In either mode, the commander manages the flash output with exceptional precision, automatically delivering the light level dictated by the camera's metering systems and supporting automatic balanced fill-flash with compatible cameras. (*Note:* The Nikon D200 features a built-in flash commander that allows the on-board flash to control the output of two groups of flash units remotely to a distance of 66 feet.)

In use, the Commander is remarkable because you can easily control the output and ratio between flashes and verify the results on the camera's LCD. With an assistant or attendee helping you, you can easily light scenes with multiple flash and control the output of each flash so that you can photograph groups at the reception—or special moments like the first dance or cake cutting—with sophisticated TTL flash lighting.

Mike Colón carries a small arsenal of Nikon SB-800 AF speedlights to every wedding. "I've been setting them up strategically around the dance floor at my weddings for a dramatic backlight or using them for my table shots to get a natural look," he says. "I'll throw some light on the table from behind with one of the SB-800s, and have an SB-800 on the camera, but powered down to minus two or

TOP—As you can see, the main light source in this image was an incandescent hall light, which photographer Jerry D let warm the scene by his choice of a daylight color balance. He used a bounce flash near the camera position to light the bride but he did not overpower the lighting. He actually underexposed the flash a bit to let the room light overpower the flash. He softened the image in Photoshop to produce a dynamic shot of the bride and her attendants. **BOTTOM**—Bruce Dorn created this stunning bridal portrait with a Westcott Spiderlite TD5 equipped with five 5500K daylight fluorescent coils in a 36x48-inch softbox. Even though the Spiderlite's fluorescents are on the warm side, Dorn decided to warm the light further by adding a ½ CTO gel filter to the softbox, warming the output by about 1000K. With the light placed slightly behind his bride, Dorn asked his assistant to position a Westcott Natural Reflector close to the bride to kick in some much-needed light for the overall exposure.

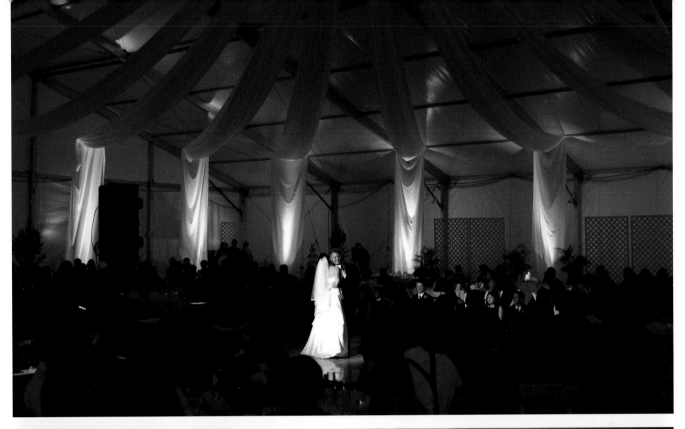

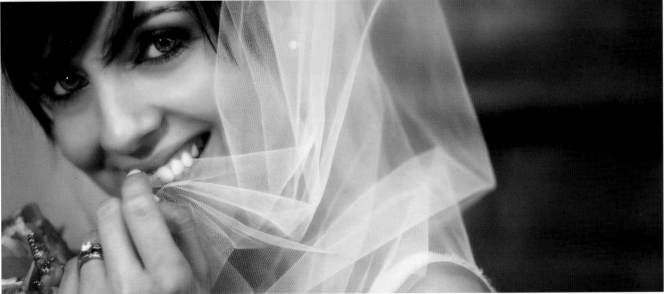

TOP—Mike Colón takes advantage of the tinted tent lighting of the reception and uses two remotely fired Nikon SB-800 AF Speedlights to light the bride and groom in their first dance. BOTTOM—Sometimes small light sources are needed on wedding day to either add a little sparkle to the eyes, or to produce a bit of a lighting pattern. In this instance, a small strobe held above and to the right of the bride did both. Photograph by Noel del Pilar.

three stops so it looks almost like the ambient light in the room is hitting the table from the front. If you took out the backlight and shot by available light only, it would look very flat. The backlighting from the Speedlights makes the image pop."

Barebulb Flash. Perhaps the most frequently used handheld flash at weddings is the barebulb flash. These units are powerful and use, instead of a reflector, an upright mounted flash tube that is sealed in a plastic housing for protection. Since there is no reflector, barebulb flash generates light that goes in all directions. It acts more like a large point-source light than a small portable flash. Light falloff with bare-bulb is less than with other handheld units, and these units are ideal for flash-fill situations.

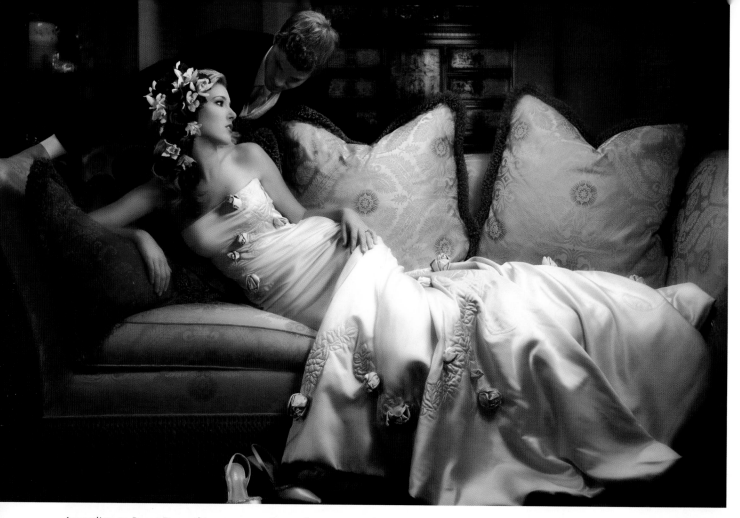

According to Bruce Dorn, this scene was the perfect opportunity to use a nifty little 12-volt Sun-Gun. With the appropriate diffusion, this setup is really quite simple and direct. Most Sun-Guns are based around 20- to 100- watt projector lamps and their undiffused beams are, according to Dorn, "almost universally nasty." He always uses a mini-softbox or adds a layer of Lee Filters' No. 261 Full Tough Spun to improve the light's character. While there are a variety of brands to chose from, he prefers the dimmable Frezzi Mini-Fill units, which he uses with either 100-watt (3200K) or 50-watt (4700K) lamps. Dorn says to keep in mind that when you dim tungsten light sources the color temperature will plummet as quickly as the output. He also suggests feathering the edges of the light onto your subject. Dorn usually starts by wasting some of the illumination well out in front of the face, then slowly panning the beam back toward the subject until he likes both the look and the intensity.

These units are predominantly manual, meaning that you must adjust their intensity by changing the flash-to-subject distance or by adjusting the flash output. Many photographers even mount a sequence of barebulb flash units on light stands at the reception for doing candids on the dance floor.

Studio-Flash Systems. You may find it useful to have a number of studio flash heads with power packs and um-brellas (see pages 76–77). You can set these up for formals or tape the light stands to the floor and use them to light the reception. Either way, you will need enough power (at least 50 watt-seconds per head) to light large areas or allow you to work at small apertures at close distances.

The most popular of these lights is the monolight type, which has a self-contained power pack and usually has an on-board photo cell that triggers the unit to fire when it senses a flash burst. All you need is an electrical outlet and the flash can be positioned anywhere. Be sure to take along

plenty of gaffers' tape and extension cords. Tape everything in position securely in order to prevent accidents.

Handheld Video Lights. David Williams uses small handheld video lights to augment existing light at a wedding. He glues a Cokin Filter holder to the front of the light and places a medium blue filter (025 Cokin) in it. The filter brings the white balance back from tungsten to about 4500K, which is still slightly warmer than daylight. It is the perfect warm fill light. If you want a warmer effect, or if you are shooting indoors with tungsten lights, you can remove the filter.

These lights sometimes have variable power settings. Used close to the subject (within ten feet) they are fairly bright, but can be bounced or feathered to cut the intensity. David uses them when shooting wide open, so they are usually just used for fill or accent.

The video light can also be used to provide what David calls a "kiss of light." He holds the light above and to the side of the subject and feathers the light back and forth while looking through the viewfinder. The idea is to produce just a little warmth and light on something that is backlit or lit nondescriptly.

Sometimes, he will use an assistant to hold two lights, which cancel out the shadows of one another. Alternately, he can combine these in a flash-bracket arrangement with a handle. His video light has a palm grip attached to the bottom to make it more maneuverable when he has a camera in the other hand.

Perhaps the most useful video lights come from Lowel Light, a video and hot-light manufacturer. Lowel's 100-watt dimmable iD light, which is ultracompact, does not get too hot to manage and is ideal for handholding when

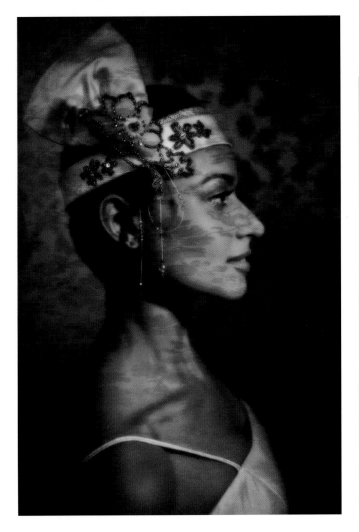

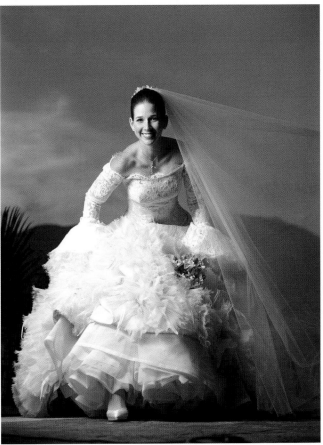

LEFT—Yervant often uses handheld video lights to illuminate subjects in dimly lit areas. He'll use an assistant to hold the light and feather its beam to attain dynamic lighting. Here, he also used a layered pattern in postproduction to give the image a 1920s iconic look. **RIGHT**—One of the ways to deal with sunlight is to overpower it, as was done here by Mauricio Donelli. He used a closely placed softbox to overpower the daylight reading by about one and a half f-stops so that he could create a defined lighting pattern with the diffused strobe. Mauricio always packs at least two battery-powered, self-contained units for moments like this.

Nick Adams made these two photos only minutes apart on the beach in Encinitas, CA. The vertical image was actually shot in front of a cliff, although it looks like an adobe wall. It was shot with natural light when the sun was close to the horizon. The light, from behind Nick and to his left, was filtered through a foggy haze. The horizontal image of the same bride with her new husband was shot just eight minutes earlier. That little bit of time, however, made the light in the vertical image cooler and less intense—more diffuse. Nick shot square to the cliff to make it backdrop-like, used a longer focal length lens (105mm equivalent) to compress the scene, and cranked the contrast way up in Photoshop to give it good separation. He also blurred the piles of seaweed in the foreground and other parts of the image.

your other hand is holding a camera. Barndoors are part of the kit and the light is crisp, bright, and—more importantly—easily feathered to produce the desired on-location lighting effect.

Umbrellas. Often, you will need to light an area, such as the dance floor or a dais at a reception. Stationary um-

brellas that are "slaved" to your camera or on-camera flash are the ideal way to accomplish this. It is important to securely tape all cords and stands to the floor in as inconspicuous a manner as possible to prevent anyone from tripping over them. Once positioned, you can adjust the umbrellas so that you get even illumination across the area.

For best results, umbrellas need to be focused so that the full amount of strobe light hits the full surface of the umbrella. If the umbrella is too close to the strobe, much of the beam of light is focused in the center portion of the umbrella, producing light with a "hot-spot" center. If the strobe is too far away from the umbrella surface, the beam of light is focused past the umbrella surface, wasting a good amount of light. Umbrellas also need to be feathered to maximize the coverage of the umbrella's beam of light. If you aim a light source directly at the area you want illuminated then meter the light, you'll find that it is falling off at the ends of the area—despite the fact that the strobe's modeling light might trick you into thinking that the lighting is even throughout. Feathering the light past the area you want illuminated will help more evenly light your

scene because you are using the edge of the light. Another trick is to move the light source back so that it is less intense overall but covers a wider area.

WORKING WITH THE AVAILABLE LIGHT

There are many occasions when the available light cannot really be improved; there are others in which it will need to be augmented, adjusted, or overwhelmed. Learning to evaluate lighting levels and patterns, both inside and out, will help you be become more advanced and refined in your approach. The following are some available-light situations you are likely to encounter when photographing a wedding.

Direct Sunlight. Sometimes you are forced to photograph wedding groups in bright sunlight. While this is not

RIGHT—Emin Kuliyev likes to pose his couples on the streets of New York, where the skyscrapers produce great light—although in diminished quantity. This image was made at $^1/_{500}$ second at f/1.6 at ISO 400. Emin likes to work near wide-open with his fast telephotos in order to blur the backgrounds as well as to produce halation in the background street lights. **BELOW**—This image was made using the last few rays of direct sunlight. You can see that the light is parallel to the horizon but produces a beautiful and diffuse lighting pattern. In another few minutes, that direct light would be gone and the color temperature would have changed drastically. Photograph by Emin Kuliyev.

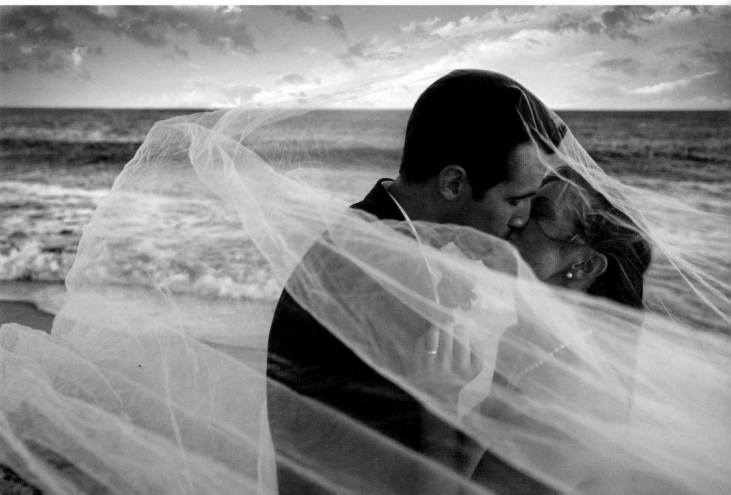

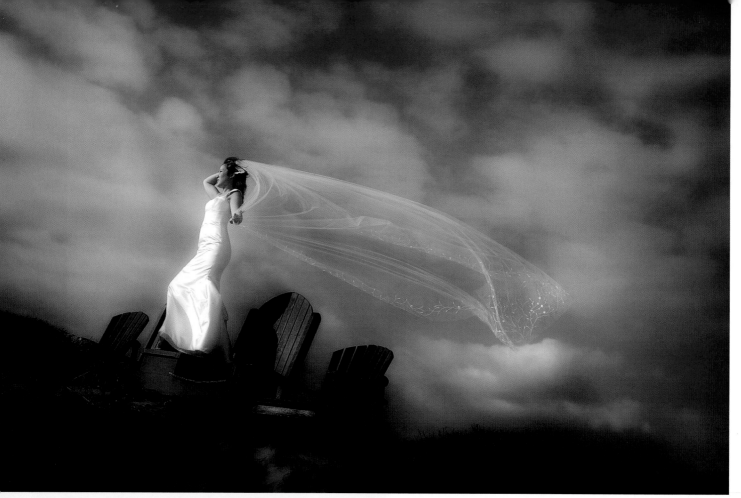

ABOVE—Joe Photo counted on the brilliant contrast of a low sun to make this stunning portrait of his bride. He filtered the image extensively in postproduction and selectively darkened areas that robbed attention from the bride. Joe faced the bride into the sun and wind in order to create a nice lighting pattern on her face and gown, and to make the veil billow in the breeze. **LEFT**—Sometimes wedding photographers are forced to work by midday sunlight, as was the case here. From the camera position, Gordon Nash fired a strobe that was slightly less powerful than the daylight in order to counteract the direct, overhead sunlight. (Nikon D200; 12–24mm f/4.0 lens)

the best scenario, it is still possible to get good results. Begin by turning your subjects so the direct sunlight is backlighting or rim lighting them. This negates the harshness of the light and prevents your subjects from squinting. To avoid creating a silhouette, you'll need to add strobe or reflected light on the front of the subject(s) and be careful not to underexpose the images. In backlit portraits, it is best to overexpose by ⅓ to ½ stop in order to "open up"

the skin tones. As usual, it is best to use the handheld incident meter in these situations. Shield the meter from any backlight, so you are only reading the light on the faces. Alternatively, take a test exposure, verify it on the camera's LCD screen, and adjust accordingly.

If the sun is low in the sky, you can use cross lighting to get good modeling on your subjects. You must be careful to position the subjects so that the sun's side lighting does not hollow out the eye sockets on the highlight sides of their faces. Subtle repositioning will usually correct this. You'll need to use fill light on the shadow side to preserve detail. Try to keep your fill-flash output about ½ to one stop lower than your daylight exposure.

Images made in bright sunlight are unusually contrasty. To lessen that contrast, try using telephoto lenses or zooms, which have less inherent contrast than shorter, prime lenses. If shooting digitally, you can adjust your contrast preset to a low setting or shoot in the RAW mode, where you can fully control the image contrast during RAW processing.

Open Shade. Open shade is soft light that is reflected from the sky on overcast days. It is different than the shade created by direct sunlight blocked by overhead obstructions, such as trees or buildings. Open shade can be particularly harsh, especially at midday when the sun is directly overhead. In this situation, open shade takes on the same characteristics as overhead sunlight, creating deep shadows in the eye sockets and under the noses and chins of the subjects. Open shade can, however, be tamed and made useful by finding an overhang, like tree branches or a porch, which blocks the overhead light but allows softer light to filter in from the sides, producing direction and

THE DIRECTION OF THE LIGHT

Even experienced photographers sometimes can't tell the direction of the light in open shade, particularly in mid-morning or mid-afternoon. A simple trick is to use a piece of gray or white folded card—an index card works well. Crease the card in the middle to form an open V shape. Hold the card vertically with the point of the V pointed toward the camera, then compare the two sides of the V. The card will tell you if the light is coming from the right or left and how intense the ratio between the highlight and shadow areas is. Held with the fold horizontal and pointed toward the camera, the card will tell you if the light is vertical in nature (coming from above). Sometimes, using this handy tool, you can gauge when a slight adjustment in subject or camera position will salvage an otherwise unusable background.

contouring on the subject. This cancels out the overhead nature of the light and produces excellent modeling on the faces.

As a top photojournalist, Cliff Mautner has learned to milk the last few seconds of great light from the day. Here Cliff recorded his bride and groom in the last rays of direct sunlight. His exposure was $^1/_{1000}$ second at f/2.8 with a 70–200mm f/2.8 lens and a Nikon D3 set to ISO 160.

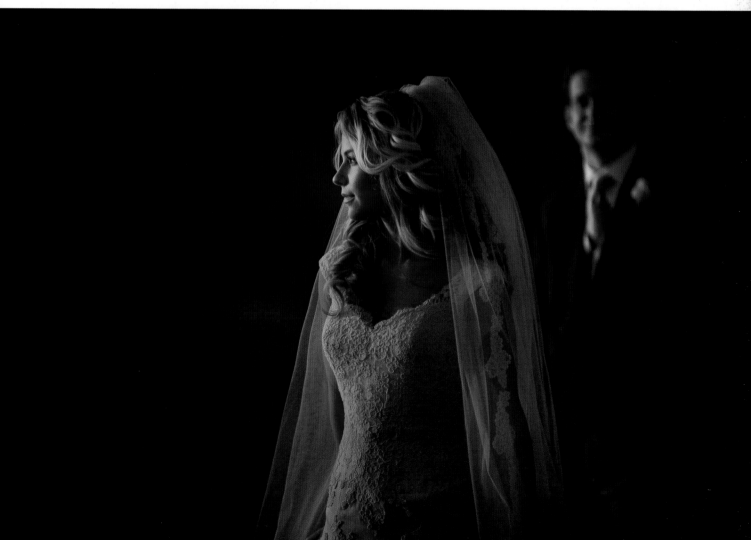

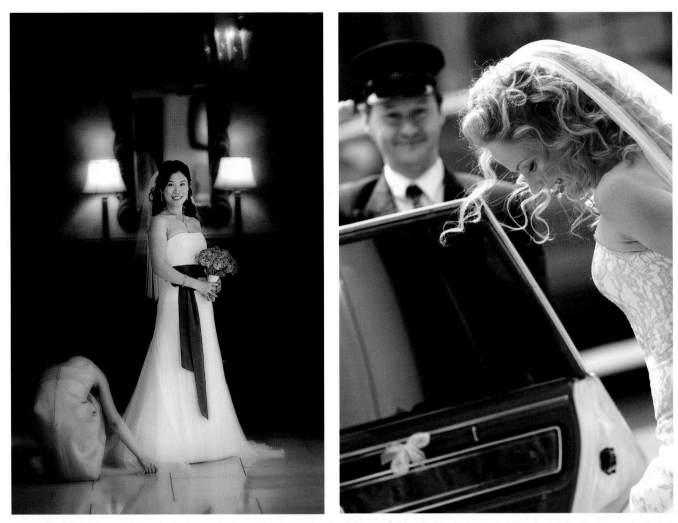

LEFT—Window light produces soft elegant light, which is perfect in this scene for a full-length portrait of the bride. Joe Photo included one of the bridesmaids for a little different look to the portrait. He also included room lights, exposed properly, to give the scene depth and the room warmth. **RIGHT**—You can see the lighting here is mid-day sun. The photographer biased the exposure toward the skin tones by overexposing slightly. See how the hair and veil are overlit and slightly overexposed. This gives a better exposure to the skin tones. Also, there is fill light from the gown and the car bouncing around. Photograph by Annika Metsla.

If forced by circumstance to shoot your subjects out in unobstructed open shade, you must add fill with a frontal flash or reflector. If photographing the bride or the bride and groom, a reflector held close to and beneath your subjects should suffice. If photographing more than two people, fill-flash is called for. The intensity of the light should be about equal to the daylight exposure.

Window Light. One of the most flattering types of lighting is window lighting. It is soft light (minimizing facial imperfections) yet also highly directional (for good facial modeling). Window light is usually a fairly bright light and it is infinitely variable, changing almost by the minute. This allows a great variety of moods, depending on how far you position your subjects from the light.

Daylight falls off rapidly once it enters a window; it is much weaker several feet from the window than it is closer to the window. Therefore, great care must be taken in determining exposure—particularly with groups of three or four people. You will undoubtedly need to use reflectors to balance the light overall when photographing that many people in a group. There are a couple of other problems. First, you will sometimes have to work with distracting backgrounds (whatever happens to be in the room where you find the window). Second, you may find yourself working at uncomfortably close shooting distances due to the size of the space.

The best quality of window light is the soft light of mid-morning or mid-afternoon. Direct sunlight is difficult

to work with because of its intensity and because it will often create shadows of the individual windowpanes on the subject.

If you find a nice location for a portrait but the light coming through the windows is direct sunlight, you can diffuse the window light with some acetate diffusing material taped to the window frame. Light diffused in this manner has the warm feeling of sunlight but without the harsh shadows.

If the light is still too harsh, try doubling the thickness of the acetate for more diffusion. Since the light will be so scattered by the diffusers, you may not even need to add

RIGHT—One of the tricks the wedding photographer employs when shooting by window light is to shoot in RAW mode and warm the color temperature in the RAW file processing. That's what was done with this Gordon Nash portrait, which was made by the light of really large windows to the bride's left. The change in color temperature gives the image a golden-sunlight look. **BELOW**—This is an unusual use of window light. Photographers usually look for diffused window light, but Cherie Steinberg Coté used direct sunlight, which formed a radial spoke pattern, to light the groom. Careful positioning helped light his face and gobo (block light from) his forehead and the top of his head for a very fashion-forward image. No fill was used and Cherie darkened the hands in Photoshop.

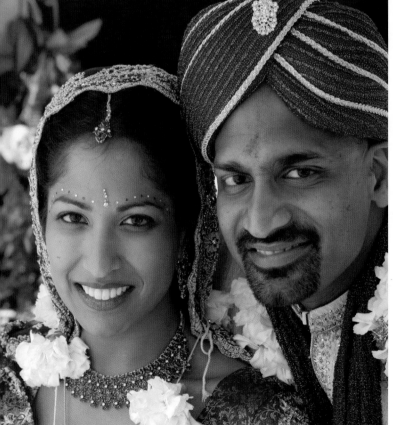

TOP—Joe Photo shoots every venue before the guests arrive to show the opulence and beauty of the room. In this image, he used a tripod and a ¼ second exposure at f/2.8. As part of his gregarious customer service, Joe sends the vendors prints of the room and place settings after each event. LEFT—Photographers have to be on their toes at all times. Here, Claude Jodoin wanted to make a close-up portrait of the bride and groom but the lighting outdoors was too direct and spotty. He solved the problem by having two assistants hold a tablecloth to camera left. The fabric acted like a softbox, diffusing the sunlight and providing the means for this quality portrait.

a fill source—unless you are working with a larger group. In that case, use reflectors to kick light back into the faces of those farthest from the window.

FLASH TECHNIQUES ON LOCATION

Flash for Fill Light. A reliable form of creating fill light is with electronic flash. As mentioned, many photographers shooting weddings using barebulb flash, a portable flash unit with a vertical flash tube that fires the flash a full 360 degrees. You can use as wide a lens as you own and you won't get flash falloff with barebulb flash. Barebulb flash produces sharp, sparkly light that is too harsh for al-

most every type of photography except outdoor fill. The trick to using it effectively is not to overpower the daylight. Let the daylight or twilight backlight your subjects, capitalizing on a colorful sky background if one exists, and use the barebulb flash to fill the frontal planes of your subjects.

Some photographers like to soften their fill-flash, opting for a softbox instead of a barebulb flash. In this situation, it is best to trigger the strobe with a radio remote. This allows you to move the diffused flash out to a 30- to 45-degree angle to the subjects. For this application, it is wise to match or slightly overpower the daylight exposure so that the off-angle flash acts more like a main light, establishing the lighting pattern. For large groups, it may be necessary to use several softboxes or to use a single one close to the camera for more even coverage. (For more on using flash as the main light, see below.)

Here is how you determine accurate fill-flash exposures every time. First, meter the daylight with an incident flashmeter in "ambi" mode. Say, for example, that the metered exposure is $\frac{1}{30}$ second at f/8. Next, meter the flash only. It is desirable for the flash output to be one stop less than the ambient exposure. Adjust the flash output or flash distance until your flash reading is f/5.6. Set the camera to $\frac{1}{30}$ second at f/8. That's it. You can set the flash output from f/8 to f/5.6 and you will not overpower the day-

ROOM LAMPS

You'll find that many hotels use coiled fluorescent bulbs in place of tungsten-filament bulbs in their room lamps. Be on the lookout for them; these fluorescents will not have the same warming quality as tungsten bulbs and could turn things a bit green. You may have to change your white balance, or use the automatic or custom white-balance setting, in these situations.

light, you will only fill in the shadows created by the daylight and add sparkle to the eyes.

Flash as the Main Light. If the light is fading—or the sky is brilliant and you want to shoot for optimal color saturation in the background—you can also overpower the daylight with the flash. This is where the flash becomes the main light and the ambient light becomes the fill light. Returning to the situation above, where the daylight exposure was $\frac{1}{30}$ second at f/8, adjust your flash output so your flashmeter reading is f/11, one stop more powerful than the daylight. Set your camera to $\frac{1}{30}$ second at f/11. The flash is now the main light and the soft twilight is the fill light. The problem with this technique is that you will get shadows from the flash. This can be acceptable, however, since there aren't really any shadows coming from the twilight.

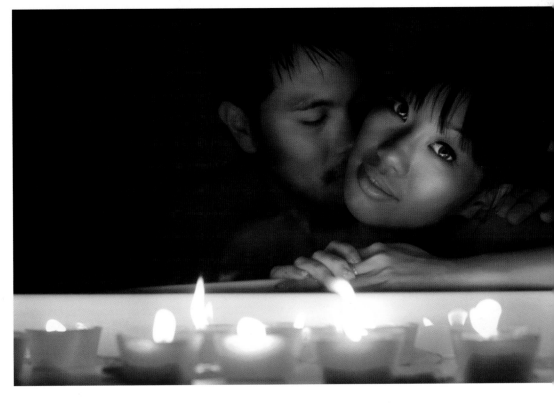

Louis Pang created this lovely portrait of the bridal couple using only candlelight and a 50mm f/1.4 lens on his Nikon D200. Ordinarily, lighting from below subject height is objectionable, but here, because there are many small light sources overlapping, the effect is to diffuse the overall light. See how soft the shadow on the bride's nose is.

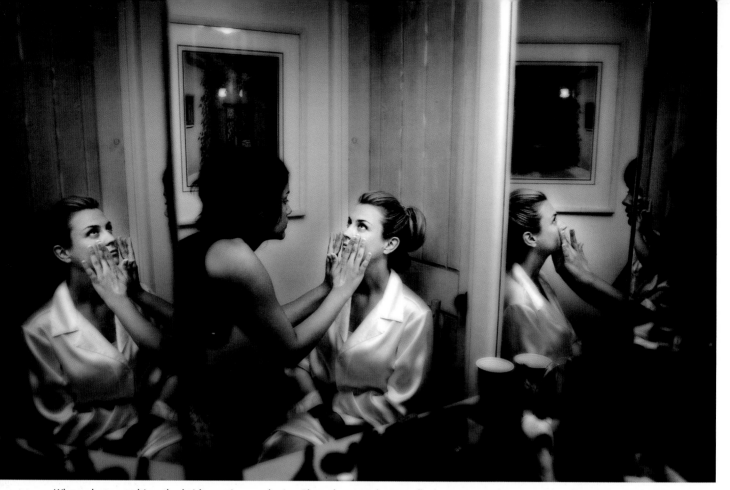

When photographing the bride getting ready, Joe Photo leaves a bounce flash permanently mounted to his Nikon D2X. The flash has a small reflector that kicks a small percentage of the light forward rather than straight up. The result is a bounce flash with a little direction to it. This image was made with a 17mm f/2.8 lens used wide open at an exposure of $^1/_{180}$ second at f/2.8.

As described previously, this technique works well when the flash is diffused and at an angle to the subjects so there is some discernable lighting pattern. It is also effective on overcast days when using barebulb flash. Position the flash to the right or left of the subject(s) and raise it up for better modeling. If you want to accentuate the lighting pattern and darken the background and shadows, increase the flash output to ½ to one stop greater than the daylight exposure and expose for the flash exposure. Do not underexpose your background by more than a stop, however; it will produce an unnatural nighttime effect.

This technique allows you to shoot in open shade without fear of hollowed-out eye sockets. The overhead nature of the diffused daylight will be overridden by the more directional flash, which creates a distinct lighting pattern.

Bounce Flash. Portable flash units do not have modeling lights, so it is impossible to see beforehand the effect they will produce. However, there are certain ways to use a camera-mounted flash in a predictable way to get excellent lighting—especially at the reception.

Bounce flash is an ideal type of portrait light. It is soft and directional. By bouncing the flash off the ceiling, you can achieve an elegant, soft light that fully illuminates your subjects. You must, however, learn to gauge angles and distances when using bounce flash. Aim the flash unit at a point on the ceiling that will produce the widest beam of light reflecting back onto your subjects.

There are two problems that commonly occur with bounce flash. The first occurs when bouncing the flash off colored surfaces. You should never use color film when bouncing flash off colored ceilings or walls; the light reflecting back onto your subjects will be the same color as the walls. Even when shooting digitally you may not be able to sufficiently compensate with custom white balance for the green-colored bounce flash coming off of a green ceiling.

The second problem with bounce flash off the ceiling is that it results in overhead lighting. With high ceilings, the problem is even worse—the light is almost directly overhead. To resolve this issue, a number of devices, like

the Lumiquest ProMax system, are available to direct some of that bounce light directly toward the subject. These accessories mount to the flash housing and transmit 10–20 percent of the light forward onto the subject, with the remainder of the light being aimed at the ceiling. This same company also offers devices like the Pocket Bouncer, which redirects light at a 90-degree angle from the flash to soften the quality of light and distribute it over a wider area. When using these devices, no exposure compensation is necessary with automatic and TTL flash exposure systems (although operating distances will be reduced).

You don't necessarily have to use your flash-sync speed when making bounce flash exposures. If the room-light exposure is within a stop or two of your bounce-flash exposure (let's say this is $\frac{1}{125}$ second at f/4), you can select a slower shutter speed to record more of the ambient room light. For example, if the room light exposure is $\frac{1}{30}$ second at f/4 you could expose the bounce-flash photos at $\frac{1}{30}$ second at f/4 for a balanced flash and room-light exposure. Be wary of shutter speeds longer than $\frac{1}{15}$ second, however; you might incur camera movement or subject movement in the background (the flash will freeze the nearer subject although the longish shutter speed might produce "ghosting" if your subject is moving). These effects are actually quite interesting, and many photographers incorporate a slow shutter speed and flash to record a sharp image over a moving one for a painterly effect.

Flash Output. TTL flashmetering systems and autoflash systems will read bounce-flash situations fairly accurately, but factors such as ceiling distance, color, and absorption qualities can affect proper exposure. Although no exposure compensation is necessary with these systems, operating distances will be reduced.

One of the best means of evaluating flash output, lighting ratios, and the balance between flash illumination and daylight or room light is by using the digital SLR's LCD monitor. While the LCD may not be the perfect tool to evaluate subtle exposure effects, it is quite effective in evaluating how well your bounce flash is performing. You can see at a glance if you need to increase or decrease the output.

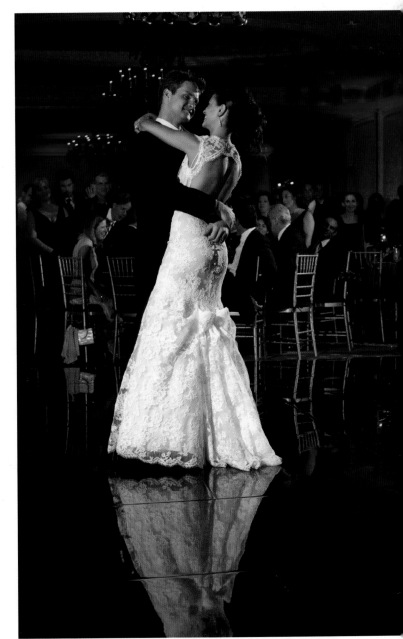

For his daughter Carly's wedding, Bruce Dorn rigged two 200-watt remotely-dimmable Mole-Richardson "InBetweenie" halogen solar-spots, which were piggy-backed with two radio triggers and warm-gelled Quantum T5d-R strobes.

Preparation and Planning

Preparation is critical when photographing a once-in-a-lifetime event that is as complicated as a wedding. With lots of people, places, and events to document, getting all the details and formulating a plan before the wedding will help ensure you're ready to capture every moment.

Checking in with the banquet manager, caterer, florist, band director, and so on will help you get a handle on all the events planned for the day and the order in which they will occur. Based on this information, you can better choreograph your movements to be in the optimum position for each phase of the wedding day. The confidence that this kind of preparation provides is immeasurable.

THE CONSULTATION

Most successful wedding photographers get to know the couple and their families before the wedding, so that everyone is accustomed to him or her and knows what to expect. This familiarity can be established in any number of ways—from handwritten notes to regular phone calls. Alisha and Brook Todd, successful wedding

If you get to know the couple in advance, they will warm to your presence and be completely relaxed with you and your camera being everywhere they are. This photograph is by Ray Prevost, who helped shoot the wedding of photographer Bruce Dorn's daughter, Carly. Jessica Claire also pitched in and the three covered the wedding together, giving Bruce more time to enjoy being the father of the bride.

California photographer Jerry D is a big believer in the complimentary engagement session because it gives the trio a chance to work together before the wedding day. Once the couple sees how great he can make them look, they are supremely confident in him as a friend and photographer. Jerry will often do both a studio session and a location session on the same day, so that he can get a variety of finished results.

photojournalists in the San Francisco area, send out a bottle of Dom Perignon and a hand-written note the day after each contract goes out. Then, they follow up with monthly phone calls to check in.

You should also arrange a meeting with the couple at least one month before the wedding. Use this time to take notes, formulate detailed plans, and get to know the bride and groom in a relaxed setting. This will be time well spent and allows you a month after the meeting to check out the locations, introduce yourself to the people at the various venues (including the minister, priest, or rabbi), and go back to the couple if there are any problems or if you have

questions. This meeting also gives the bride and groom a chance to ask any questions of you that they may have.

Tell the couple what you plan to photograph and show them examples. Ask if they have any special requests or special guests who may be coming from far away. Avoid creating a list of required photographs, however; depending on how the events of the wedding actually unfold, it may not be possible to accomplish them all.

Note the names of each parent, the bridesmaids, groomsmen, the best man, and maid of honor so that you can address each by name. If you are not good with names, spend some time studying them. (As photographer Frank Frost notes, photography requires people skills. He says, "There can be twenty people in the wedding party and I'm able to call everybody by name. It makes a big impression and, by the end of the evening, everybody is my friend.")

LEFT—There are many shots that you should definitely not miss at the wedding or reception—such as the bouquet toss. Photograph by Regina and Denis Zaslavets. RIGHT—If there is a choir loft or balcony at the church, it can be advantageous for you or an assistant to capture the bride's entrance. Note the serendipitous flash that went off at the exact moment Joe Buissink made the exposure.

You should also make notes on the color scheme, the supplier of the flowers, the caterer, the band, and so on. You should contact all of these people in advance, just to touch base. You may find out interesting details that will affect your timetable or how you make certain photos.

THE ENGAGEMENT PORTRAIT

Another good preparatory practice is scheduling an engagement portrait. This has become a classic element of modern-day wedding coverage. The portrait can be made virtually anywhere, but it allows the couple to get used to (and confident in) the working methods of the photographer, so that on the wedding day they are accustomed to the photographer's rhythms and unique style of shooting. The experience also helps the threesome get to know each other, so that the photographer doesn't seem like an outsider at the wedding.

VISIT THE VENUES

Armed with information from the meeting, you should visit the wedding venues (especially if you have not been there before). Visit at the same times of day as the wedding and reception, so that you can check lighting, make notes of special locations, and catalog any potential problems.

Also, you should make note of the walls and types of ceilings, particularly at the reception. This will affect your ability to use bounce flash. It is useful to produce an "A" list and a "B" list of locations. On the "A" list, note the best possible spots; on the "B" list, select alternate locations in case the "A" locations don't work out. Make notes, too, of any special equipment you'll require to make use of these spots so you'll be well prepared.

Acclaimed wedding photographer Marcus Bell says that if he doesn't get a chance to scout the location before the wedding, he'll arrive hours early and take a few shots of

special locations. These will serve as a guide for where he may want to make portraits of the bride and groom.

CHECK THE CUSTOMS

If the ceremony is to take place at a church or synagogue where you do not know the customs, make sure you visit the minister beforehand. If you are unfamiliar with the customs, ask to attend another wedding as an observer. Such experiences will give you invaluable insight into how you will photograph the wedding.

At many religious ceremonies, you can move about and even use flash—but it should really be avoided in favor of a more discreet, available-light approach. Besides, available light will provide a more intimate feeling to the images. At some churches you may only be able to take photographs from the back, in others you may be offered the chance to go into a gallery or the balcony. You should also be prepared for the possibility that you may not be able to make pictures at all during the ceremony.

Al Gordon and his friend, Tyler Nafziger, made this image together at Old Sheldon Church, near Beaufort, SC. The church was built around 1745, and has been burned down twice, the last time in the 1860s by General Sherman's troops. There is nothing left of the church but incredible brick walls and gorgeous surrounding trees. Knowing there was no power outlet at the old church, the photographers brought along some Alien Bees strobes with a Vagabond battery pack, which allowed them to use a large light source with as much power as 1800 watt-seconds out of one or more strobe heads. Working quickly as the sun set, they put a large softbox on a light stand and raised it about thirteen feet in the air. Working at 400 ISO, this was set at f/11. Another strobe (at f/5.6) highlighted the walls, and a Quantum Q-flash (at f/8) lit the veil. The ambient light metered 1/30 second, but Al set his shutter to 1/90 second to bring out the sky colors. He then shot from the ground with his Sigma 10–20mm f/3.5 EX DC HSM lens on a Fuji Finepix S5 Pro camera.

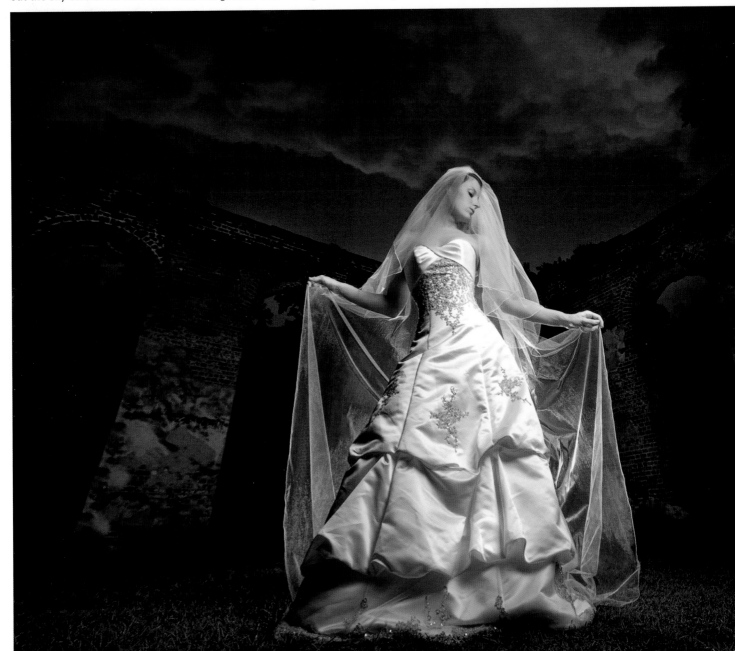

CREATE A MASTER SCHEDULE

Planning your schedule is essential to smooth sailing on the wedding day. The couple should know that if there are delays, adjustments or deletions will have to be made to the requested pictures. Good planning and an understanding of exactly what the bride and groom want will help prevent any problems.

Inform the bride that you will arrive at her home or hotel room forty-five minutes to an hour before she leaves for the church. You should then leave the bride's house in time to arrive at the church thirty minutes before the ceremony—at about the same time as the groom. (*Note:* To do this, you'll need to know how long it takes for you to drive from the bride's home to the ceremony site.) At that time you can make portraits of the groom, groomsmen, and best man. Bridesmaids will arrive at the church at about the same time.

Determine approximately how long the ceremony will last and set out time between the ceremony and reception for formals. One formula is to spend up to twenty minutes on groups at the church, and about the same amount of time on portraits of the couple at the reception.

Bear in mind that having a master schedule does not preclude massive scheduling changes. A good plan will only guarantee that you are prepared for the events as they are planned, not necessarily how they will actually unfold. Yet, the better your preparation and planning, the more adept you and your team will be at making any last-minute adjustments.

BE A TEAM PLAYER

As the photographer, you are part of a group of wedding specialists who will ensure that the bride and groom have a great day. Be friendly and helpful to all of the people on the team—the minister, the limo driver, the wedding coordinator, the banquet manager, the band members, the florist, and other vendors involved in the wedding. They are great sources of referrals. Get the addresses of their companies so that you can send them a print of their specialty after the wedding.

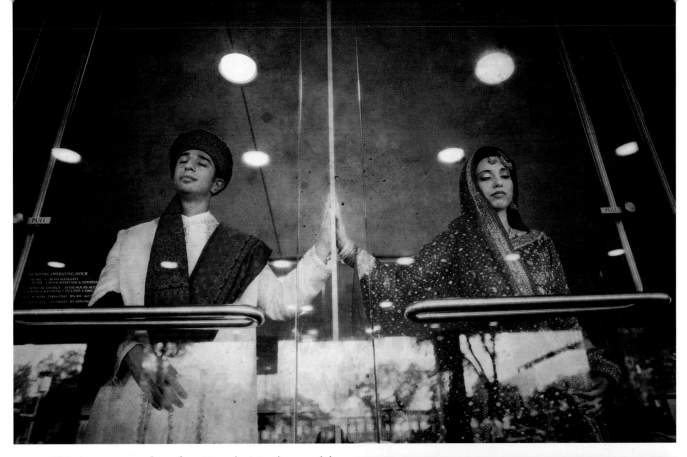

ABOVE—This image, one of my favorites, depicts the couple's serenity and bliss—yet the glass prevents us from entering their sphere. The uniquely spiritual moment was captured by Jesh de Rox. RIGHT—Regardless of whether it is before the wedding, at the wedding, or after the wedding, always be prepared for that perfect shot that will present itself. Photograph by Regina and Denis Zaslavets of Assolux Photography.

ASSISTANTS

An assistant is invaluable at the wedding. He or she can run interference for you, change or download memory cards, organize guests for a group shot, help you by taking flash readings and predetermining exposure, tape light stands and cords securely, and tackle a thousand other chores. Your assistant can survey your backgrounds looking for unwanted elements—even become a moveable light stand by holding your secondary flash or reflectors.

An assistant must be trained in your posing and lighting techniques. The wedding day is not the time to find out that the assistant either doesn't understand (or, worse yet, approve) of your techniques. You should both be on the same page—and a good assistant will even be able to keep you on track for upcoming shots.

Most assistants go on to become full-fledged wedding photographers. After you've developed confidence in an assistant, he or she can help with the photography, partic-

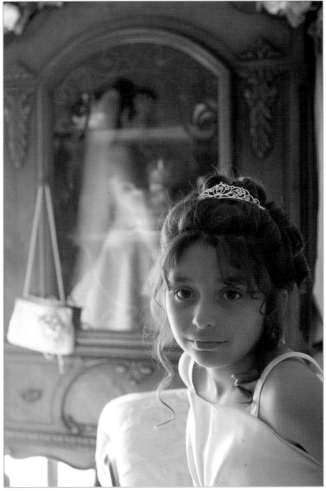

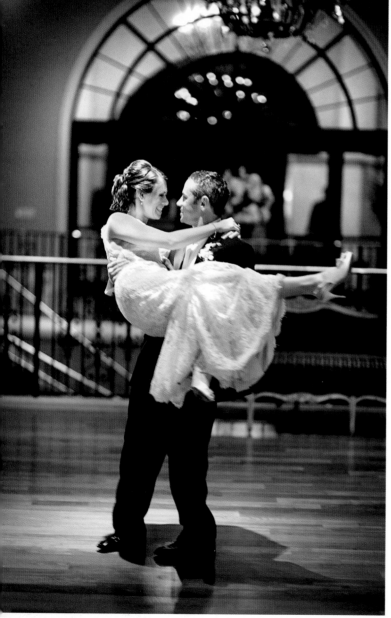

TOP LEFT—Be prepared to photograph the venue before anyone gets in so that you can record the elegance of the place settings and the beauty of the location. Jeff Kolodny made this 30 second at f/10 exposure with an 18mm lens. **TOP RIGHT**—Tom Muñoz created this beautiful shot with a 24mm lens and a mix of window light and tungsten ceiling lighting. The exposure was ¹⁄₅₀ second at f/4 at ISO 800. **LEFT**—Jeff Kolodny used an overhead chandelier to light the bride and groom during a spontaneous moment. The image was made with a Nikon D3 and 85mm f/1.4 lens at ISO 1600. The exposure was ¹⁄₆₀ second at f/1.6.

ularly at the reception, when there are too many things going on at once for one person to cover them all. Most assistants try to work for several different wedding photographers to broaden their experience. It's not a bad idea to employ more than one assistant so that if you get a really big job you can use both of them—or if one is unavailable, you have a backup assistant.

Assistants also make good security guards. I have heard many stories of gear "disappearing" at weddings. An assistant is another set of eyes whose priority it should be to safeguard the equipment.

A POSITIVE, RELAXED ATTITUDE

The wedding day is usually a tense time when people wear their emotions on their sleeves. Your demeanor and professionalism should be a calming and reassuring presence, especially to the bride. Be calm and positive, be funny and lighthearted—and above all, don't force the situation. If you can see that demanding to make a picture is going to really upset people, have the will power to hold off until later. Remember that positive energy is contagious and can usually save a sticky situation.

The Key Shots

At every wedding, there are some key events that the bride and groom will expect to see documented in their images. Including these is important for creating an album that tells the whole story of the couple's special day. The following are a few tips on what to shoot and some ideas for making the most of each moment as it happens.

ENGAGEMENT PORTRAIT

The engagement portrait is usually made prior to the wedding, providing the time to get something spectacular. Many photographers use this session as an opportunity to get to know the couple and to allow the couple to get to know them. Engagement portraits may involve great creativity and intimacy and are often made in the photographer's studio or at some special location.

THE BRIDE GETTING READY

Typically, wedding coverage begins with images of the bride getting ready. Determine what time to arrive and be

An engagement portrait session gives the photographer and the couple a chance to work together before the big day. It also gives the couple a chance to have a fun time together. Here, Jeff Kolodny used a 1/6 second exposure and flash from the camera position to photograph the couple in the middle of a busy train station. The slow shutter speed didn't freeze the passersby, but the stationary couple are nice and sharp thanks to the flash.

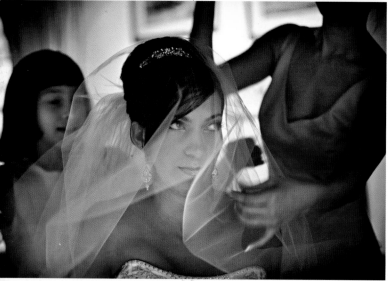

ABOVE—Arriving early at any of the venues, including the bride's home or the reception can produce some photographic gems. Photograph by Michael Greenberg. LEFT—Getting the bride ready to go is often an operation requiring many hands. This is a fun time as everyone feels like they are helping ready the bride for her big moment. Photograph by Greg Gibson. (Canon EOS 5D; EF 70–200mm f/2.8L USM lens; 1/50 second at f/2.8; ISO 1600)

THE GROOM BEFORE THE WEDDING

You do, of course, want to photograph the groom before the wedding. Some grooms are nervous, while others are gregarious—like it's any other day. Regardless, there are ample picture opportunities before anyone else arrives at the church. It's also a great opportunity to do formal portraits of the groom, the groom and his dad, and the groom and his best man. A three-quarter-length portrait is a good choice—and you can include the architecture of the church or building if you want.

When photographing men, always check that their ties are properly knotted. If they are wearing vests, make sure that they are correctly buttoned and that the bottom button is undone.

there a little early. You may have to wait a bit, as there are a million details to attend to, but you can use the opportunity to capture still lifes or family shots. When you get the okay to go up to the bedrooms, realize that it may be tense in there. Try to blend in and observe. Shots will present themselves, particularly with the mother and daughter or the bridesmaids.

TOP AND CENTER—Be sure to get a great portrait of the groom alone—as well as a formal portrait of the bride and groom together. Photographs by Jerry Ghionis. (Canon EOS 5D; 100mm lens; 1/250 second at f/4; ISO 400) BOTTOM—Be on the lookout for casual interactions between the guys as the ceremony draws near. Photograph by Marcus Bell.

THE CEREMONY

Regardless of whether you're a wedding photojournalist or a traditionalist, you must be discreet during the ceremony. Nobody wants to hear the "ca-chunk" of a camera or see a blinding flash as the couple exchange their vows. It's better by far to work from a distance with a tripod- or monopod-mounted DSLR, and to work by available light. Work quietly and unobserved—in short, be invisible.

Some of the events you will need to cover are the bridesmaids and flower girls entering the church; the bride entering the church; the parents being escorted in; the bride's dad "giving her away"; the first time the bride and groom meet at the altar; the minister or priest talking with them; the ring exchange; the exchange of vows; the kiss; the bride and groom turning to face the assembly; the bride and groom coming up the aisle; and any number of two dozen variations—plus all the surprises along the way. Note that this scenario applies only to a Christian wedding. Every religion has its own customs and traditions that you need to be thoroughly familiar with before the wedding.

FORMAL PORTRAITS

Regardless of your style of coverage, family groups are pictures that will be desired by all. You must find time to make the requisite group shots, but also be aware of shots that the bride may not have requested but expects to see. The bride with her new parents and the groom with his are great shots, but they are not ones that will necessarily be "on the list."

Following the ceremony, you should be able to steal the bride and groom for a brief time.

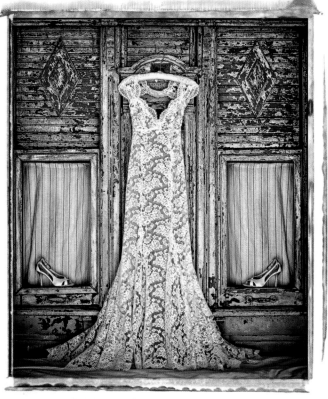

TOP LEFT—Some alone time with the bride and groom can yield fabulous shots on the day of the wedding. Marc Weisberg made this shot at sunset, with the sky backlighting the architecture and the couple. He used an 85mm lens with an exposure of $\frac{1}{6400}$ second at f/2.2 with a Canon EOS 5D. BOTTOM LEFT—The latest generation of DSLRs (here, the Nikon D3) provide great low-light opportunities. Michael Greenberg shot this graphic of the bride and groom using exterior parking-lot lighting. The scene was exposed for $\frac{1}{100}$ second at f/2.8 at ISO 4000 with a 24mm f/2.8 lens. Notice how little noise is evident in this ISO 4000 image. ABOVE—This is a remarkable detail shot of the wedding dress composed like a still life by Marc Weisberg. The original image was made with a Canon EOS-1D Mark III and EF 24–70mm f/2.8L USM lens at ISO 800. In RAW processing, its brightness and contrast were bumped up considerably and a vignette was added. The image was later treated with a LucisArt filter in Photoshop.

asked for. If there are too many "must" shots to do in a short time, arrange to do some at the reception. This can be all thought out beforehand.

The Bride and Groom. Generally speaking, this should be a romantic pose, with the couple looking at one another. While a very traditional pose or two is advisable, most couples will opt for the more romantic and emotional portraits. Make at least two formal portraits, a full-length shot and a three-quarter-length portrait.

In these images, be sure to highlight the dress, as it is a crucial element in all of the formal portraits (more on

Limit yourself to ten minutes, or you will be taking too much of their time and the others in attendance will get a little edgy. Most photographers will get what they need in less than ten minutes.

In addition to a number of formal portraits of the couple—their first pictures as man and wife—you should try to make whatever obligatory group shots the bride has

this topic in the following section). Make sure the bouquet is visible and have the bride closer to the camera than the groom. Have the groom place his arm around his bride but with his hand in the middle of her back. Have them lean in toward each other, with their weight on their back feet and a slight bend to their forward knees. That's it—quick and easy!

The Bride Alone. In most cases, the bride will spend more money on her wedding dress (and more time on her appearance) than for any other occasion in her entire life. She will often look more beautiful than on any other day. The portraits you make will be a permanent record of this.

To display the dress beautifully, the bride must stand well. Although you may only be taking a three-quarter-length or head-and-shoulders portrait, start the pose at the feet. When you arrange the bride's feet with one foot forward of the other, the shoulders will naturally be at their most flattering—one higher than the other. Have her stand at an angle to the lens, with her weight on her back

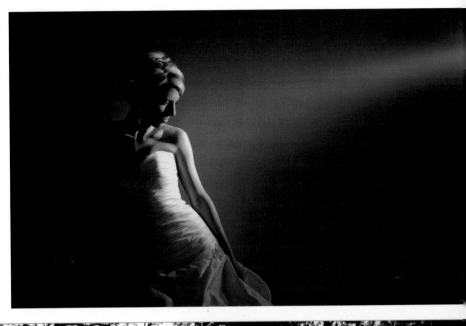

RIGHT—A single grid spot was used to create a column of light on the wall, as well as to produce an elegant Rembrandt-style lighting pattern on the bride. No fill was used and the "S" curve pose is excellent. Photograph by Frank Cava. **BELOW**—Joe Buissink kept the bride's size small to enhance the illusion that the naked winter trees, darkened in printing, were rising up as if to protect her. (Canon EOS 5D; EF 16–35mm f/2.8L USM lens; $1/125$ second at f/5; ISO 320)

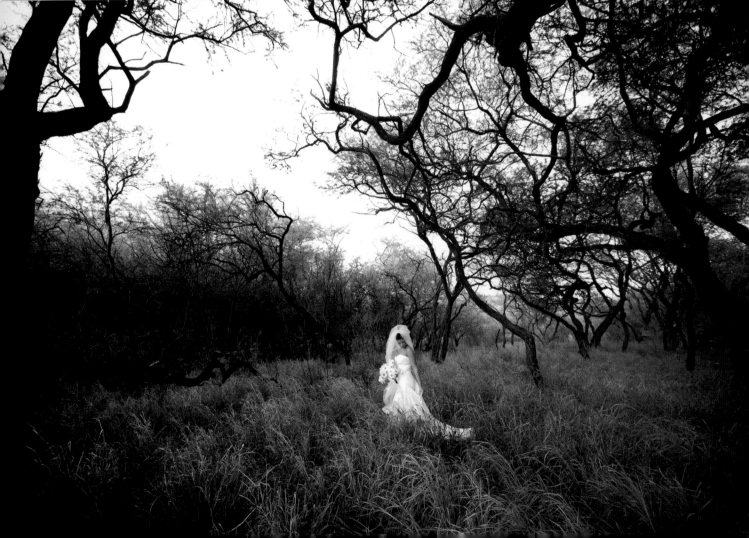

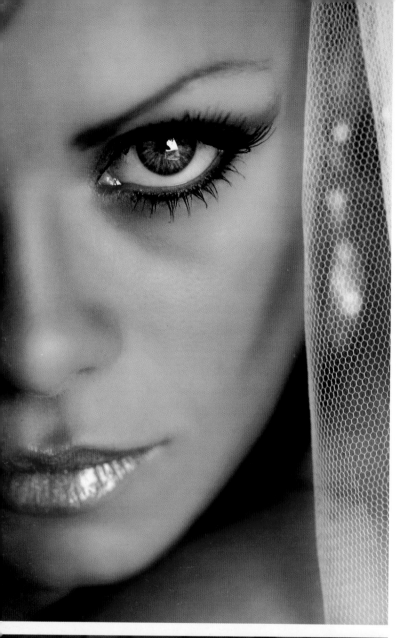

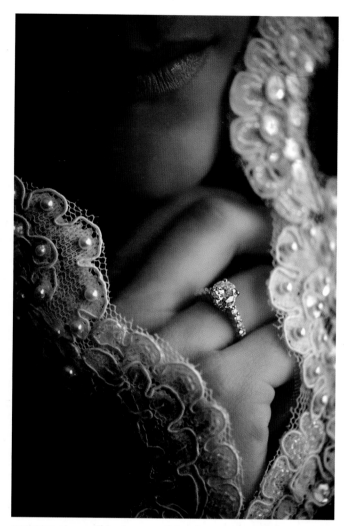

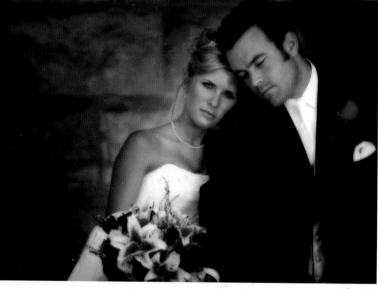

TOP LEFT—Jerry Ghionis moved in close to reveal the unusual emerald color of this bride's eyes. Jerry used a Canon EOS 5D and 50mm lens exposed for 0.6 seconds at f/9.0 at ISO 100. Working at a close distances, depth of field is minimized. Here the photographer wanted the eye and mask of the face as well as the veil sharp. **ABOVE**—The bride loved this image as it showed both her engagement ring and the unique appliqué on the edge of her bridal veil. The available light exposure was $\frac{1}{500}$ second at f/3.2 at ISO 2000 handholding a Nikkor 105mm Micro lens mounted on a Nikon D3. Some extra unsharp filter masking was applied to the ring in Photoshop. Photograph by Michael O'Neill. **BOTTOM LEFT**—This is both a formal portrait of the bride and groom and a beautiful rendering of the bouquet. Jeff and Julia Woods created this image in which the couple's shapes form a perfect triangle, which is a very pleasing compositional form.

foot and her front knee slightly bent. The most feminine position for her head is to have it turned and tilted toward the higher shoulder. This places the entire body in an attractive S-curve, a classic bridal pose.

When creating these images, do not ignore the back of the dress; designers incorporate as much style and elegance

in the back of the dress as the front. Formal wedding dresses often include flowing trains. It is important to get several full-length portraits of the full train, draped out in front of the bride in a circular fashion or flowing behind her. These may be the only photographs of her full wedding gown, so take the time to style them carefully. One way to make the train look natural is to pick it up and let it gently fall to the ground.

Make sure to get some close-ups of the bride through her veil. It acts like a diffuser and produces romantic, beautiful results. Lighting should be from the side rather than head-on to avoid shadows on the bride's face caused by the patterned mesh. Many photographers use the veil as a compositional element in their portraits. To do this, lightly stretch the veil so that the corners slant down toward the lower corners of the portrait, forming a loose triangle that leads your eyes up to the bride's eyes.

Be sure not to allow the bouquet to overpower your compositions—particularly in your formal portrait of the bride. Have the bride hold her bouquet in the hand on the same side of her body as the foot that is extended. If the bouquet is held in the left hand, the right arm should come in behind the bouquet to meet the other at wrist level. She should hold the flowers a bit below waist level to show off the waistline of the dress, which is an important part of the design. The bouquet should still be held high enough, however, to put a slight bend in her elbows, keeping her arms slightly separated from her body.

THE WEDDING PARTY

This is one formal group that does not have to be formal. I have seen group portraits of the wedding party done as a panoramic, with the bride, groom, bridesmaids, and groomsmen doing a conga line down the beach, dresses held high out of the water and the

KEVIN JAIRAJ'S BRIDAL SESSIONS

Kevin Jairaj says that planning a bridal session before the wedding is a great idea (and very profitable too!) as it allows him to get to know the bride a lot better before the wedding day and to see what she is comfortable and not comfortable doing with regard to her photos. It is also a great dress rehearsal for the bride, who can make sure that all the parts fit just right and look exactly the way she likes.

Kevin always approaches his bridal sessions with the attitude that it's more like a fashion shoot. He tells brides to "expect to be my model for a day and to have a lot of fun." During the session, he will do quite a variety of shots from very sexy and fashion-forward, to a few traditional ones to please mom and grandma.

The following are a few of Kevin's tips to ensure that the session goes well.

First, tell the bride to have a glass of wine and relax before the session. Putting on the wedding dress usually comes with a few nerves.

Second, have the bride wear comfortable shoes (tennis shoes or flip flops)—especially if you cannot see her shoes under her dress when she is standing. Having the bride get blisters while walking around in her heels is no way to have a productive shoot! For any shots made sitting down, simply have her put her heels on when you get to the spot.

Third, bring a white sheet or clean painter's plastic to place under the dress. This is the secret to not getting the dress dirty—and many brides are terrified about getting their $10,000 dress soiled before the wedding. Have her sit on the sheet or the plastic and then tuck it under her dress so that it doesn't show.

Finally, have the bride bring a few friends to the session to help out with all the stuff (shoes, makeup, tissues, etc.). "I have found that most brides seem to relax more when their friends are around," says Kevin.

Kevin tries to do the bridal session about two months before the actual wedding, when the bride's weight, hair length, etc. will be pretty close to what they will be on the wedding day. Also, that allows him plenty of time to order and frame a print to be displayed at the reception. A typical bridal session will last about two to three hours.

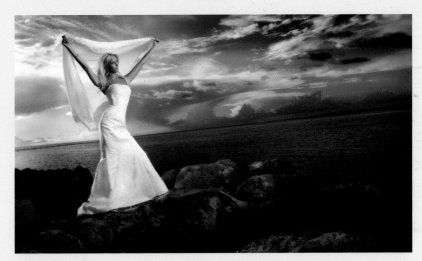

Here is an atypical shot from a bridal session. The shot was taken in sunlight at around 3PM. Kevin Jairaj used a softbox to overpower the daylight and create a more flattering lighting pattern from about six feet away. According to Kevin, "I set the strobe in the softbox to almost full power so that I could overpower the sun and create some deep blue skies by slightly underexposing the background."

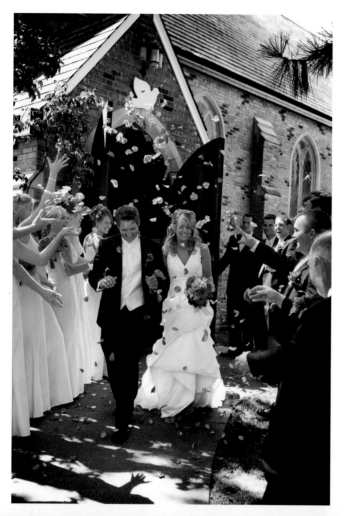

men's pant legs rolled up. And I have seen elegant, formal pyramid arrangements, where every bouquet and every pose is identical and beautiful. It all depends on your client and your tastes. It should be a portrait that you have fun doing. Most photographers opt for boy–girl arrangements, with the bride and groom somewhere central in the image. As with the bridal portrait, the bridesmaids should be in front of the groomsmen in order to highlight their dresses.

THE RINGS

The bride and groom usually love their new rings and want a shot that includes them. A close-up of the couple's hands displaying the rings makes a great detail image in the

LEFT—The rice toss—or, in this case, the rose petal toss—is one shot you want to have well covered from several angles. If you work with an assistant, choose separate locations from which to capture the fleeting event. Don't be afraid to choreograph the event; you'll only get one chance to make a great shot. Photograph by Jeff and Julia Woods. **BELOW**—This macro shot was made from just inches away handholding a Nikon D3 camera fitted with a 105mm Micro-Nikkor lens. Even at f/32, the back edge of the groom's ring and the front of the invitation fall out of focus, drawing your eyes to the incredible detail of the wedding bands. The image was exposed for $\frac{1}{1000}$ second at ISO 1600 using the light from a Sunpak Readylite 20, which was lying on the table next to the rings. Photograph by Michael O'Neill

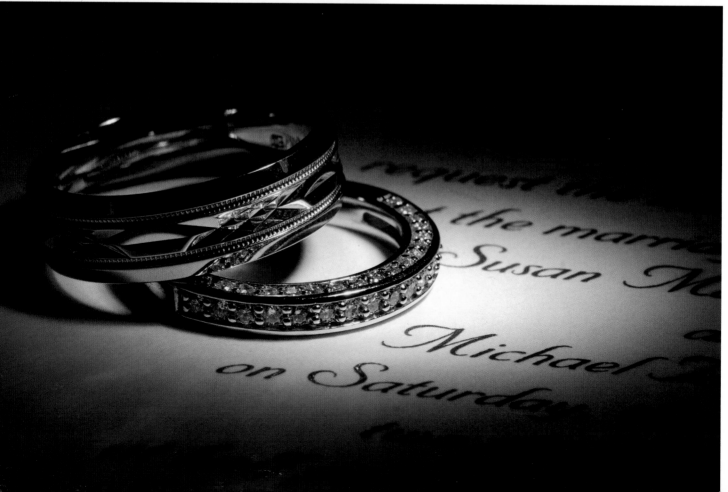

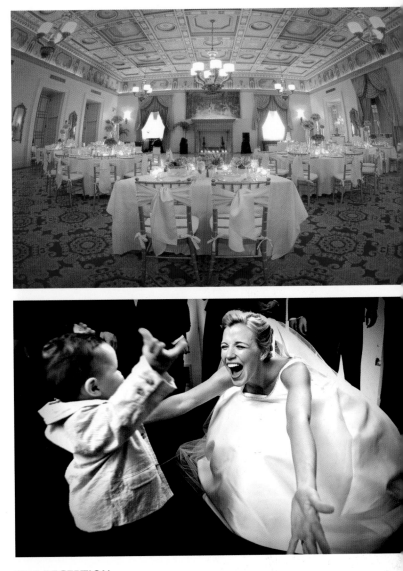

TOP—Jeff Kolodny used a Nikon D200 and 10.5mm fisheye lens to create this image of the reception venue. With the camera tripod-mounted, he photographed the scene for thirty seconds at f/22 to extend the depth of field to cover the entire room. His white balance was set to auto, but he warmed the scene in RAW file processing to bring out the delicate pinks and yellows. He also lowered the contrast so he could better deal with the blown-out windows at the far end of the room. The original scene was shot at 100 ISO. BOTTOM—No one has better reactions and storytelling skills than a Pulitzer Prize-winning photojournalist. Here, Greg Gibson captures the full gamut of emotion as these two connect.

album. You can use any type of attractive pose, but remember that hands are difficult to pose. If you want a really close-up image of the rings, you will need a macro lens, and you will probably have to light the scene with flash—unless you make the shot outdoors or in good light.

LEAVING THE CHURCH

Predetermine the composition and exposure and be ready and waiting as the couple exits the church. If guests are throwing confetti or rice, don't be afraid to choreograph the event in advance. You can alert guests to get ready and "release" on your count of three. Using a slow (1/30 second) shutter speed and flash, you will freeze the couple and the rice, but the moving objects will have a slightly blurred edge. If you'd rather just let the event happen, opt for a burst sequence using the camera's fastest burst rate and a wide-angle-to-short-telephoto zoom. Be alert for the unexpected, and consider having a second shooter cover events like this to better your odds of getting a memorable picture.

THE RECEPTION SITE

Whenever possible, try to make a photograph of the reception site before the guests arrive. Photograph one table in the foreground and be sure to include the floral and lighting effects. Also, photograph a single place setting and a few other details. The bride will love them, and you'll find use for them in the album design. The caterers and other vendors will also appreciate a print that reflects their fine efforts. Some photographers try to include the bride and groom in the scene, which can be tricky. Their presence does, however, add to the shot. Before the guests enter the reception area, for instance, Ken Sklute often photographs the bride and groom dancing slowly in the background and it is a nice touch.

THE RECEPTION

This is the time when most of your photojournalistic coverage will be made—and the possibilities are endless. As the reception goes on and guests relax, the opportunities for great pictures will increase. Be aware of the bride and groom all the time, as they are the central players. Fast zooms and fast telephoto lenses paired with fast film or high ISO settings will give you the best chance to work unobserved.

Be prepared for the scheduled events at the reception—the bouquet toss, removing the garter, the toasts, the first dance, and so on. If you have done your homework, you will know where and when each of these events will take place, and you will be prepared to light and photograph it. Often, the reception is best lit with a number of corner-mounted umbrellas, triggered by your on-camera flash. That way, anything within the perimeter of your lights can

be photographed by strobe. Be certain you meter various areas within your lighting perimeter so that you know what your exposure needs to be everywhere on the floor.

The reception calls upon all of your skills and instincts. Things happen quickly, so don't get caught with an important event coming up and only two frames left on a memory card that's almost full. Also, people are having a great time, so be cautious about intruding upon events. Try to observe the flow of the reception and anticipate the individual events before they happen. Coordinate your efforts with the person in charge, usually the wedding planner or banquet manager. He or she can run interference and cue you when certain events are about to occur—often not letting the event begin until you are ready.

I have watched Joe Photo work a reception and it is an amazing sight. He often uses his Nikon D1X and flash in bounce mode and works quickly and quietly. His Nikon

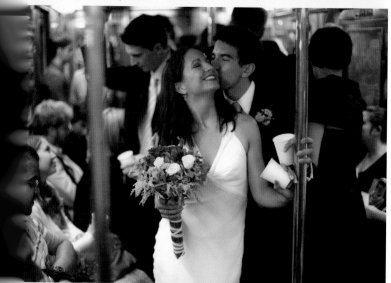

TOP LEFT—The toast is a great time to get reaction shots of the couple and wedding party. A good toast is funny and touching; it will produce true emotions in the wedding party. **CENTER LEFT**—Great pictures are yours for the taking, like this one made on a rocky New York City subway car. **BELOW**—The cake cutting rarely has such melodrama, but you should be prepared for anything. The photographer planned to make this shot from outside the window, but he did not anticipate the humor. Photographs by Emin Kuliyev.

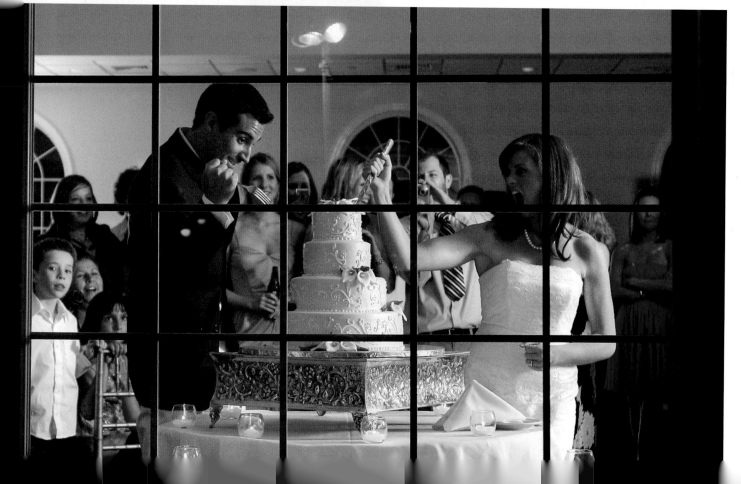

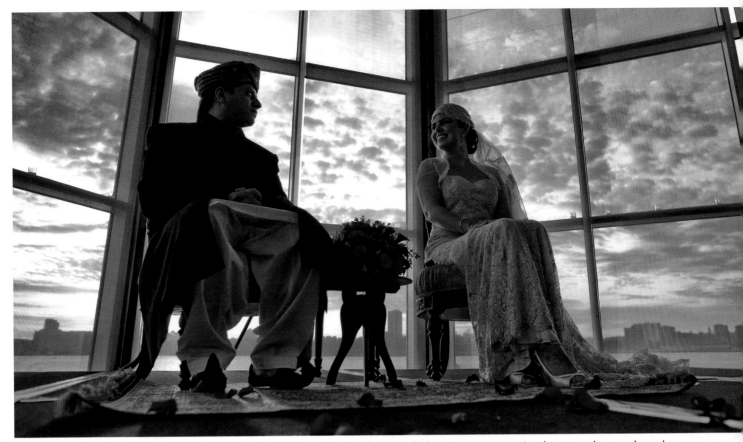

What a perfect portrait of the bride and groom. There is great late afternoon light, a great connection between the couple and a beautiful setting. Photograph by Emin Kuliyev.

Speedlite is outfitted with a small forward-facing internal reflector that redirects some of the bounce flash directly onto his subject, making the flash function simultaneously as both the main and the fill light. If he is observed and noticed, he'll often walk over and show the principals the image on the LCD, offer some thoughtful compliment about how good they all look, and quickly move on. Other times he just shoots, observes, and shoots some more. His intensity and concentration at the reception are keen and he comes away with priceless images—the rewards of good work habits.

The Cake Cutting. Cakes have gotten incredibly expensive; some are in the $10,000 price range. For this reason, a stand-alone portrait of the cake is a good idea—both for the cake-maker and for the bride and groom.

The First Dance. One trick you can use is to tell the couple beforehand, "Look at me and smile." That will keep you from having to circle the couple on the dance floor until you get both of them looking at you for the "first dance" shot. Or you can tell them, "Just look at each other and don't worry about me, I'll get the shot."

Sometimes, photographers will cover the first dance using whatever light exists (often spotlights) on the dance floor. This is possible with fast lenses and fast ISOs. Just as frequently, the photographer will use bounce flash and a slow shutter speed to record the ambient light in the room and the surrounding faces watching the couple's first dance. The bounce flash will freeze the couple but there is often some blurring due to the slow shutter speed needed to capture the people only lit by ambient light.

The Bouquet Toss. This is one of the more memorable shots at any wedding reception. Whether you're a photojournalist or traditionalist, this shot looks best when it's spontaneous. You need plenty of depth of field, which almost dictates a wide-angle lens. You'll want to show not only the bride but also the expectant faces in the background. Although you can use available light, the shot is usually best done with two flashes: one on the bride and one on the ladies waiting for the bouquet. Your timing has to be excellent, as the bride will often "fake out" the group just for laughs. This might fake you out, as well. Try to get the bouquet as it leaves the bride's hands and before

it is caught—and if your flash recycles fast enough, get a shot of the lucky lady who catches it.

Table Shots. Table shots don't usually turn out well, are rarely ordered, and are tedious to make. If your couple absolutely wants table shots, ask them to accompany you from table to table. That way they can greet all of their guests, and it will make the posing quick and painless. Instead of table shots, consider one big group that encompasses nearly everyone at the reception (for more on this type of image, see page 57).

Kids. A great photo opportunity comes from spending time with the smallest attendees and attendants: the flower girls and ring bearers. They are thrilled with the pageantry of the wedding day and their involvement often offers a multitude of memorable shots.

LEFT—The bride will appreciate it if you get lots of precious shots of the little ones in the wedding party (usually relatives or close friends of the family). Kids are, by nature, hams in front of the camera and can be a great addition to the wedding album. Photograph by Jeff and Julia Woods. **BELOW**—At the reception be on the lookout for glamorous groups such as this one. They were actually eager to have their photo made. Photograph by Brett Florens made with a Nikon D3 and 80–200mm f/2.8 lens.

Postproduction and Album Design

Since the digital revolution, the photographer's job has become more complex. Responsibility for retouching, color management, album design, and even printing is now something that many wedding photographers readily shoulder—in exchange for the vastly improved creative control that comes with being able to control every step of the process.

The work done at this phase of the process is something that often helps a great photographer stand out from the competition.

COLOR MANAGEMENT

So why, even in a color-managed system, does the print sometimes look different than the screen image? The answer rests not so much in the color-management process, but in the differences between media. Because monitors and printers have different color gamuts (fixed ranges of color values they can produce), the physical properties make it impossible to show exactly the same colors on your screen and on paper. However, effective color management allows you to align the output from all of your devices to simulate how the color values of your image will be reproduced in a print.

Monitor Profiles. If you set up three identical monitors and had them display the exact same image, they would each look a bit different. This is where profiles come into play. Profiling, which uses a hardware calibration device and accompanying software, characterizes the monitor's output so that it displays a neutral (or at least a predictable) range of colors.

A monitor profile is like a color-correction filter. Returning to the example of the three monitors above, one monitor might be slightly green, one magenta, and one slightly darker than the other two. Once a monitor is cal-

The GretagMacBeth Eye One spectrophotometer comes with a convenient ruler guide and backing board so that the colored wedges of the test print can be read quickly and accurately. The data is then processed to create a color profile that gets loaded into the computers that are printing to a specific printer with the profiled paper.

OPTIMAL VIEWING

It is recommended that you set your computer desktop to a neutral gray for the purpose of viewing and optimizing images. Because you will most likely make adjustments to color and luminosity, it is important to provide a completely neutral, colorless backdrop to avoid distractions that might affect your critical ability to judge color. Since I deal with tens of thousands of images each year, my monitors all are optimized with neutral gray backgrounds. It's not as exciting as wallpaper, but it helps keep my sense of accurate color balance intact. To optimize your working area, the room lighting should also be adjusted to avoid any harsh, direct lighting on the monitor. This will allow more accurate adjustments to your images and will reduce eyestrain. Attempt to keep ambient light in the room as low as possible.

ibrated and profiled, and the resulting profile is stored in your computer, the profile will send a correction to the computer's video card, correcting the excess green, magenta, or brightness, respectively, so that all three monitors represent the same image identically.

Monitor profiling devices range from relatively inexpensive ($250–500) to outlandishly expensive (several thousand dollars), but it is an investment you cannot avoid if you are going to get predictable results from your digital systems.

Printer Profiles. Printer profiles are built by printing a set of known color patches from a special digital image file. A spectrophotometer then reads the color patches so the software can interpret the difference between the orig-

Printer profiles are built by printing a set of known color patches. A spectrophotometer then reads the color patches so the software can interpret the difference between the original file and the printed patches. This is a target that Claude Jodoin uses.

inal file and the actual printed patches. This information is stored in the form of a printer profile, which is then applied to future prints to ensure they are rendered correctly. Custom printer profiles ensure that you are getting the full range of colors that your printer can produce. For best results, use a unique profile for each inkjet paper you use.

Custom profiles, such as the Atkinson profiles, which are highly regarded, can be downloaded from the Epson web site (www.epson.com) and a variety of other sites. Here's how it works: go to the web site, then download and print out a color chart. Mail it back to the company, and they will send you a profile or set of profiles via e-mail.

Another great source of custom profiles for a wide variety of papers and printers is Dry Creek Photo (www.dry creekphoto.com/custom/customprofiles.htm). This company offers a profile-update package so that each time you change ink or ribbons (as in dye-sublimation printing) you can update the profile. Profiles are available for a wide variety of printer types and brands. (*Note:* Most of the expensive commercial printers that labs use include rigorous self-calibration routines, which means that a single profile will last until major maintenance is done or until the machine settings are changed.)

Camera Profiles. DSLRs are used in a wide variety of shooting conditions. This is especially true in wedding photography, where the photographer may encounter a dozen different combinations of lighting in a single afternoon, all with varying intensities and color temperatures. The wedding photographer is looking at a world of color.

Just as all monitors are different, all digital cameras vary at least a little in how they capture color. As a result, some camera manufacturers, like Canon, don't provide device profiles for their cameras. After all, if the manufacturer made one profile for all their cameras, it would prove somewhat useless. Additionally, there are software controls built into the setup and processing modes for each DSLR that allow photographers sufficient control to alter and correct the color of the captured image.

Creating a custom camera profile is beneficial if your camera consistently delivers off-color images under a variety of lighting conditions, captures skin tones improperly, or fails to record colors accurately when such precision is critical, such as in the fashion and garment industry. Commercial photographers, for example, use camera profiles to satisfy the color-rendering needs of specific assignments.

THE PHOTOSHOP REVOLUTION

Up until a few years ago, the image was rendered in the camera, but all the magic happened in the darkroom. There are countless great photographers who tell of becoming "hooked" on photography when they first saw a print emerging in the safelight gloom of the developer tray. And who can forget learning to load 35mm film onto stainless steel reels? It was a badge of courage that made learning the basics of photography seem more rewarding than a post-graduate degree.

Conventional printing and developing techniques have not disappeared; they have been rolled into Photoshop with tools that far exceed darkroom techniques. Literally everything you could do in the darkroom, except getting brown hypo stains on your clothes, can be done in Photoshop—and done better and more extensively.

The designers of Photoshop could have used any frame of reference on which to build the application—mathe-

PHOTOSHOP DOESN'T MAKE THE PHOTOGRAPHER

While Photoshop is an exciting and powerful tool for crafting elegant images, Yervant Zanazanian, an award-winning Australian wedding photographer, puts things in perspective: "A lot of photographers still think it is my tools (digital capture and Photoshop) that make my images what they are. They forget the fact that these are only new tools; imagemaking is in the eye, the mind, and the heart of a good photographer. During all my talks and presentations, I always remind the audience that you have to be a good photographer first and that you can't expect or rely on some modern tool or technology to fix a bad photograph." It's good advice.

matical or scientific, for example. But they chose photography as the medium that provided the most useful language and logic of image enhancement. And they borrowed heavily from the science of photography. Burning,

This image by Yervant is one in which the bride's veil was a very light silk and kept flying in the wind while she had fun under it with her bridesmaids. Yervant often chooses a few images that he works on in Photoshop, even before showing any proofs to the couple. These are his "signature" images. Here he copied sections of the image to make a new layer—the veil. Once he had the new layer, he then added motion blur in Photoshop in the direction of the veil's natural flow to boost the life in the moment. He then selected a section of the background and applied the purple hue to make it less tonally demanding. After he flattened the image, he added a bit of grain (Filter>Texture>Grain) to make the image suit his own personal taste.

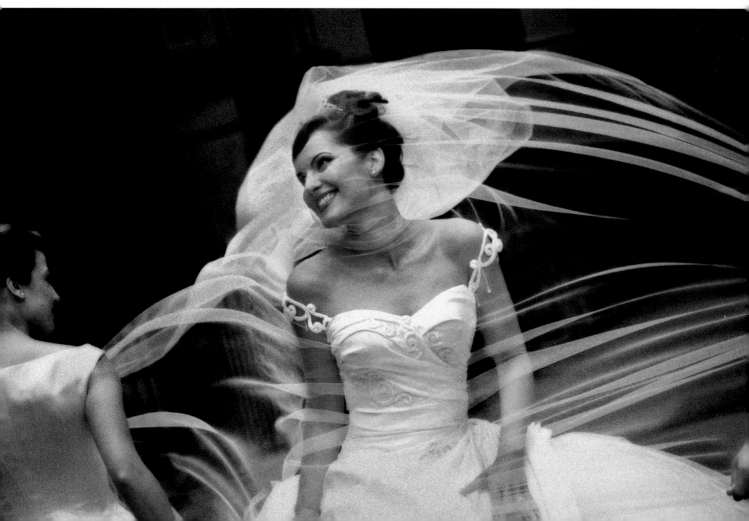

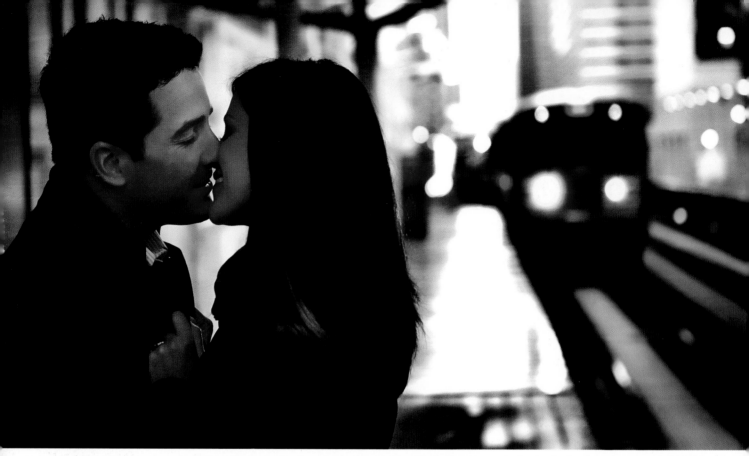

Sal Cincotta is an award-winning photographer born and raised in New York City. He works in the St. Louis metro area and his clients are couples "looking to have fun on their day and do something different." Says Sal, "Every bride wants to look like she belongs on the cover of a magazine and it's my job to help them achieve that one shot—the one they look at twenty-five years from now and say, 'Damn, I looked good!'"

dodging, cropping, curves, shadow and highlight control, and many other functions are all part of day-to-day operations with Photoshop, just as they are part of the conventional photographic lexicon.

PHOTOSHOP TOOLS AND TECHNIQUES

Layers and Masks. Layers allow you to work on one element of an image without disturbing the others. Think of layers as sheets of clear acetate stacked one on top of the other; where there is no image on a layer, you can see through to the layers below. You can change the composition of an image by changing the order and attributes of layers. In addition, special features such as adjustment layers, fill layers, and layer styles let you create sophisticated effects.

Masks control how different areas within a layer or layer set are hidden and revealed. By making changes to the mask, you can apply a variety of special effects to the layer without actually affecting the pixels on that layer. You can then apply the mask and make the changes permanent or remove the mask without applying the changes.

Using Layers. Layers are one of the most flexible tools in Photoshop. You should get into the habit of naming each layer as you create it. This will help you to organize and work with multiple layers. Just double-click on the layer name to rename it with up to 63 characters.

You should also make it your practice to duplicate the background layer before getting started working on an image. This preserves the original, which floats to the bottom of the layers palette. It also opens up creative possibilities, allowing you to alter the new layer and then lower its opacity to allow the original to show through. The eraser tool can also be useful when working on a duplicate of the background layer. For example, you can apply the posterize command (Image>Adjustments>Posterize). This will affect the entire image, but if you want to retain the photorealistic portions of the portrait, you can use the eraser tool to reveal the underlying background layer. By adjusting the opacity, you can blend the effect with the underlying data.

On many images, you will end up with quite a few layers. If you need to move them around, it's a good idea to

link them together. With one of the layers active, click to the left of the layers you want linked and a chain-link symbol appears. Linked layers can be moved or affected all at once. Clicking the chain-link symbol again will unlink the layers.

Using Layer Masks. Layer masks are used to temporarily hide portions of a layer. To create a layer mask, activate a layer (other than the background layer) and click on the layer mask icon (the circle in a square) at the bottom of the layers palette. A second thumbnail will appear beside the layer in the layers palette. With black as your foreground color, you can then use the brush tool to paint away (conceal) details in the upper layer, allowing the underlying layer to show through. To reveal the hidden areas again, change the foreground color to white and paint the areas back in.

RETOUCHING TECHNIQUES
Removing Blemishes. To remove small blemishes, dust spots, marks, or wrinkles, select the healing brush tool (or, if using Photoshop 6 or lower, the clone tool). When this tool is selected, an options bar will appear at the top of the screen. Select the normal mode and sampled as the source. Choose a soft-edged brush that is slightly larger than the area you are going to repair. Press Opt/Alt and click to sample a nearby area that has the same tone and texture as the area you wish to fix. Then, click on the blemish and the sample will replace it. If it doesn't work, hit Command + Z (Edit>Undo), then resample another area and try again. The healing brush differs from the clone tool in that the healing brush automatically blends the sampled tonality with the area surrounding the blemish or mark.

The best Photoshop work is invisible to the viewer. Salvatore Cincotta is a wedding photographer who strives to include unforgettable places and moments in his couples' wedding images. Here, the St. Louis arch serves as a backdrop for this couples wedding portrait.

Eliminating Shininess and Wrinkles. These two topics are lumped together because fixing them is easily done using the same tool and technique. The clone tool, used at an opacity of about 25 percent, is a very forgiving tool that can be applied numerous times in succession to restore a relatively large area. The mode should be set to normal and the brush should, as usual, be soft-edged. As you would when using the healing brush, sample an area by hitting Opt/Alt and clicking once. A fleeting crosshair symbol shows the sampled area as you apply the tool.

For both wrinkles and areas of shininess, sample an adjacent area with the proper tonality and begin to rework

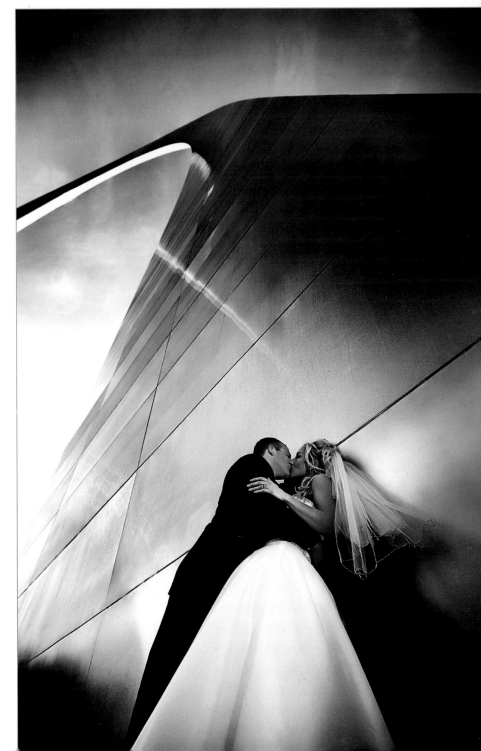

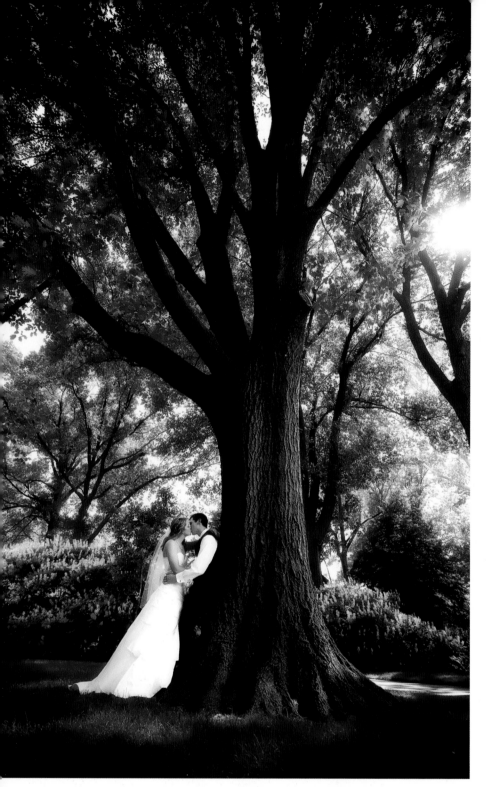

Selective Soft Focus. Selective soft focus is one of the most frequently used retouching effects in wedding and portrait photography. To create this effect, duplicate the background layer and apply the Gaussian blur filter to the new layer. Click the layer mask button to create a mask. With the brush tool selected and the foreground color set to black, start painting away the diffusion from areas like the teeth, eyes, eyebrows, hairline, lips, and bridge of the nose. By varying the opacity and flow you will restore sharpness in the critical areas while leaving the rest of the face pleasingly soft. The best thing is that there will be no telltale sign of your retouching. When you're done, flatten the layers.

Smoothing the Skin. Make a rough selection around the face, then copy and paste it to a new layer. Using a filter called Airbrush Gem Professional from Kodak, you can select a default value of 60 percent to airbrush the sharpness and pores out of the face. If you go too far, reduce the opacity in the layers palette. To disaffect certain areas, create a mask and paint on the areas with black that you want to be masked (concealed).

An alternate method is to duplicate the background layer and add 4 pixels worth of Gaussian blur. After adding a layer mask, go to Edit> Fill>Black to unmask the entire layer so that you can see through to the retouched layer underneath. Using about 35-percent opacity setting on the layer, set the foreground color to white and brush the softness back in (unmask it) with a medium-sized brush. If you overdo it, go back to the Layers Palette and reduce the opacity by about 10 percent, then inspect your results again.

the area. You will find that the more you apply the cloned image data, the lighter the wrinkle becomes or the darker the shiny area becomes. Be sure to zoom out and check to make sure you haven't overdone it. It is important not to remove the highlight or wrinkle entirely, you just want to subdue it. This is one reason why it is always safer to work on a copy of the background layer instead of the original image itself.

Enhancing the Eyes. Create a curves adjustment layer and lighten the overall image by about 20 percent. With the adjustment layer, a layer mask will automatically be created. Go to Edit>Fill>Black to mask the entire layer so that you can see through to the retouched layer underneath. With white as the foreground color, paint over the eyes to lighten them. For a natural and realistic look, you should not, however, make them completely white, nor should you entirely eliminate the natural blood vessels. To increase the color contrast between the pupil and the iris, create a second curves adjustment layer and darken the image slightly. Repeat the rest of the technique as described above, painting over the pupils to darken them.

More on Eyes. Using a small brush and the dodge tool set to highlights or midtones, you can lighten the whites. Use the burn tool and a small brush to lighten the interior of the iris, but not the edge. This increases the edge contrast in the iris for a more dynamic look. Also, burn in the pupil with black to make it more stark.

Color Correction and Toning. *Targeting White & Gray Points in Levels.* Go to levels (Image>Adjustments> Levels), select the white point eyedropper and click on a white point in the scene—a white point on the bride's wedding dress, for example. One click will not only color balance the whites, but it will bring any color shifts in the flesh tones back in line. The same technique will work well when using the gray point eyedropper (also in levels) on a neutral gray area of the photo.

When an image doesn't have a well-defined gray or white point, you cannot use this method of correction. Instead, create a new layer and go to selective color (Image> Adjustments>Selective Color). Correct the neutrals by adding or subtracting color, and then adjust the opacity of the new layer over the background layer. You will get more subtlety than if you tried to correct the entire image.

Selective Color. Many people like to use curves to color correct an image, but there are also those who prefer the selective color function (Image>Adjustments>Selective Color). It is among the most powerful tools in Photoshop. This tool does not require you to know in advance which channel (R, G, or B) is the one affecting the color shift. It only requires you to select which color needs adjustment—reds, yellows, greens, cyans, blues, magentas, whites, neutrals, and blacks. Once you've selected the color you want to adjust, use the slider controls (cyan, magenta, yellow,

and black) to make the needed correction. (*Note:* Make sure the "method" is set to absolute, which gives a more definitive result in smaller increments.) If, for example, you select reds, no other colors in the scene will be changed by any adjustments you make using the slider bars.

Skin tones are easy to correct using selective color, as well. Most caucasian skin tones consist of varying amounts of magenta and yellow. Usually when skin tones are off, they can be easily corrected by selecting neutrals, then experimenting with either the magenta or yellow sliders. In outdoor images, you will sometimes pick up excess cyan in the skin tones; this is easily dialed out in selective color.

The selective color tool is also very useful for eliminating color casts on wedding dresses, which often reflect a nearby color—particularly if the material has a satiny sheen. Outdoors, the dress might go green or blue, depending on whether shade or grass is being reflected into it. To correct the problem, you would select whites. Then, if the dress is blue or cyan, you'd add a little yellow or remove a little cyan and judge the preview. If the dress has gone green, add a little magenta and perhaps remove a slight amount of yellow.

In selective color, the black slider adds density to the image. Be sure to adjust only the black channel using the black slider, otherwise it will fog the image. When converting images from RGB to CMYK, the black slider is very useful for adding the punch that is missing after the conversion.

KODAK COLOR PRINT VIEWING FILTER KIT

If you aren't sure of the color shift in an image, there is a product available from Kodak for making color prints. It is called the Kodak Color Print Viewing Filter Kit, and is comprised of six cards—cyan, magenta, and yellow; and red, green, and blue. In a darkened room, inspect your image on the monitor using the card that is the complementary color of the indicated color shift. For example, if the shift looks blue, use the yellow card to view the image. If the color shift is green, choose the magenta card, and so on. Flick the appropriate card quickly in and out of your field of view, examining the midtones and shadows as you do so. Avoid looking at the image highlights; you will learn nothing from this. If the yellow card, in this example, neutralizes the color shift in the midtones and shadows, then you are on the right track. There are three densities on each card, so try each one before ruling out a specific color correction.

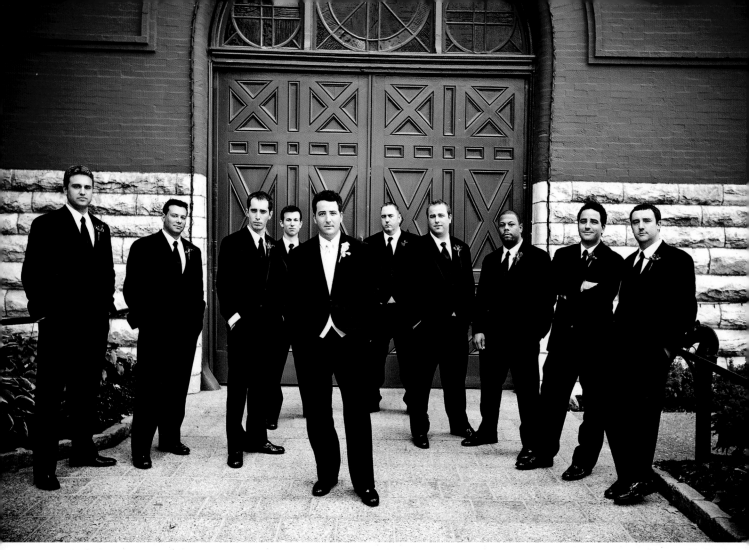

This is a nice blend of soft color and increased contrast by Sal Cincotta. Sal reduced the saturation by –50 in Lightroom and increased brightness and contrast by +50 and +75, respectively. He also adjusted the tint and white balance as well as adding a healthy vignette, all in Lightroom.

You can also create a selection and color correct only that area. For teeth, for example, a loose selection around the mouth will do; then adjust the whites by subtracting yellow. It's a quick and effective means of whitening teeth.

Sepia/Blue Tone. Create a copy of your background layer, then go to Image>Adjustments>Desaturate to create a grayscale image. In necessary, you can adjust the levels at this point.

Next, go to selective color (Image>Adjustments>Selective Color). Select the neutrals channel and adjust the magenta and yellow sliders up. More magenta than yellow will give you a truer sepia tone. More yellow than magenta will give a brown or selenium image tone. The entire range of warm toners is available using these two controls.

If you want to a cool-toned image, either add cyan, reduce yellow, or do both. Again, a full range of cool tones is available in almost infinite variety.

Once you have created a number of image tones you like, you can create actions for them, specifying the exact values for each adjusted color.

Soft Color. This is a technique that mutes the colors in an image. To achieve it, duplicate the background layer and convert it using Image>Adjustments>Gradient Map. Choose a black-to-white gradient for a full-tone black & white image. Blur the underlying color layer using the Gaussian blur filter with a radius setting of about 12 pixels. In the layers palette, reduce opacity of the black & white layer to about 65 percent. Add another adjustment layer (Layer>New Adjustment Layer>Photo Filter), then vary the setting of the filter for a range of colored effects.

Liquify. Liquify is a separate application within Photoshop. The liquify filter lets you push, pull, rotate, reflect, pucker, and bloat any area of an image. The distortions you create can be subtle or drastic, which makes the com-

mand a powerful tool for retouching images as well as creating artistic effects.

The best way to control your results is to begin by making a selection with the lasso tool. Then go to Filter> Liquify. When your selection comes up, you'll see that it has a brush with a crosshair in it. In the panel to the right, you can adjust this brush size for more precise control. Gently push the area that you want to shrink or stretch, gradually working it until you form a clean line. Hit Enter, and you will return to the original image with the selection still active—but with your modifications in place.

Single-Channel Sharpening. If you sharpen the image in the RGB composite channel, you are sharpening all three channels simultaneously. This can lead to color shifts and degradation in quality. Instead, go to the channels palette and look at each channel individually. Sharpen the channel with the most midtones (usually the green channel, but not always), then turn the other two channels back on. This will produce a much finer rendition than sharpening all three channels.

Color Sampling. One of Charles Maring's tricks of the trade is sampling colors from the images on his album pages in Photoshop. This is done by using Photoshop's eyedropper tool. When you click on an area, the eyedropper reveals the component colors in either CMYK or RGB in the color palette. He then uses those color readings for graphic elements on the page he designs for those photographs, producing an integrated, color-coordinated design on the album page. If using a page-layout program like QuarkXpress or InDesign, those colors can be used at 100 percent or any lesser percentage for color washes on the page or background colors that match the Photoshop colors precisely.

Jerry D, who specializes in digital makeovers, says his clients many times love the pictures but sometimes don't love themselves in the pictures. Jerry utilized many Photoshop tricks to get this image right. He selectively softened it, vignetted the image with a diffused colored vignette, and then the magic started. The bride asked him to make her slimmer, which he did by moving her arm closer to her body to mask the line of her torso. In this image, Jerry removed her arm in Photoshop and pasted it back onto her body, made thinner with the liquify filter. You cannot tell where the retouching was done and the bride was ecstatic over Jerry's magic.

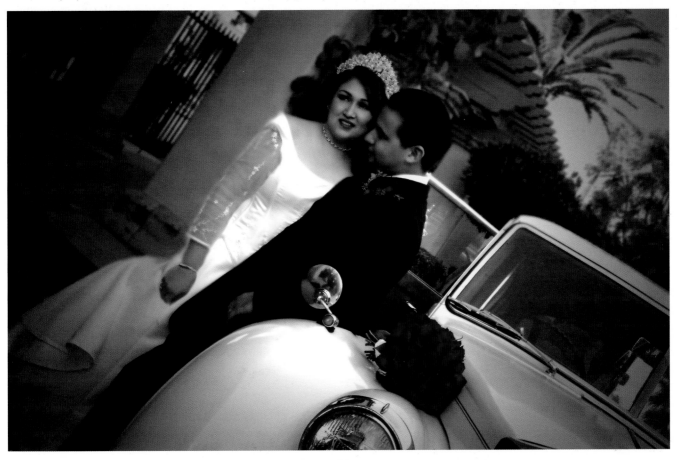

WEDDING ALBUMS

Creating an outstanding wedding album is the objective of virtually all wedding photographers—and one of the reasons that many photographers are also expanding their skills to include graphic design. Today's brides demand very refined styles.

Album Types. Many wedding photographers prefer to use traditional wedding albums, either because their clients request them or because they feel that traditional albums represent a hallmark of timeless elegance. These feature drop-in pages or pages to which images are permanently mounted and can be bound in a variety of fashions.

More recently, magazine-type album with flush bleed pages, exotic covers, and just about any other design feature you can imagine have become a very popular choice among brides seeking a contemporary style.

Album Design. Like any good story, a wedding album should have a beginning, a middle, and an end. For the most part, albums are laid out chronologically. However, there are now vast differences in the presentation—primarily caused by the digital page-layout process. Often, events are jumbled in favor of themes or other methods of organization. There still must be a logic to the layout, though, and it should be readily apparent to everyone who examines the album. The wedding album has changed drastically, evolving into more of a storytelling medium. Still, album design is basically the same thing as laying out a book, and there are some basic design principles that should be followed.

Title Page. An album should always include a title page, giving the details of the wedding day. It will become a family album, and having a title page will add an historic element to its priceless nature.

Left and Right Pages. Look at any well designed book or magazine and study the images on left- and right-hand pages. They are decidedly different, but have one thing in common: they lead the eye into the center of the book, commonly referred to as the "gutter." These photos use the same design elements that photographers use in creating effective images—lead-in lines, curves, shapes, and patterns. If a line or pattern forms a "C" shape, it is an ideal left-hand page, since it draws the eye toward the gutter and across to the right-hand page. If an image is a backward "C" shape, it is an ideal right-hand page.

Variety. When you lay out your images for the album, think in terms of variety of size. Some images should be small, some big. Some should extend across the spread. Some, if you are daring, can even be hinged and extend outside (above or to the right or left) the bounds of the album. No matter how good the individual photographs are, the effect of an album in which all the images are the same size is static.

Visual Weight. Learn as much as you can about the dynamics of page design. Think in terms of visual weight, not just size. Use symmetry and asymmetry, contrast and balance. Create visual tension by combining dissimilar elements. Don't be afraid to try different things.

Reading Direction. Remember a simple concept: in Western civilization, we read from left to right and top to bottom. We start on the left page and finish on the right. Good page design starts the eye at the left and takes it to the right, and it does so differently on every page.

CREATIVITY COUNTS

Wedding photojournalism seems to be bringing the best and brightest artists into the field because of its wide-open level of creativity. Martin Schembri, who produces elegant, magazine-style digital wedding albums, is as much a graphic designer as a top-drawer photographer. Schembri assimilates design elements from the landscape of the wedding—color, shape, line, architecture, light and shadow—and he also studies the dress, accessories, etc. He then works on creating an overall work of art that reflects these design elements on every page.

Conclusion

The digital age is fully upon us, and particularly upon the wedding photographer. Every day, new professionals—whose self-confidence is buoyed by the technical ease of the latest generation of DSLRs—are entering the field. Established wedding professionals are feeling the pinch of competition, and the recent economic woes have not improved their situation. The number of high-end weddings is dwindling, no doubt about it. Whether this represents a lasting trend or a temporary reaction to the state of the economy remains to be seen. Is there cause for pessimism? Probably not. This type of cycle has occurred before, most notably when the autofocus SLR was first introduced, making professional pictures easier to make. Camera sales flourished but the number of professional photographers stayed roughly the same. The reason? The talented and creative photographer with savvy business and marketing skills will win out every time. If you want to be among the select few who thrive in this competitive marketplace, however, there is a need to improve ones skills, technique, and business acumen.

The technology designed almost specifically for wedding photographers, such as ultra-high ISO speeds and WiFi simultaneous transmission of images, and radically improved small-flash lighting control—not to mention the radical new lens designs that vastly exceed the quality of existing lens designs—are all signs of a healthy market situation. After all, camera makers do not increase research and development or add new product releases in the face of dwindling sales. Currently, we are witnessing the rejuvenation of once-famous brands like Pentax, Leica and Olympus, with impressive offerings for the professional.

The number of new photographers and young photographers is staggering. But as trends cycle—in this case a partial return to more traditional posing and lighting—greater skill and knowledge will be expected of the contemporary wedding photographer. Greater emphasis will fall on education and knowledge, as has always been the case. The professional wedding photographer is, after all, the one who can handle any situation that comes up on wedding day, no matter how trying.

Will photojournalism and reduced formalism still dominate wedding pictures? Probably, at least until the pendulum swings back to a more formal style. Will we ever return to the cookie-cutter albums of yesteryear? Probably not. Today's and tomorrow's brides are way too sophisticated to accept wedding photographs that do not offer originality and uniqueness.

The Photographers

Nick and Signe Adams. Nick and Signe Adams started Nick Adams Photography in St. George, UT, in 2002. They have been winning awards since they became WPPI members. They maintain a boutique-type studio business in an historic section of St. George. Their web site is www.nickadams.com.

Stuart Bebb. Stuart Bebb is a Craftsman of the Guild of Photographers UK and has been awarded Wedding Photographer of the Year in both 2000 and 2002. In 2001 Stuart won *Cosmopolitan Bride* Wedding Photographer of the Year. He was also a finalist in the Fuji wedding photographer of the Year. Stuart has been capturing stunning wedding images for over twenty years and works with his wife Jan, who creates and designs all the albums.

David Beckstead. David Beckstead has lived in a small town in Arizona for twenty-two years. With help from the Internet, forums, digital cameras, seminars, WPPI, Pictage and his artistic background, his passion has grown into a national and international wedding photography business. He refers to his style of wedding photography as "artistic photojournalism."

Marcus Bell. Marcus Bell's creative vision, fluid natural style and sensitivity have made him one of Australia's most revered photographers. It's this talent combined with his natural ability to make people feel at ease in front of the lens that attracts so many of his clients. Marcus' work has been published in numerous magazines in Australia and overseas including *Black White, Capture, Portfolio Bride,* and countless other bridal magazines.

Joe Buissink. Joe Buissink is an internationally recognized wedding photographer from Beverly Hills, CA. Almost every potential bride who picks up a bridal magazine will have seen Joe Buissink's photography. He has photographed numerous celebrity weddings, including Christina Aguilera's 2005 wedding, and is a multiple Grand Award winner in WPPI print competition.

Frank Cava. Co-owner of Photolux Studio in Ottawa, Canada, Frank is a successful and award-winning wedding and portrait photographer. Frank is a member of the Professional Photographers of Canada and WPPI and speaks to professional organizations in the U.S. and Canada along with his brother Anthony Cava, also an acclaimed photographer.

Ben Chen. Ben Chen is a freelance photojournalist located in Southern California. He is best known for his sports photographs, which have been published in the nation's leading magazines and newspapers. Ben has recently become a wedding photographer and is using his instincts as a photojournalist to build his business. Visit his web site at www.socalpixels.com.

Salvatore Cincotta. Sal Cincotta is an award-winning photographer, born and raised in New York City. He works in the St. Louis metro area and his clients are couples "looking to have fun on their day and do something different." Says Sal, "Every bride wants to look like she belongs on the cover of a magazine and it's my job to help them achieve that one shot—the one they'll look at years from now and say, 'Damn, I looked good!'"

Mike Colón. Mike Colón is a celebrated wedding photojournalist from the San Diego area. Colón's natural and fun approach frees his subjects to be themselves, revealing their true personality and emotion. His images combine inner beauty, joy, life, and love frozen in time forever. He has spoken before national audiences on the art of wedding photography.

Michael Costa. Michael Costa is an award-winning photographer who graduated with honors from the world-renowned Brooks Institute of Photography in Santa Barbara, CA, receiving the coveted Departmental Award in the Still Photography program. He started his successful business with his wife, Anna during his last year at Brooks.

Jerry D. Jerry D owns and operates Enchanted Memories, a successful portrait and wedding studio in Upland, CA. Jerry has had several careers in his lifetime, from licensed cosmetologist to black belt martial arts instructor. Jerry is a highly decorated photographer by WPPI and has achieved many national awards since joining the organization.

Jesh de Rox. Jesh de Rox is a Canadian photographer from Edmonton, Alberta who burst onto the wedding photography scene at the WPPI 2006 convention, where thirty-eight of his

entries scored eighty or above. He now teaches extensively all over the country and has a growing wedding business. He is the author and designer of Fine Art Textures, for sale to other photographers for enhancing their artwork, at www.jesh derox.com.

Noel Del Pilar. Noel Del Pilar is an award-winning wedding photographer from San Juan, Puerto Rico. After 15 years of photographing weddings, he has established a reputation as a wedding photographer on the cutting edge; his embrace of wedding photojournalism has helped transform the look of wedding photography in Puerto Rico today. Noel Del Pilar specializes in destination weddings and is a preferred vendor of some of the best hotels in Puerto Rico.

Dan Doke. Daniel has a drive for perfection, abundant creativity, and special eye for light and form. He is a modern photographer with traditional skills, who draws on his experience in commercial, fashion, and portrait photography to create memorable wedding images.

Mauricio Donelli. Mauricio Donelli is a wedding photographer from Miami, FL. His work is a combination of styles, consisting of traditional photojournalism with a twist of fashion and art. His weddings are photographed in what he calls, "real time." His photographs have been published in *Vogue, Town & Country,* and many national and international magazines. He has photographed weddings around the world.

Bruce Dorn and Maura Dutra. These award-winning digital imagemakers learned their craft in Hollywood, New York, and Paris. Maura has twenty years' experience as an art director and visual effects producer, and Bruce capped a youthful career in fashion and advertising photography with a twenty-year tenure in the very exclusive Director's Guild of America. They have earned a plethora of industry awards for excellence in image-making, and now teach worldwide.

Brett Florens. Having started as a photojournalist, Brett has become a renowned international wedding photographer, travelling from South Africa to Europe, Australia, and the U.S. for discerning bridal couples requiring the ultimate in professionalism and creativity. His exceptional albums are fast making him the "must have" photographer around the globe and the number one photographer in his native South Africa.

Jerry Ghionis. Jerry Ghionis of XSiGHT Photography and Video is one of Australia's leading photographers. In 1999, he was honored with the AIPP (Australian Institute of Professional Photography) award for best new talent in Victoria. In 2002, he won the AIPP's Victorian Wedding Album of the Year; a year later, he won the Grand Award in WPPI's album competition.

Greg Gibson. Greg is a two-time Pulitzer Prize winner whose assignments have included three Presidential campaigns, daily coverage of the White House, the Gulf War, Super Bowls, and much more. Despite numerous offers to return to journalism, Greg finds shooting weddings the perfect genre to continually test his skills.

Al Gordon. Alfred Gordon was recognized as one of Florida's top-ten photographers in 2001, 2002, and 2003. He operates a full-service studio and has photographed weddings throughout the Southeast. He holds the Master Photographer and Photographic Craftsman degrees from the PPA. He is also a Certified Professional Photographer from the PPA, and has earned the AOPA degree from WPPI. He received the coveted Kodak Trylon Gallery Award twice, and has images in the coveted ASP Masters Loan Collection.

Jo Gram and Johannes Van Kan. Johannes and Jo are the principals at New Zealand's Flax Studios, which caters to high-end wedding clients. Johannes has a background in newspaper photography; Jo learned her skills assisting top wedding photographers. In 2005, they teamed up—and they have been winning major awards in both Australia and New Zealand ever since.

Michael Greenberg. Michael Greenberg, of Phototerra Studios in Toronto, is self-taught as a wedding photographer. In other lives he's been a doctor and a computer programmer—but he loves the sheer joy of shooting weddings. In 2008, Michael was awarded first place by WPPI in the Photojournalism category and twenty-three of his images were awarded Awards of Excellence. Visit Michael's site and blog at www.weddingpicture.info.

Jeff and Kathleen Hawkins. Jeff and Kathleen operate a high-end wedding and portrait photography studio in Orlando, FL, and are the authors of *Professional Marketing & Selling Techniques for Wedding Photographers* (Amherst Media). Jeff has been a professional photographer for over twenty years. Kathleen holds an MBA and is a past president of the Wedding Professionals of Central Florida (WPCF). They can be reached at www.jeffhawkins.com.

Gene Higa. Gene Higa travels the world doing what he loves: photographing weddings. He is one of the most sought-after wedding photographers in the world. Originally from Los Angeles, Gene makes his home in San Francisco, but calls the world his office. He has been commissioned to photograph weddings in Spain, the Philippines, Peru, India, Italy, Greece, Mexico, Hawaii, Jamaica, Thailand and on and on. For more, visit www.genehiga.com.

Kevin Jairaj. Kevin is a fashion photographer turned wedding and portrait photographer whose creative eye has earned him a stellar reputation in the Dallas/Fort Worth, TX area. His web site is www.kjimages.com.

Claude Jodoin. Claude Jodoin is an award-winning photographer from Detroit, MI. He has been involved in digital imaging since 1986 and has not used film since 1999. He is an event specialist who shoots numerous weddings and portrait sessions throughout the year. You can e-mail him at claudej1@aol.com.

Jeff Kolodny. Jeff Kolodny began his career as a professional photographer in 1985 after receiving a BA in Film Pro-

duction from Adelphi University in New York. Jeff recently relocated his business from Los Angeles to south Florida, where his ultimate goal is to produce digital wedding photography that is cutting edge and sets him apart from others in his field.

Kevin Kubota. Kevin Kubota formed Kubota Photo-Design in 1990 as a solution to stifled personal creativity. The studio shoots a mix of wedding, portrait, and commercial photography, and was one of the early pioneers of pure-digital wedding photography. Kubota is well know for training other photographers to make a successful transition from film to digital.

Emin Kuliyev. Emin is originally from Russia, a large town in Azerbaijan. He has been photographing weddings in New York for more than six years and he has trained under many respected photographers from around the world. He started his own wedding studio in the Bronx in 2000. Today he is a well respected and award-winning wedding photograqpher.

Scott Robert Lim. Scott Robert Lim is an award winning photographer, educator and national speaker with a photographic style that blends both photojournalism and portraiture with an elegant flare. He is one of America's most in-demand wedding photographers and is a preferred photographer at world-renowned establishments like Los Angeles' Bel-Air Hotel.

Charles and Jennifer Maring. Charles and Jennifer Maring own Maring Photography Inc. in Wallingford, CT. His parents, also photographers, operate Rlab (resolutionlab.com), a digital lab that does all of the work for Maring Photography and other discriminating photographers. Charles Maring was the winner of WPPI's Album of the Year Award in 2001.

Cliff Mautner. After fifteen years as a photojournalist with the *Philadelphia Inquirer*, Cliff Mautner has experienced just about every situation a photographer could possibly encounter. Whether he was shooting in Liberia, following the President on a campaign stop, covering spelunking in central Pennsylvania or any of the 6000 or so other assignments he's documented, he never dreamed that he would be enjoying wedding photography as much as he does. His images have been featured in *Modern Bride, Elegant Wedding, The Knot,* and various other wedding publications.

Annika Metsla. Photographer Annika Metsla lives in Estonia, a small country in Eastern Europe between Latvia and Russia, bordering the Baltic Sea and Gulf of Finland. An active member of WPPI, Annika operates a thriving photography and wedding planning business, and has recently won a number of awards in WPPI competitions. Visit her at www.annika metsla.com.

Tom Muñoz. Tom Muñoz is a fourth-generation photographer whose studio is in Fort Lauderdale, FL. Tom up holds the classic family traditions of posing, lighting, and composition, yet is 100-percent digital. He believes that the traditional techniques blend perfectly with exceptional quality of digital imaging.

Gordon Nash. Gordon Nash owns A Paradise Dream Wedding, one of Hawaii's largest and most successful wedding photography and coordination businesses. He also developed a second, lower-end wedding company called Aekai Beach, staffed by younger photographers whom he mentors. To learn more, visit www.gordonnash.com and www.mauiwedding.net.

Laura Novak. Laura Novak is a studio owner in Delaware. She has achieved more than a dozen Accolades of Excellence from WPPI print competitions. She is also a member of PPA and the Wedding Photojournalist Association of New Jersey. Laura's work can be seen in wedding magazines across the country, including *Modern Bride* and *The Knot*.

Michael O'Neill. As an advertising and editorial photographer who specializes in people, personalities, and product illustration, Michael O'Neill has worked clients including Nikon USA, The New York Jets, Calvin Klein, and Avis. Finding his editorial style of portraiture being the most sought after of his creations, Michael narrowed his specialty to producing portraits—not only for large corporate concerns, but for a discriminating retail market as well.

Louis Pang. Louis Pang is Malysia's most awarded wedding and portrait photographer and the first Malaysian to win a first place in WPPI's largest and most prestigious print competitions. Louis is an Epson Stylus Pro and covers weddings throughout the world. He and his wife Jasmine reside in Sabah, East Malaysia.

Joe Photo. Joe Photo's wedding images have been featured in numerous publications such as Grace Ormonde's *Wedding Style, Elegant Bride, Wedding Dresses,* and *Modern Bride*. His weddings have also been seen on NBC's *Life Moments* and Lifetime's *Weddings of a Lifetime* and *My Best Friend's Wedding*.

Ray Prevost. Ray Prevost worked for twenty-seven years as a medical technologist in the Modesto, CA area. He was always interested in photography but it wasn't until his two daughters were in college that he decided to open up his studio full time. He received Certification from PPA in 1992, and his masters degree in 1996.

JB and DeEtte Sallee. Sallee Photography has only been in business since 2003, but it has already earned many accomplishments. In 2004, JB received the first Hy Sheanin Memorial Scholarship through WPPI. In 2005, JB and DeEtte were also named Dallas Photographer of the Year.

Ryan Schembri. Ryan Schembri has grown up in the world of wedding photography, having worked with his dad, Martin Schembri, since the age of twelve. In 2004, at the age of twenty, Ryan became the youngest Master of Photography with the Australian Institute of Professional Photographers. He has gone on to earn many other distinctions and has also spoken at seminars around the world. www.martinschembri.com.au/.

Michael Schuhmann. Michael Schuhmann of Tampa Bay, FL, is an acclaimed wedding photojournalist who believes in creating weddings with the style and flair of the fashion and

bridal magazines. He says, "I document weddings as a journalist and an artist, reporting what takes place, capturing the essence of the moment." He has been the subject of profiles in *Rangefinder* and *Studio Photography & Design*.

Kenneth Sklute. Kenneth began his career in Long Island, and now operates a thriving studio in Arizona. He has been named Long Island Wedding Photographer of The Year (fourteen times!), PPA Photographer of the Year, and APPA Wedding Photographer of the Year. He has also earned numerous Fuji Masterpiece Awards and Kodak Gallery Awards.

Cherie Steinberg Coté. Cherie began her photography career as a photojournalist at the *Toronto Sun*, where she had the distinction of being the first female freelance photographer. She currently lives in Los Angeles and has recently been published in the *L.A. Times, Los Angeles Magazine,* and *Town & Country.*

Steve Tarling. After having freelanced in travel, fashion, wedding, and industrial photography since leaving art school in 1985, Steve Tarling established A Little Box of Memories. He is now an in-demand speaker on contemporary wedding photography. Steve was also named Great Britain's 2003 Wedding Photographer of the Year.

Roberto Valenzuela. Roberto Valenzuela is an internationally recognized photographer. He graduated from the University of Arizona with a double major in international economics and marketing. He is fluent in Spanish and English. Roberto Valenzuela currently resides in Beverly Hills, CA but travels frequently to Tucson, AZ (his hometown), Boston, MA and throughout the U.S. photographing weddings nationwide. He is also available for destination weddings worldwide.

Marc Weisberg. Marc Weisberg specializes in wedding and event photography. A graduate of UC Irvine with a degree in fine art and photography, he also attended the School of Visual Arts in New York City before relocating to Southern California in 1991. His images have been featured in *Wines and Spirits, Riviera, Orange Coast Magazine,* and *Where Los Angeles.*

David Anthony Williams (M.Photog. FRPS). Williams operates a wedding studio in Ashburton, Victoria, Australia. In 1992, he was awarded Associateship and Fellowship of the Royal Photographic Society of Great Britain (FRPS). In 2000, he was awarded the Accolade of Outstanding Photographic Achievement from WPPI. He was also a Grand Award winner at their annual conventions in both 1997 and 2000.

Jeffrey and Julia Woods. Jeffrey and Julia Woods are award-winning wedding and portrait photographers who work as a team. They were awarded WPPI's Best Wedding Album of the Year for 2002 and 2003, two Fuji Masterpiece awards, and a Kodak Gallery Award. See more of their images at www.jw weddinglife.com.

Yervant Zanazanian (M. Photog. AIPP, F.AIPP). Yervant was born in Ethiopia (East Africa), where he worked after school at his father's photography business (his father was photographer to the Emperor Hailé Silassé of Ethiopia). Yervant owns one of the most prestigious photography studios of Australia and services clients both nationally and internationally.

Regina and Denis Zaslavets. Denis and Regina are originally from Odessa, Ukraine but now reside in the U.S., where they own Assolux Photography. This small studio offers portraiture for adults and children, formal engagements, and family portraits—but weddings, which they cover as a team, are their main passion.

Glossary

Adobe Camera Raw. A plug-in lets you open a camera's RAW image file directly in Photoshop without using another program to convert the camera RAW image into a readable format. As a result, all your work with camera RAW image files can be completely done in Photoshop.

Adobe DNG. Adobe Digital Negative (DNG) is a publicly available archival format for the RAW files generated by digital cameras. By addressing the lack of an open standard for the RAW files created by individual camera models, DNG helps ensure that photographers will be able to access their files in the future.

Adobe RGB 1998. The largest recommended RGB working space. Well suited for print production with a broad range of colors. Widest gamut color space of working RGBs.

Balance. A state of visual symmetry among elements in a photograph.

Barn Doors. Black folding doors that attach to a light's reflector; used to control the width of the beam of light.

Bleed. A page in a book or album in which the photograph extends to the edges of the page.

Bounce Flash. Bouncing the light of a studio or portable flash off a surface to produce indirect, shadowless lighting.

Broad Lighting. Portrait lighting in which the key light illuminates the side of the face turned toward the camera.

Burning. A darkroom technique in which specific areas of the photograph are given additional exposure to darken them. In Adobe Photoshop, the burn tool accomplishes the same job.

Butterfly Lighting. Portrait lighting pattern characterized by a high key light placed directly in line with the line of the subject's nose. This lighting produces a butterfly-like shadow under the nose. Also called Paramount lighting.

Calibration. The process of altering the behavior of a device so that it will function within a known range of performance or output.

Catchlight. Specular highlights that appear in the iris or pupil of the subject's eyes reflected from the portrait lights.

Channel. Used extensively in Photoshop, channels are images that use grayscale data to portray image components. Channels are created whenever you open a new image and accessed in the channels palette. The image's color mode determines the number of color channels created. For example, an RGB image has four default channels: one for each of the red, green, and blue primary colors, plus a composite channel used for editing the image. Additional channels can be created in an image file for such things as masks or selections.

Color Management. A system of software-based checks and balances that ensures consistent color through a variety of capture, display, editing, and output device profiles.

Color Space. The range of colors a device can produce.

Color Temperature. The degrees Kelvin of a light source, film sensitivity, or white-balance setting. Color films are balanced for 5500K (daylight), 3200K (tungsten), or 3400K (photoflood).

Cross-Lighting. Lighting that comes from the side of the subject, skimming facial surfaces to reveal the texture in the skin. Also called side-lighting.

Curves. In Photoshop, a tool that allows you to change the tonality and color of an image. In the RGB mode, bowing the curve upward lightens an image; bowing the curve downward darkens it. The steeper sections of the curve represent portions of an image with more contrast. Conversely, flatter sections of the curve represent areas of lower contrast in an image.

Depth of Field. The distance that is sharp beyond and in front of the focus point at a given f-stop.

Dodging. Darkroom technique in which specific areas of the print are given less exposure by blocking the light. In Photoshop, the dodge tool accomplishes the same job.

Dragging The Shutter. Using a shutter speed slower than the X-sync speed to capture the ambient light in a scene.

Embedding. The process of including a color profile as part of the data within an image file. Color space, for example, is an embedded profile.

EPS (Encapsulated Postscript). File format capable of containing both high-quality vector and bitmap graphics, including flexible font capabilities. The EPS format is supported by most graphic, illustration, and page-layout software.

EXIF (Exchangeable Image Format). EXIF is a digital imaging standard for storing metadata, such as camera settings and other text, within image files. EXIF data is found under File>File Info in Photoshop.

Feathering. (1) Misdirecting the light so that the edge of the beam illuminates the subject. (2) In Adobe Photoshop, softening the edge of a selection so that changes to it blend seamlessly with the areas around it.

Fill Card. A white or silver-foil-covered reflector used to redirect light back into the shadow areas of the subject.

Fill Light. Secondary light source used to fill in the shadows created by the key light.

Flashmeter. An incident light meter that measures the ambient light of a scene and, when connected to an electronic flash, will read flash only or a combination of flash and ambient light.

Foreshortening. A distortion of normal perspective caused by close proximity of the lens to the subject.

45-degree lighting. Portrait lighting pattern characterized by a triangular highlight on the shadow side of the face. Also known as Rembrandt lighting.

FTP (File Transfer Protocol). A means of opening a portal on a web site for direct transfer of large files or folders to or from a web site .

Gamut. Fixed range of color values reproducible on a display (*e.g.,* monitor) or output (*e.g.,* printer) device. Gamut is determined by the color gamut, which refers to the actual range of colors, and the dynamic range, which refers to the brightness values.

Gaussian Blur. Filter used to blur a selection by an adjustable amount. Gaussian refers to the bell-shaped curve that is generated when Photoshop applies a weighted average to the pixels. The Gaussian blur filter adds low-frequency detail and can produce a hazy effect.

High-Key Lighting. Type of lighting characterized by a low lighting ratio and a predominance of light tones.

Highlight Brilliance. The specularity of highlights on the skin. An image with good highlight brilliance shows specular highlights within a major highlight area.

Histogram. A graph associated with a single image file that indicates the number of pixels that exist for each brightness level. The range of the histogram represents 0 to 255 from left to right, with 0 indicating "absolute" black and 255 indicating "absolute" white.

ICC Profile. File containing device-specific information describing how the device behaves toward color density and color gamut. Since all devices communicate differently as far as color is concerned, profiles enable the color management system to convert device-dependent colors into or out of each specific color space based on the profile for each component in the workflow. ICC profiles can utilize a device-independent color space to act as a translator between different devices.

Interpolation. When an image is resampled, an interpolation method is used to assign color values to any new pixels Photoshop creates, based on the color values of existing pixels in the image. For interpolation, choose one of the following options: bilinear for a medium-quality method; bicubic for the slow but more precise method, resulting in the smoothest tonal gradations; bicubic smoother when you're enlarging images; and bicubic sharper for reducing image size. This method maintains the detail in a resampled image. It may, however, oversharpen some areas of an image. In this case, try using bicubic.

JPEG (Joint Photographic Experts Group). An image file format with various compression levels. The higher the compression rate, the lower the image quality. Although there is a form of JPEG that employs lossless compression, the most commonly used forms of JPEG employ lossy compression algorithms, which discard varying amounts of image data in order to reduce file storage size.

Kicker. A backlight (from behind the subject) that highlights the hair, side of the face or contour of the body.

Lead-In Line. A pleasing line that leads the viewer's eye toward the subject.

Levels. In Photoshop, levels allows you to correct the tonal range and color balance of an image. In the levels dialog box, input refers to the original intensity values of the pixels in an image and output refers to the revised color values based on your adjustments.

Lossy/Lossless Compression. Many file formats use compression to reduce the file size of bitmap images. Lossless techniques compress the file without removing image detail or color information; lossy techniques remove detail.

Lighting Ratio. The difference in intensity between the highlight side of the face and the shadow side of the face.

Loop Lighting. Portrait lighting pattern characterized by a loop-like shadow on the shadow side of the face. Differs from Paramount or butterfly lighting because the main light is slightly lower and farther to the side of the subject.

Low-Key Lighting. Lighting characterized by a high ratio, strong scene contrast, and a predominance of dark tones.

Main Light. The light used to establish the lighting pattern and define the facial features of the subject.

Mask. In Photoshop, an adjustment tool that sits atop a layer, allowing you to isolate areas of an image as you apply color changes, filters, or other effects to the unmasked part of the image. When you select part of an image, the area that is not selected is "masked" or protected from editing.

Metadata. Metadata (literally, data about data) preserves information about the contents, copyright status, origin, and history of documents, and can be used to search for files.

Modeling Light. Secondary light in the center of a studio flash head that gives a close approximation of the lighting that the flash tube will produce. Usually high-intensity quartz bulbs.

Noise. Extraneous visible artifacts that degrade image quality. Image noise is made up of luminance (grayscale) noise, which makes an image look grainy, and chroma (color) noise, which is usually visible as colored artifacts in the image. Photographing with a higher ISO can result in images with objectionable noise. Luminance smoothing reduces grayscale noise, while color noise reduction reduces chroma noise.

Overlighting. Main light is either too close to the subject, or too intense and oversaturates the skin with light, making it impossible to record detail in highlighted areas. Best corrected by feathering the light or moving it back.

Parabolic Reflector. Oval-shaped dish that houses a light and directs its beam outward in an even, controlled manner.

Paramount Lighting. One of the basic portrait lighting patterns. Characterized by a high-key light placed in line with the subject's nose. This lighting produces a butterfly-like shadow under the nose. Also called butterfly lighting.

Perspective. The appearance of objects in a scene as determined by their relative distance and position.

Profiling. Method by which the color reproduction characteristics of a device are measured and recorded in a standardized fashion. Profiles are used to ensure color consistency throughout the workflow process.

PSD (Photoshop Document). The default file format in Photoshop and the only format that supports all Photoshop features. The PSD format saves all image layers created within the file.

RAW File. A file format that records data from the sensor without applying in-camera corrections. To use the images, the files must be processed by compatible software.

Reflected Light Meter. A meter that measures the amount of light reflected from a surface or scene. All in-camera meters are of the reflected type.

Reflector. (1) Same as fill card. (2) A housing on a light that reflects the light outward in a controlled beam.

Rembrandt Lighting. Same as 45-degree lighting.

Resolution. The number of pixels or dots per inch. When printed, higher-resolution images can reproduce more detail and subtler color transitions than lower-resolution images because of the density of the pixels in the images.

Rim Lighting. Portrait lighting pattern wherein the key light is behind the subject and illuminates the edges of the subject's features. Most often used with profile poses.

Seven-Eighths View. Facial pose that shows approximately seven-eighths of the face. Almost a full-face view as seen from the camera.

Sharpening. In Photoshop, filters that increase apparent sharpness by increasing the contrast of adjacent pixels in an image.

Short Lighting. One of two basic types of portrait lighting in which the key light illuminates the side of the face turned away from the camera.

Slave. A remote triggering device used to fire auxiliary flash units. These may be optical or radio-controlled.

Specular Highlights. Sharp, dense image points on the negative. Specular highlights are very small and usually appear on pores in the skin.

Split Lighting. Type of portrait lighting that splits the face into two distinct areas: shadow and highlight. The key light is placed far to the side of the subject and slightly higher than the subject's head height.

sRGB. Color-matching standard jointly developed by Microsoft and Hewlett-Packard. Cameras, monitors, applications, and printers that comply with this standard are able to reproduce colors the same way. Also known as a color space designated for digital cameras. sRGB is suitable for RGB images destined for the web but not recommended for print production work, according to Adobe.

Straight Flash. The light of an on-camera flash unit that is used without diffusion.

TTL-Balanced Fill-Flash. Flash exposure system that reads the flash exposure through the camera lens and adjusts flash output to relative to the ambient light for a balanced flash–ambient exposure.

Tension. A state of visual imbalance within a photograph.

Three-Quarter-Length Pose. A pose that includes all but the lower portion of the subject's anatomy. Can be from above the knees and up, or below the knees and up.

Three-Quarters View. Facial pose that allows the camera to see three-quarters of the facial area. Subject's face is usually turned 45-degrees away from the lens so that the far ear disappears from camera view.

TIFF (Tagged Image File Format). A file format commonly used for image files. TIFF files offer the option to employ lossless LZW compression, meaning that no matter how many times they are opened and closed, the data remains the same (unlike JPEG files, which are designated as lossy files, meaning that data is lost each time the files are opened and closed).

Vignette. A semicircular, soft-edged border around the main subject. Vignettes can be either light or dark in tone and can be included at the time of shooting, or created later in printing.

Watt-Seconds. Numerical system used to rate the power output of electronic flash units. Primarily used to rate studio strobe systems.

White Balance. The camera's ability to correct color and tint when shooting under different lighting conditions including daylight, indoor, and fluorescent lighting.

X-Sync Speed. The shutter speed at which focal-plane shutters synchronize with electronic flash.

Index

THE BEST OF WEDDING PHOTOJOURNALISM, 2nd Ed.

Bill Hurter

From the pre-wedding preparations to the ceremony and reception, you'll see how professionals identify the fleeting moments that will make truly memorable images and capture them in an instant. $34.95 list, 8.5x11, 128p, 150 color images, index, order no. 1910.

MOTHER AND CHILD PORTRAITS

Norman Phillips

Learn how to create the right environment for the shoot and carefully select props, backgrounds, and lighting to make your subjects look great—and allow them to interact naturally, revealing the character of their relationship. $34.95 list, 8.5x11, 128p, 225 color images, index, order no. 1899.

MASTER POSING GUIDE FOR WEDDING PHOTOGRAPHERS

Bill Hurter

Learn a balanced approach to wedding posing and create images that make your clients look their very best while still reflecting the spontaneity and joy of the event. $34.95 list, 8.5x11, 128p, 180 color images and diagrams, index, order no. 1881.

JEFF SMITH'S GUIDE TO
HEAD AND SHOULDERS PORTRAIT PHOTOGRAPHY

Jeff Smith shows you how to make head and shoulders portraits a more creative and lucrative part of your business—whether in the studio or on location. $34.95 list, 8.5x11, 128p, 200 color images, index, order no. 1886.

JERRY D'S EXTREME MAKEOVER TECHNIQUES FOR DIGITAL GLAMOUR PHOTOGRAPHY

Bill Hurter

Rangefinder editor Bill Hurter teams up with acclaimed photographer Jerry D, revealing the secrets of creating glamour images that bring out the very best in every woman. $34.95 list, 8.5x11, 128p, 270 color images, index, order no. 1897.

THE PHOTOGRAPHER'S GUIDE TO
MAKING MONEY
150 IDEAS FOR CUTTING COSTS AND BOOSTING PROFITS

Karen Dórame

Learn how to reduce overhead, improve marketing, and increase your studio's overall profitability. $34.95 list, 8.5x11, 128p, 200 color images, index, order no. 1887.

PROFESSIONAL COMMERCIAL PHOTOGRAPHY

Lou Jacobs Jr.

Insights from ten top commercial photographers make reading this book like taking ten master classes—without having to leave the comfort of your living room! $34.95 list, 8.5x11, 128p, 160 color images, index, order no. 2006.

ON-CAMERA FLASH
TECHNIQUES FOR DIGITAL WEDDING AND PORTRAIT PHOTOGRAPHY

Neil van Niekerk

Discover how you can use on-camera flash to create soft, flawless lighting that flatters your subjects—and doesn't slow you down on location shoots. $34.95 list, 8.5x11, 128p, 190 color images, index, order no. 1888.

PROFESSIONAL DIGITAL TECHNIQUES FOR
PHOTOGRAPHING BAR AND BAT MITZVAHS

Stan Turkel

Learn the important shots to get—from the synagogue, to the party, to family portraits—and the symbolism of each phase of the ceremony and celebration. $34.95 list, 8.5x11, 128p, 140 color images, index, order no. 1898.

LIGHTING TECHNIQUES
FOR PHOTOGRAPHING MODEL PORTFOLIOS

Billy Pegram

Learn how to light images that will get you—and your model—noticed. Pegram provides start-to-finish analysis of real-life sessions, showing you how to make the right decisions each step of the way. $34.95 list, 8.5x11, 128p, 150 color images, index, order no. 1889.

COMMERCIAL PHOTOGRAPHY HANDBOOK

BUSINESS TECHNIQUES
FOR PROFESSIONAL DIGITAL PHOTOGRAPHERS

Kirk Tuck

Learn how to identify, market to, and satisfy your target markets—and make important financial decisions to maximize profits. $34.95 list, 8.5x11, 128p, 110 color images, index, order no. 1890.

CREATIVE WEDDING ALBUM DESIGN WITH ADOBE® PHOTOSHOP®

Mark Chen

Master the skills you need to design wedding albums that will elevate your studio above the competition. $34.95 list, 8.5x11, 128p, 225 color images, index, order no. 1891.

CHRISTOPHER GREY'S STUDIO LIGHTING TECHNIQUES FOR PHOTOGRAPHY

Grey takes the intimidation out of studio lighting with techniques that can be emulated and refined to suit your style. With these strategies—and some practice—you'll approach your sessions with confidence! $34.95 list, 8.5x11, 128p, 320 color images, index, order no. 1892.

THE BEGINNER'S GUIDE TO PHOTOGRAPHING NUDES

Peter Bilous

Peter Bilous puts you on the path to success in this fundamental art form, covering every aspect of finding models, planning a successful session, and sharing your images. $34.95 list, 8.5x11, 128p, 200 color/b&w images, index, order no. 1893.

PORTRAIT LIGHTING FOR DIGITAL PHOTOGRAPHERS

Stephen Dantzig

Dantzig covers the basics and beyond, showing you the hows and whys of portrait lighting and providing demonstrations to make learning easy. Advanced techniques are also included, allowing you to enhance your work. $34.95 list, 8.5x11, 128p, 230 color images, index, order no. 1894.

FREELANCE PHOTOGRAPHER'S HANDBOOK, 2nd Ed.

Cliff and Nancy Hollenbeck

The Hollenbecks show you the ins and outs of this challenging field. From to starting a small business, to delivering images, you'll learn what you need to know to succeed. $34.95 list, 8.5x11, 128p, 100 color images, index, order no. 1895.

JEFF SMITH' SENIOR PORTRAIT PHOTOGRAPHY HANDBOOK

Improve your images and profitability through better design, market analysis, and business practices. This book charts a clear path to success, ensuring you're maximizing every sale you make. $34.95 list, 8.5x11, 128p, 170 color images, index, order no. 1896.

ELLIE VAYO'S GUIDE TO BOUDOIR PHOTOGRAPHY

Learn how to create flattering, sensual images that women will love as gifts for their significant others or keepsakes for themselves. Covers everything you need to know—from getting clients in the door, to running a succesful session, to making a big sale. $34.95 list, 8.5x11, 128p, 180 color images, index, order no. 1882.

MASTER GUIDE FOR PHOTOGRAPHING HIGH SCHOOL SENIORS

Dave, Jean, and J. D. Wacker

Learn how to stay at the top of the ever-changing senior portrait market with these techniques for success. $34.95 list, 8.5x11, 128p, 270 color images, index, order no. 1883.

PHOTOGRAPHING JEWISH WEDDINGS

Stan Turkel

Learn the key elements of the Jewish wedding ceremony, terms you may encounter, and how to plan your schedule for flawless coverage of the event. $39.95 list, 8.5x11, 128p, 170 color images, index, order no. 1884.

50 LIGHTING SETUPS FOR PORTRAIT PHOTOGRAPHERS

Steven H. Begleiter

Filled with unique portraits and lighting diagrams, plus the "recipe" for creating each one, this book is an indispensable resource you'll rely on for a wide range of portrait situations and subjects. $34.95 list, 8.5x11, 128p, 150 color images and diagrams, index, order no. 1872.

DIGITAL PHOTOGRAPHY BOOT CAMP, 2nd Ed.

Kevin Kubota

This popular book based on Kevin Kubota's sell-out workshop series is now fully updated with techniques for Adobe Photoshop and Lightroom. It's a down-and-dirty, step-by-step course for professionals! $34.95 list, 8.5x11, 128p, 220 color images, index, order no. 1873.

AVAILABLE LIGHT
PHOTOGRAPHIC TECHNIQUES FOR USING EXISTING LIGHT SOURCES

Don Marr

Don Marr shows you how to find great light, modify not-so-great light, and harness the beauty of some unusual light sources in this step-by-step book. $34.95 list, 8.5x11, 128p, 135 color images, index, order no. 1885.

SCULPTING WITH LIGHT

Allison Earnest

Learn how to design the lighting effect that will best flatter your subject. Studio and location lighting setups are covered in detail with an assortment of helpful variations provided for each shot. $34.95 list, 8.5x11, 128p, 175 color images, diagrams, index, order no. 1867.

STEP-BY-STEP WEDDING PHOTOGRAPHY

Damon Tucci

Deliver the top-quality images that your clients demand with the tips in this essential book. Tucci shows you how to become more creative, more efficient, and more successful. $34.95 list, 8.5x11, 128p, 175 color images, index, order no. 1868.

PROFESSIONAL WEDDING PHOTOGRAPHY

Lou Jacobs Jr.

Jacobs explores techniques and images from over a dozen top professional wedding photographers in this revealing book, taking you behind the scenes and into the minds of the masters. $34.95 list, 8.5x11, 128p, 175 color images, index, order no. 2004.

DOUG BOX'S

GUIDE TO POSING
FOR PORTRAIT PHOTOGRAPHERS

Based on Doug Box's popular workshops for professional photographers, this visually intensive book allows you to quickly master the skills needed to pose men, women, children, and groups. $34.95 list, 8.5x11, 128p, 200 color images, index, order no. 1878.

500 POSES FOR PHOTOGRAPHING WOMEN

Michelle Perkins

A vast assortment of inspiring images, from head-and-shoulders to full-length portraits, and classic to contemporary styles—perfect for when you need a shot of inspiration to create a new pose. $34.95 list, 8.5x11, 128p, 500 color images, order no. 1879.

POWER MARKETING, SELLING, AND PRICING
A BUSINESS GUIDE FOR WEDDING AND PORTRAIT PHOTOGRAPHERS, 2ND ED.

Mitche Graf

Master the skills you need to take control of your business, boost your bottom line, and build the life you want. $34.95 list, 8.5x11, 144p, 90 color images, index, order no. 1876.

500 POSES FOR PHOTOGRAPHING BRIDES

Michelle Perkins

Filled with images by some of the world's most accomplished wedding photographers, this book can provide the inspiration you need to spice up your posing or refine your techniques. $34.95 list, 8.5x11, 128p, 500 color images, index, order no. 1909.

ADVANCED WEDDING PHOTOJOURNALISM

Tracy Dorr

Tracy Dorr charts a path to a new creative mindset, showing you how to get better tuned in to a wedding's events and participants so you're poised to capture outstanding, emotional images. $34.95 list, 8.5x11, 128p, 200 color images, index, order no. 1915.